Colour

HOW TO USE COLOUR IN ART AND DESIGN

SECOND EDITION

HOW TO USE COLOUR IN ART AND DESIGN

Edith Anderson Feisner

Laurence King Publishing

701.85

174392

Published in 2006 by Laurence King Publishing Ltd 361–373 City Road
London EC1V 1LR
United Kingdom
Tel: + 44 20 7841 6900
Fax: + 44 20 7841 6910
e-mail:enquiries@laurenceking.com
www.laurenceking.com

Copyright © 2006, 2001 Fairchild Publications, Inc.

All rights reserved. No part of this publication may be reproduced or transmitted in any form or by any means, electronic or mechanical, including photocopy, recording or any information storage and retrieval system, without prior permission in writing from the publisher.

A catalogue record for this book is available from the British Library.

ISBN 185669 441 0

Project Editor: Rada Radojicic Designer: Andrew Shoolbred Cover Design: Frost Design Picture Researcher: Peter Kent Color charts by Fakenham Phototypesetting Printed in Singapore

Contents

Preface	ix	Josef Albers	20	
		Faber Birren	2	
Part I		Frans Gerritsen	2	
COLOR FOUNDATIONS	1	Concepts to Remember	22	
COLOR FOUNDATIONS	1	Exercises	22	
Chapter 1 What Is Color?	2	Chapter 4 Coloring Agents	23	
Physiology	3	Additive Color Mixing	23	
How Light Gives Objects Color	4	Subtractive Color Mixing	23	
Factors in Perception	4	Pigments and Dyes	23	
Media and Techniques	4	Binders and Grounds	26	
Eye and Brain	4	Color Printing	27	
Psychology and Culture	5	Photography	30	
Local, Optical, and Arbitrary Color	5	Concepts to Remember	31	
Concepts to Remember	7	Exercises	31	
Exercises	7			
Chapter 2 Color Systems and Color Wheels	8	Part II		
The Pigment Wheel	9	DIMENSIONS OF COLOR	33	
The Process Wheel	9			
The Munsell Wheel	10	Chapter 5 The Dimension of Hue	34	
The Light Wheel	11	Mixing Hues	34	
The Visual Wheel	11	Pigment Wheel	35	
Concepts to Remember	12	Munsell Wheel	35	
Exercises	12	Light Wheel	35	
		Process Wheel	35	
Chapter 3 Color Theorists	13	Broken Hues	37	
Color Theory in the Ancient World	13	Hues in Compositions	37	
Leonardo da Vinci	13	Concepts to Remember	38	
Sir Isaac Newton	13	Exercises	38	
Moses Harris	14		9.	
Johann Wolfgang von Goethe	14	Chapter 6 The Dimension of Value	39	
Philip Otto Runge	15	The Values of Hues	39	
J. C. Maxwell	16	Discords	40	
Michel Eugène Chevreul	16	Value and Spatial Clarity	41	
Ogden Rood	16	Shading	41	
Ewald Hering	16	Pattern and Texture	42	
Albert Munsell	16	Emotion	42	
Wilhelm Ostwald	18	Definition and Emphasis	42	
CIE	19	Contrast and Toning	43	
Johannes Itten	19	Value in Compositions	43	
Alfred Hickethier	20	Order	45	

Concepts to Remember	48	Intensity and Space	84
Exercises	48	Presentation	84
		Line	85
Chapter 7 The Dimension of Intensity	49	Outlining	85
Chroma	49	Legibility	87
Colored Grays	49	Other Types of Line Formation	87
Complementary Hues	50	Form and Shape	88
Complementaries on the Different Wheels	50	Texture	89
False Pairs	51	Reflective Surfaces	89
Glazing	52	Light	91
Intensity in Compositions	52	Types of Lighting	92
Balance	53	Concepts to Remember	93
Intensity and Value	54	Exercises	93
Effects of Depth	54		
Proportion	54	Chapter 11 Color Interactions	94
Concepts to Remember	55	Afterimages	94
Exercises	55	Successive Contrast	94
		Simultaneous Contrast	95
Chapter 8 The Dimension of Temperature	56	Achromatic Simultaneous Contrast	95
Mixing	56	Chromatic Simultaneous Contrast	96
Neutrals	57	Bezold Effect	97
"Relative" Temperatures	57	Optical Mixing	97
The Effects of Backgrounds	59	Concepts to Remember	102
Tonality	59	Exercises	102
Proportion	61		
Metals	62	Chapter 12 Color and the Effects of Illumination	103
Concepts to Remember	63	Shadows	103
Exercises	63	Time and Weather	109
		Chromatic Light	112
		Structural Color	112
Part III		Luminosity	113
COLOR IN COMPOSITIONS	65	Iridescence	115
		Luster	116
Chapter 9 Color and the Principles of Design	66	Concepts to Remember	116
Rhythm	66	Exercises	117
Balance	67		
Proportion	69		
Scale	71	Part IV	
Emphasis	72	THE INFLUENCE OF COLOR	119
Harmony	74		
Concepts to Remember	77	Chapter 13 Color Symbolism	120
Exercises	77	How Color Influences Life	12C
		Color Associations in Language and Emotion	120
Chapter 10 Color and the Elements of Design Space	78	Black, White, and Gray	120
Space	78	Red and Pink	121
The Illusion of Transparency	80	Orange and Brown	121
Translucency	83	Yellow	121
Volume Color	83	Green	122
Film Color	84	Blue	122

Purple, Violet, and Indigo	123	Modernism and the Late Twentieth	
Influences of the Dimensions of Color	123	Century	143
Religious and Cultural Color Symbolism	124	Color Application in Contemporary Arts	144
The Bible	124	Environmental Arts	145
Christianity	124	Architecture	145
Judaism	125	Landscape Design	148
Islam	125	Interior Design	149
Buddhism and Taoism	125	Product Design	149
Hinduism	125	Studio Arts	150
Cultural Symbolism	126	Sculpture	150
The Zodiac	127	Ceramics	151
Academic Color	127	Glass	151
Flags and Heraldry	127	Photography	151
Color and the Environment	129	Fiber Arts	152
Color in Nature	130	Fashion	154
Human Use of Natural Effects of Color	130	Clothing	154
Color and Health Care	132	Jewelry	154
Concepts to Remember	133	Commercial Arts and Technology	155
Exercises	133	Graphic Design	155
		Printing	155
Chapter 14 Putting Color to Use—Then and Now	134	Computer Technology and the Internet	156
A Brief Survey of Color in Art History	134	Conclusion	157
The Paleolithic Era	134	Exercises	157
Ancient Egypt	135		
Egyptian Painting	135	Appendix 1: Color Content Identification Charts	158
Color in Egyptian Fashion	135	Appendix 2: Chronological List of Color Theorists	162
Ancient Greece	135	Appendix 3: Coloring Agents—Dry Binders	163
Greek Sculpture and Ceramics	135	Appendix 4: Coloring Agents—Liquid Binders	164
The Greek Color Palette	137	Appendix 5: Coloring Agents—Pigment Origins	
Ancient Rome	137	and Characteristics of Common	
The Middle Ages	138	Colors	164
Early Medieval Mosaics	138	Appendix 6: Hue—Various Art Media Matched to	
Medieval Manuscript Illumination	138	Color-Aid Paper Pure Hues	165
Medieval Stained Glass	138	Appendix 7: Value Orders	168
Medieval Tapestries	138	Appendix 8: Color Legibility Rankings	168
The Renaissance	138	Appendix 9: Color Symbols in Religion	169
The Baroque	140	Appendix 10: Historical Color Palettes	170
The Modern World and Color	141		
Neoclassicism and Romanticism	141	Glossary	171
Impressionism and Postimpressionism	142	Bibliography	175
Decorative Arts in the Nineteenth		Index	177
Century	143	Credits	182

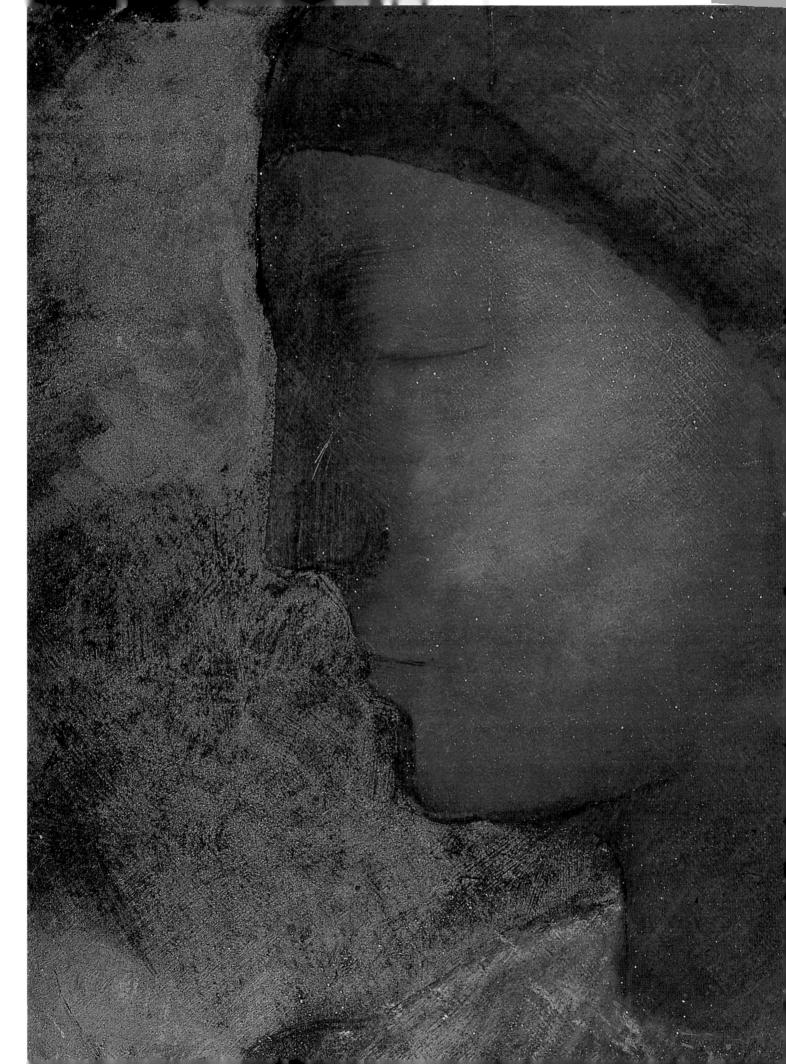

PART I

Color Foundations

Three basic elements are required for an appreciation of color: a light source, an object, and a viewer. This part begins with the fundamentals of color observation. We describe the physiology of the eye and how light imparts color to objects, as well as the psychological and cultural factors involved in perception. These factors in turn affect whether an artist chooses to use local, optical, or arbitrary color. Next we examine the different color systems and "wheels," along with their application to different media.

The science and psychology of color have fascinated thinkers for centuries. On our historical journey, we meet such individuals as Leonardo da Vinci, Sir Isaac Newton, Albert Munsell, and Josef Albers. Their influence on the discipline of color today remains strong.

Finally, we look at coloring agents—additive and subtractive color mixing, pigments, dyes, binders, grounds—and discover how color is employed in the art of four-color printing and photography.

What is Color?

More than any other element of design, color has the ability to make us aware of what we see, for nothing has meaning without color (here we extend the meaning of color to include black and white). Try to describe the sky, for example, without referring to color—it is very difficult.

Color defines our world and our emotions. It is usually seen before imagery. Our eyes are attracted to color to such an extent that the color of an object is perceived before the details imparted by its shapes and lines. At first glance we do not see the different species of trees present in a summer woodland, but

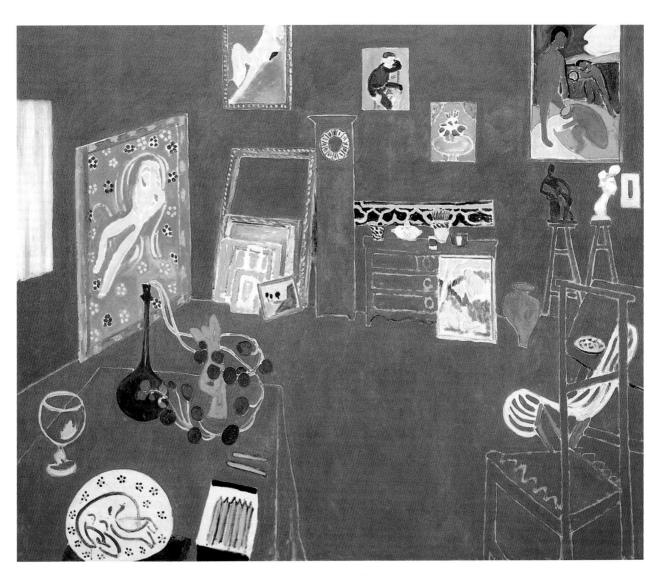

1.1 Henri Matisse, *The Red Studio*, 1911. Oil on canvas. $71\frac{1}{4} \times 86\frac{1}{4}$ in (181 \times 219.1 cm). The Museum of Modern Art, New York. Mrs. Simon Guggenheim Fund. Our initial impression is of an abundance of red color. We must take a second look to determine the objects in *The Red Studio*. This is an example of how color is seen before imagery. However, Matisse has tempered this initial reaction with judicious use of values and complementary combinations.

rather see the preponderance of green. The artist, architect, and designer, however, are generally concerned with having color and imagery perceived simultaneously. Upon entering a room we first see the color or colors used in the interior design and then discern the furnishings and artifacts contained within the space. An artwork, be it fine or commercial, works best when its color usage allows the viewer to see the content of the piece (both color and imagery) together. When this is accomplished a work's message is conveyed immediately, without a "second look" on the part of the viewer (fig. 1.1).

Color can also be described by two very different methods or points of view—objectively, by referring to the laws of chemistry, physics, and physiology; and subjectively, by referring to the concepts found in psychology. Similarly, our perception of objects depends both on physical factors—such as their actual **hues** (the name of a color: red, yellow, blue), their lightness and darkness in relationship to surroundings (**value** of a hue)—and on more psychological and cultural factors.

PHYSIOLOGY

Physiologically color is a sensation of light that is transmitted to the brain through the eye. Light consists of waves of energy, which travel at different wavelengths. Tiny differences in wavelengths are processed by the brain into a myriad nuances of color, in much the same way as our ear/brain partnership results in our interpretation of sound. Sound lets us interpret our auditory language; color lets us interpret our visual language. Because each of us is unique, our eye/brain reactions differ. Thus, when we speak of color, we cannot speak in absolutes but must resort to generalizations. These are sensations that *seem* to happen to all of us.

As light passes into the eye (fig. 1.2) it comes in contact with the covering near the back of the eye known as the retina. The retina is made up of layers of different cells, including those known as rods and cones. The function of the rods is to allow the brain to see dimly lit forms. They do not distinguish hue, only black and white. The cones, however, help us to perceive hues. The cones in the eye only recognize red (long wavelengths), blue-violet (short wavelengths), and green (middle wavelengths), and relay these color messages to the cones of the fovea, an area at the center of the retina, whose cones transmit to the brain.

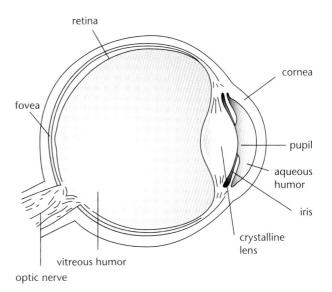

1.2 The human eye. We distinguish the world of color after light passes through the cornea and pupil and strikes the retina, which subsequently passes messages to the fovea from where they are transmitted to the brain.

1.3 The eye/brain processing the color yellow. The yellow sensation is passed through the lens of the eye and is converted in the retina to the light components of red and green. From the retina these components are conveyed to the fovea, which transmits them to the brain. The brain mixes the red and green messages to create the yellow that we see.

The brain then assimilates the red, blue-violet, and green impulses and mixes them into a single message that informs us of the color being viewed. When we see red, for example, this is because the red-sensitive cones are activated while the green and blue-violet ones are relatively dormant. Keep in mind that objects emit many colored wavelengths (red, orange, yellow, green, blue, violet) but our eye cones break these colored wavelengths into red, blue-violet, and green which our brain processes into the colors we actually see. Yellow is the result of the green-sensitive and red sensitive cones being activated and mixed while the blue-violet cones remain comparatively inactive (fig. 1.3).

HOW LIGHT GIVES OBJECTS COLOR

The great physicist and mathematician Sir Isaac Newton (1642–1727) was a pioneer in studying light under laboratory conditions to provide a logical framework for understanding color (see page 13). His early research into color phenomena resulted in his discovery that sunlight is composed of all the colors in the spectrum (**fig. 1.4**). Using a ray of sunlight directed through a prism, Newton observed that the ray of light was bent, or refracted, and the result was an array of projected colors, each with a different range of wavelengths, in the following order: red, orange, yellow, green, blue, blue-violet, and violet. This array, the constituents of light, is known as the **visible spectrum**.

When light strikes a surface, certain wavelengths are absorbed and others are reflected (bounced back) by its **pigments**, or coloring matter. This process gives the surface its color. For example, we see red when

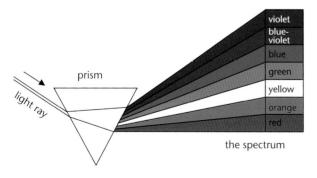

1.4 The visible spectrum. Of the seven lightwaves, violet has the shortest wavelength and red the longest. A close examination of the colors of the spectrum also reveals that the human eye can detect graduated colors between them such as red-orange between red and orange, and blue-green between blue and green.

only the red wavelengths are reflected off the surface of an object, such as a red apple, and the remaining wavelengths are absorbed. Different combinations of reflected wavelengths form all the observed colors. When all the wavelengths are reflected off a surface and mixed, the result is white. (White light is that light that we perceive as daylight at noon.)

FACTORS IN PERCEPTION

There are many factors affecting our perception of a color, such as the surroundings of the object, its surface texture, and the lighting conditions under which it is seen. How much of a color is used, whether it is bright, dull, light, or dark, and where it is placed in relation to another color are also crucial factors in our perception.

Media and Techniques

Our perception of color in works of art is strongly affected by the type of medium used. Painting alone offers a myriad different types of media, such as oil, acrylics, and water, that affect our perception of color. We must also take into consideration the type of support employed—canvas, board, or paper, and so on-and what grounds are used, such as gesso or primer. Even the brands of paint can provide differences, because of the media used for their mixture. How does a pencil line or sketch affect the visual perception of color in a watercolor painting? The textile artist works with a vast array of yarns and fibers, each imparting its unique qualities of sheen and texture. Ceramic glazes can result in an overlapping of colors that changes our perception of the piece. We can also experience the same types of color variations in printmaking. Consider also that interior design and fashion combine many types of media and textures which can produce a different perception of the same color (fig. 1.5).

Eye and Brain

The human eye in combination with the brain's reaction tells us how to distinguish the type of color being seen, as well as its relative purity and lightness. But memory also exerts an influence. Most of what we see is based on the memory of a color—when and how we have experienced it before. In addition, certain colors are perceived more easily than others. Yellows and greens are seen before other hues, while red and violet are the most difficult to perceive. If we take another look at the hue order of the visual spectrum,

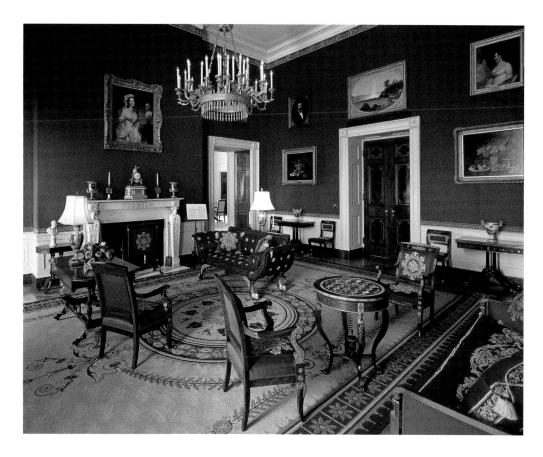

we see that a perception curve is formed, with the yellow and green hues at the curve's height and red and violet forming its lower extremities (fig. 1.6).

Psychology and Culture

Memory, experiences, intelligence, and cultural background all affect the way a color's impact can vary from individual to individual. This is not to say that the color will be perceived differently, but that that perception will mean different things to different people. In most Western Cultures, for example, black is associated with death, but in China and India white is regarded as a symbol of death. In America and many Western cultures the bride usually wears white and white is deemed a bridal or wedding color. In China, however, the bride is attired in red. The mailbox on the streets of the United States is blue, but in Sweden the mailboxes are red. The American tourist in Sweden has a more difficult time finding a site to mail those postcards home because of the color change from the familiar blue to red.

LOCAL, OPTICAL, AND ARBITRARY COLOR

The quality of light further determines the quality of any color that we see. A red barn in brilliant noon

1.5 Illustration of interior space—the Red Room in the White House, Washington, D.C. Notice that the red on the walls, the upholstery, and the rug all appear different as well as the white of the candles, the molding paint, the flowers, the bust sculpture, the lampshade, and the porcelain lamp base. These nuances are the result of the influence of the media employed on the color.

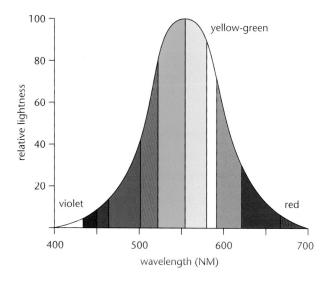

1.6 The perception curve. The yellow and green wavelengths register highest on the relative lightness axis. Someone with normal vision perceiving colored lights of equal energies will register the yellow-green segments of the spectrum first, because they appear brighter than all the other ones.

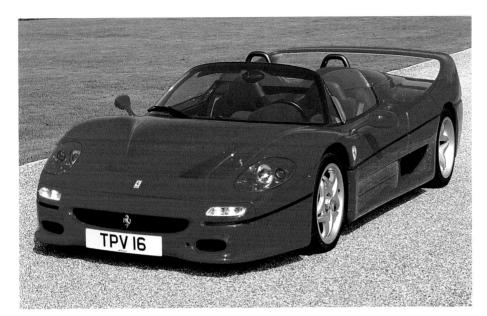

1.7 Ferrari F50, 1996. The local color of this car stands out on a bright, cloudless day.

sunlight will appear red, but a different red than one we would observe at sundown or on a rainy day. Armed with this knowledge, artists, architects, and designers can influence the color sensations of those who view their work. They may use color in three ways to impose these sensations: local or objective color, optical color, and arbitrary color. **Local color** is the most natural. It reproduces the effect of colors as seen in white daylight, exactly as we expect them to be: blue sky, red barn, and green grass. When the artist has a highly realistic style, the composition is rendered in exact colors and values (**fig. 1.7**). **Optical color** reproduces hues as seen in lighting conditions other

than white daylight: in the rain or thunder (fig. 1.8), at sunset, or in indoor lighting. Again the composition is rendered in a somewhat naturalistic way. Arbitrary color allows the artist to impose his or her feelings and interpretation of color onto the images (fig. 1.9). Here, natural color is abandoned for the artist's choice. A gray stone bridge may be executed in warm oranges and beiges if the artist wants the bridge to impart a feeling of vitality and warmth. Arbitrary color is most often seen in twentieth-century art, especially among the Expressionists and Fauves, whereas local and optical color are employed in more realistic styles.

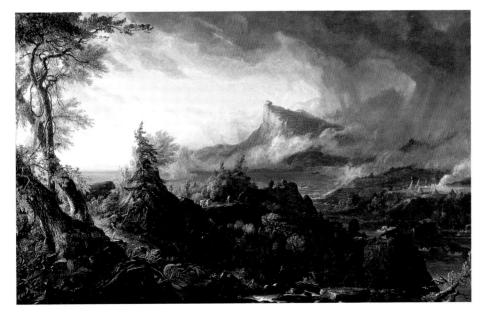

1.8 Thomas Cole, *The Course of Empire:* The Savage State, 1834. Oil on canvas, $39 \frac{1}{4} \times 63 \frac{1}{4}$ in (99.7 × 160.6 cm). The New York Historical Society, New York. Weather conditions determine subtle changes in the optical color of this landscape. The effects of sunlight originating beyond the left of the painting can be seen tinging the light-green leaves in the left foreground, while gray thunderclouds serve to darken the landscape in the central and right-hand areas.

1.9 Odilon Redon, The Golden Cell (Blue Profile), 1892. Oil and colored chalks, with gold, 11 % \times $9\frac{3}{4}$ in (30.1 × 24.7 cm). British Museum, London. Bequest Campbell Dodgson. The Symbolist painter Redon uses a gold background in order to suggest a Byzantine mosaic of the fourteenth or fifteenth century, which typically employed this color. However, he chooses to interpret the woman's dreaming face in arbitrary color, associating her in his fantasy with the Virgin Mary, who is traditionally rendered in blue.

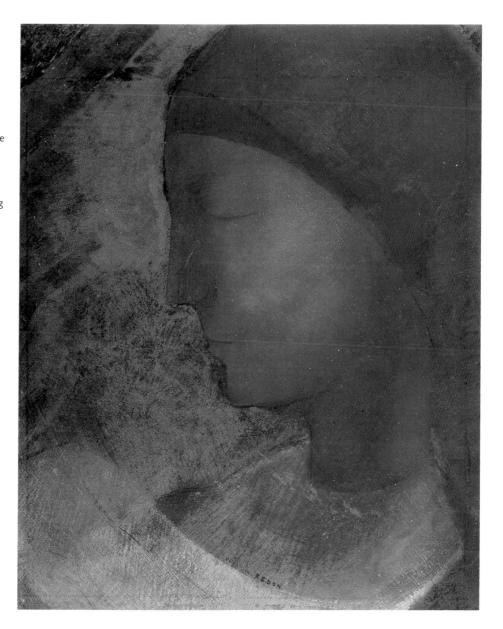

Concepts To Remember

Color is usually seen before imagery.

The physiology of the eye and the brain's reaction enable us to perceive light as different colors. The color imparted by an object is produced by the mixture of wavelengths reflected from its surface.

Our perception of the color of an object is dependent upon several factors, such as illumination, media, techniques, quantity, relationship to other colors present, memory, and culture.

Most color usage employs one of three aspects of color—local color, optical color, or arbitrary

color—and any of these can be manipulated by users to create desired reactions in the viewer.

Exercises

- Observe an object under different lighting conditions, and, if you can, take some color photographs. How do the different conditions affect its color?
- **2** Collect and label pictures (magazine photographs are good) showing local, optical, and arbitrary color.

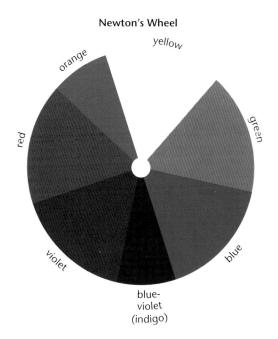

3.1 Newton's wheel. Newton proposed a color wheel based on the adjacent sequence of seven wavelengths within the visible spectrum (see fig. 1.4). The hue divisions are unequal because they are based on the proportion of each wavelength relative to others in the spectrum. The white at the center indicates the light source within which all the wavelengths are contained.

perception. He discovered that as a ray of white light passes and is bent, or refracted, through a prism it is broken into an array of colors, or spectral hues—red, orange, yellow, green, blue, indigo, and violet (see fig. 1.4). He noted that white light was a mixture of all the spectral hues. He took this "array" and turned it into a two-dimensional circular model that became the first color wheel. Notice that the hue divisions of Newton's wheel are not equal but are based on the extension or proportion of each hue in relation to the spectrum (fig. 3.1). Newton found when mixing pigments of opposite hues on his wheel (complementaries) that "some faint anonymous colour" resulted. Newton was never able, in his experiments, to mix pigments of two or three of his hues to obtain white, because his theory was based on the mixing of light (additive color), while the mixing of hue pigments is based on subtractive color.

MOSES HARRIS

Moses Harris, an English entomologist and engraver (active 1766–1785), wrote *The Natural System of Colors* in 1766. In this book he presented red, yellow, and blue as the primary hues, which he termed "primitives." The

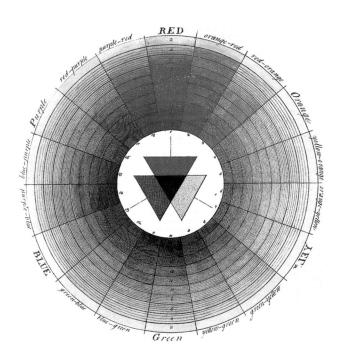

3.2 Harris's color wheel, from *The Natural System of Colors*, c. 1766. Royal Academy of Arts, London. Moses Harris derived his eighteen-step color wheel from the three primaries of red, yellow, and blue, which here overlap to black. As each hue approaches the center, it takes on deeper shades of gray.

mixture of these primitives produced the "compound" hues (secondaries) of orange, green, and purple. The primitive/compound mixtures were each categorized into two progressions—red and orange yielded redorange which was more red than orange, and orange-red which was more orange than red. The Harris wheel was divided into eighteen equal hue divisions and each division was then graded by value, light (plus white) to dark (plus black) (fig. 3.2).

JOHANN WOLFGANG VON GOETHE

In 1810 the German poet Goethe (1749–1832) published his *Theory of Colors*, which he thought would be more important to posterity than his poetry. He was one of the first modern thinkers to investigate and record the function of the eye and its interpretation of color, rather than the properties of light. He was a vigorous opponent of Newton's physics of light.

The two-dimensional wheel he developed was based on a triad of primaries—red, yellow, and blue—with the secondaries as complements of the primaries. In addition to his color wheel (fig. 3.3 top), which reflected previous diagrams, Goethe formulated a color triangle which he felt further reinforced color

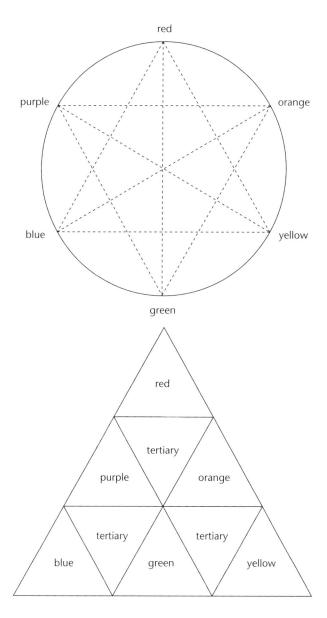

3.3 Goethe's color wheel (*top*) and color triangle (*bottom*). The corners of the triangle contain the primaries: red, yellow, and blue. The secondaries form the middle of the triangle's sides, connecting the primaries. The remaining areas are the tertiaries, which are the result of mixing two secondaries with the adjacent primary. These tertiary mixtures were less intense than what we commonly call tertiaries today.

relationships (**fig. 3.3** bottom). He assigned a number to each of the hues according to their relative **luminosity** (ability to give a glowing impression):

- yellow = 9
- orange = 8
- red = 6
- green = 6
- blue = 4
- violet = 3.

White was the most luminous at 10 and black the least at 0. In fact, he explored every aspect of color and its reactions, including the role of complementary colors in creating shadows, simultaneous contrast, **successive contrast**, the effects of cast light on an object, and proportional color use, leaving us with one of the foremost research references available to artists in all fields of endeavor.

PHILIP OTTO RUNGE

Philip Runge (1777–1810) was a German painter. In his book *The Color Sphere*, published in 1810, he arranged twelve hues in a spherical format, thus giving us the first three-dimensional color model. Runge's primaries were still red, yellow, and blue, and the remaining nine hues were interspersed to form a diameter or equator around the center of the sphere (**fig. 3.4**). The hues were each mixed in two steps, with white on one side of this equator and two steps of black on the

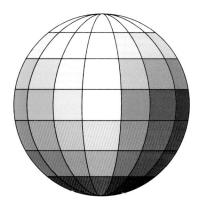

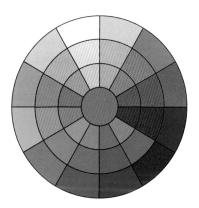

3.4 Runge's color sphere. The outer edges of Runge's sphere show near white at the top and black at the bottom (top diagram), with pure hues in the middle (equator). Note that the pure hues at the equator are different values, while the hues plus white at the top merge into the same value.

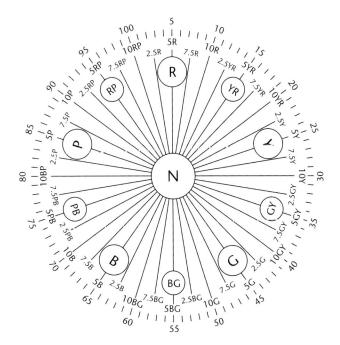

3.9 A cross-section of the Munsell tree. This bird's-eye view shows the five primaries and five secondaries of the Munsell wheel and tree (see figs. 2.4, 2.5), with "N" signifying the neutral, non-chromatic value of hues closest to the vertical axis. The numbers 5, 7.5, 10, and 2.5 running clockwise around the two innermost rings of numbers signify different stages in the progression from one primary to the next secondary, and so on. Courtesy of GretagMacbeth, New Windsor, NY.

that falls halfway between 5R and 5YR. The number 5, therefore, indicates the midpoint of each hue family (fig. 3.9).

Munsell expressed the value of the hue by adding a number between 0 and 9 as the second part of the notation, so that 5R5 is a middle-value red, and 5R9 is a very pale pink. Finally, Munsell added a notation after a slash to indicate the chroma, or level of saturation or purity, of the hue at that value, measured in equal steps from neutral gray to the greatest saturation seen in each hue at a particular value. So, a pure middle-value red is 5R5/14, whereas a less saturated red of equal value may be 5R5/6.

The Munsell notation may be summed up as follows: the first number and letter is the hue, the second number is the value, and the third is the chroma. Each plotting of a hue was flattened out into pages that became the branches of the Munsell color tree revolving around the value–scale trunk. This system allowed the artist to determine the components of a color without experimentation, and therefore to determine the reaction or interaction that a particular color

choice would impart. It also provided pigment specifications that were precise, allowing industry to become color standardized.

WILHELM OSTWALD

The Nobel Prize-winning German chemist Wilhelm Ostwald (1853–1932) based his color model on geometric progression. A value scale based on the absorption qualities (the quantity of white light absorbed) added arithmetically would result in a 1, 2, 3, 4 ... format. However, when absorption is analyzed on a geometric basis, we see a scale of 1, 2, 4, 8, 16, 32 ... This provided a scale with more optically equal steps in value gradation. Ostwald's resulting gray scale contained eight steps.

His color system consisted of two triangular solids joined at one side, with black at one point, white at the other, and twenty-four pure hues at the "equator" (fig. 3.10). He based his hues on the familiar red, yellow, and blue primaries. Ostwald's premise was that all colors are a combination of hue, black, and white. Thus the intermediate portions of his color triangles were based on percentages of black, white, and hue. Within each of these percentage mixtures the total was always 100 percent, which made them "complete." Ostwald termed the addition of white to a hue or color "tinting"; the addition of black, "shading."

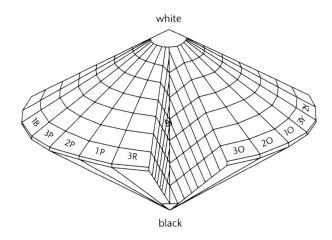

3.10 Ostwald's color solid, from *Color Science*, 1931. Ostwald first presented his color specification model in 1917. It has since been criticized by some artists for being too scientific in the creation of artworks. Adding black and white to a hue to create gray is markedly different from Munsell's method of arriving at gray by mixing a hue with its complementary hue.

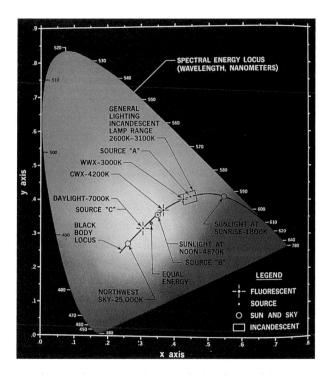

3.11 The CIE color diagram. The scientific foundation of the CIE diagram affords a precise color standard for industry, but the diagram is not a practical tool for the artist.

differences in human interpretation, as well as problems caused by the fading of painted or colored swatches.

JOHANNES ITTEN

The Swiss teacher and artist Johannes Itten (1888–1967) is probably best known to the color student for his book The Art of Color and its condensed version The Elements of Color. Itten taught both color and design at the enormously influential Bauhaus School in Germany, where his approach to education included both mental and physical conditioning. Each morning Bauhaus students did aerobic-type exercises on the roof of the building prior to Itten's lectures and classroom work. Itten developed his color sphere and "star" for his Bauhaus preliminary course in 1919. The star was simply a flattened version of the sphere developed earlier by Runge (see page 15). However, Itten placed yellow at the top of the diagram because it was the brightest of the hues and the closest visually to white light. The diagram contained twelve hues that

CIE

At the 1931 International Commission on Illumination (Commission Internationale de l'Eclairage, or CIE) the need for standardization of color notations was explored. The outcome was a precise color matching system based on lights. Here mechanics rather than observation or pigment measure served as the basis for color identification. A colorimeter was used to measure the three variables of any color: the luminance (intensity of light given off), the hue, and the saturation. Together, these three values determine the "chromaticity" of a color.

The CIE chromaticity diagram, or triangle, has the hues (stated as spectral hues or wavelengths) around the edge and the mixing or sum of these hues in the center, called E for equal energy (fig. 3.11). For light mixtures E is white; for pigment mixtures E is black or a dark neutral mixture. Although the diagram is termed a triangle, in fact it is a curve based on the luminosity curve.

The advantage of the CIE system is that it provides industry with the means of accurately and consistently matching colors of barely perceptible differences. Such an objective standard eliminates

Itten's Wheel

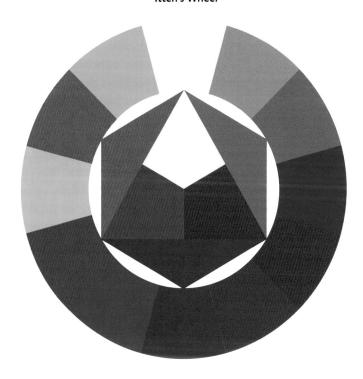

3.12 Itten's color wheel. Itten employs the primaries red, yellow, and blue in the center triangle. This triangle is surrounded by the secondaries green, violet, and orange, which are the respective complementary hues of the primaries. The outer circle is an arrangement of primary, secondary, and tertiary hues.

believed that all current color theories could be explained in terms of his own concept if they were viewed from the perspective of the eye or, more simply, the light that is entering the eye. He established yellow, magenta, cyan, and black as the new primaries for photolithography.

Gerritsen's color wheel identified colors by a numbered position on a multi-dimensional complex shape where the primaries were designated by absolute wavelengths and intensities between 0 and 100. This system, he claimed, could positively identify over six million different colors. In summary, Gerritsen accomplished the following:

- 1 He established that the eye was the point at which all color theory started.
- 2 He fixed the colors of red, green, and blue (light sources) as the primaries for all future color theory work.
- 3 He eliminated the confusion between the different color theories by re-interpreting them in terms of his new concept.
- 4 He put all future color research on a sound scientific basis.

Refer to Appendix 2 for a more complete chronological listing of color theorists.

Concepts To Remember

Distinct steps can be discerned in the development of color theory over the centuries.

- At first, color was viewed in terms only of light versus dark and as relating to the elements of fire, water, air, and earth.
- From Newton onward, the behavior of light, especially white light, became a subject of concern, for example, how it was divided into various wavelengths which imparted hues.
- Various attempts were made to impose order on such findings by proposing "wheels" to show the relationship of one color to another. This aided the study of the mixing of color.
- As knowledge of optics and brain function grew, color theorists concerned themselves increasingly with the reaction that color has on the eye (observation), our brains (perception), and our memory (consciousness). Color theorists attempted to encompass all of these variables in a single system. However, we see and use color in so many different forms that no single system can answer all the needs of color theory.

Exercises

- 1 Do a simple composition based on the colors of one of the color theorists in this chapter.
- 2 Do two identically structured compositions, one based on the colors identified by Aristotle and the other on the primary colors identified by Leonardo da Vinci.

Coloring Agents

Artists, architects, and designers must use materials in the creation of their works and these materials all contain color that is either **achromatic** (neutral, such as black, white, or grays) or **chromatic** (hued, such as red, yellow, or brown). The aim of the practitioner is to reproduce the colors found within the visible spectrum and their variations. Each work or medium employed in a project requires a different form of color usage or coloring agent. Prior to the nineteenth century, artists mixed their own pigments according to desired usage. Now, however, the artist usually deals with premixed colors, although the components of a color can differ from manufacturer to manufacturer and from medium to medium.

ADDITIVE COLOR MIXING

Let us begin with the mixing of light, which is an additive process. The art media using light mixing include theater, film, video, and television. The lights are mixed by placing colored filters (red, blue, or green) in front of a projected light ray. If red, green, and blue are all projected we get white light (fig. 4.1).

The video camera records images that are transmitted as light patterns. Again, we see three light primaries at work: red, blue, and green. The transmitted light patterns are converted into signals indicating chromaticity, a measure of the combination of hue and saturation, and luminance, a measure of value, or lightness and darkness. The picture tube is coated with dots of phosphors in red, green, and blue that are activated by the transmitted signals, resulting in the color television image. Magnification of a television image reveals combinations of tiny red, green, and blue-violet dots. When two light rays are projected their sum or combination is brighter than either ray by itself. For instance, yellow is much brighter than the red and green light beams projected as its components.

Computer graphics color monitors function in much the same way as video with the same light primaries of red, blue, and green (see pages 156–157). While the light primaries are the basis for computer

graphics, the computer graphics color menus are fashioned after the Munsell system of color notation, which allows the artist to function in a pigment-like environment. Thus, although the computer-screen image is based on additive color mixing, the computer-printer image is based on subtractive color mixing. The printout of the screen image will be duller than that seen on the screen.

SUBTRACTIVE COLOR MIXING

Pigments and Dyes

Subtractive methods of creating colors are based on pigments or **dyes**. Pigments are powders that are in a **binder** such as acrylic or oil which covers or adheres to a surface. Dyes are pigments that are dissolved and

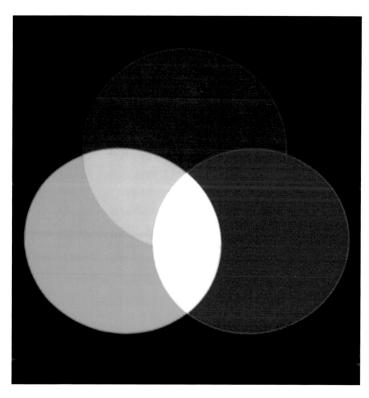

4.1 The mixing of light. When two of the projected additive primary colors—red, green, and blue—are overlapped, they create the secondary colors of yellow, cyan, and magenta. White light is the result of combining the three primaries.

4.7 The four-color printing process. Here we see the yellow, magenta, cyan, and black printing plates used in four-color printing, as well as the finished shot with all plates combined. The color values print as a series of dots so small as to be undetectable as dots by the human eye. The enlargement shows the dots that are combined and printed to create the illusion of the four-color image.

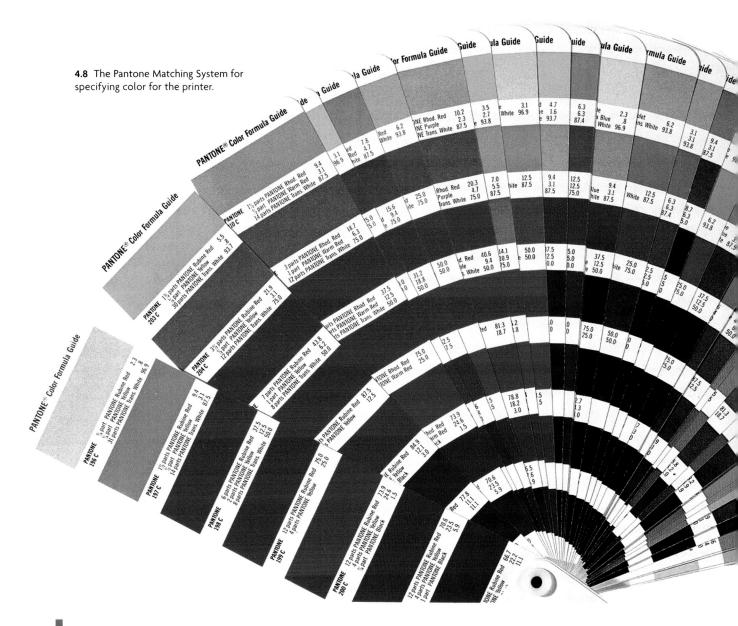

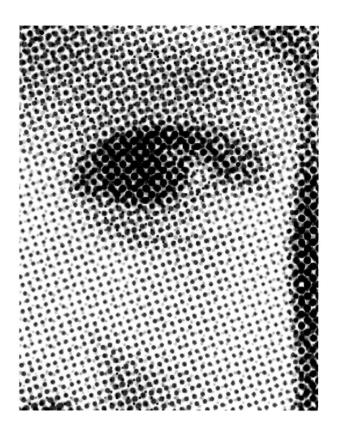

of colors next to each other. The easiest method of accomplishing this was the use of small dots, as seen in pointillism.

The same concept is found at work in color printing. In four-color process printing, screens of dots are layered on top of each other, each screen containing a different color (fig. 4.7). The screens used are black, process yellow, process magenta, and process cyan inks. The eye optically mixes these dots to form all the hues. The density of the screen and the size of the dots determine the lightness or darkness of the color. The smaller the dots, the paler the color will be. Flat color printing also works with transparent overlays of yellow, magenta, and cyan that are superimposed upon each other. Here, however, the designer indicates on the overlays which areas are to be printed in which colors.

Printers also rely on the **PMS system** (Pantone Matching System) for color matching (**fig. 4.8**). Based on nine colors, plus black and transparent white, the system shows the percentages of these colors required to produce a particular color. "Recipes" are given for 747 different colors, allowing the printer to mix the inks to produce the desired color. The graphic designer using printing inks must take care when attempting to reproduce various colors accurately.

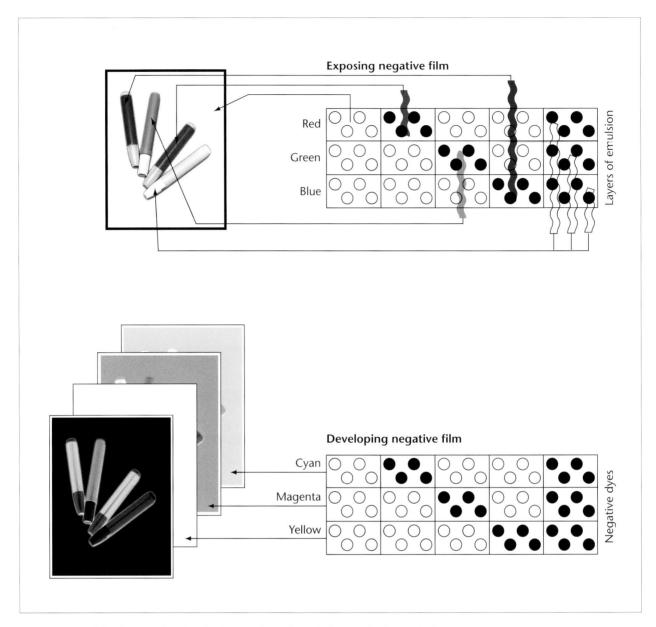

4.9 Exposing and developing color film. The diagram above shows different color layers of film exposure. The diagram below reveals the process colors of cyan, magenta, yellow, and black that are used in printing from plates exposed to negative film.

Dark blues, dark greens, and very warm reds cause problems because printing inks are transparent; these color choices require numerous layers of printing ink to achieve the desired result. Many graphic designers are also faced with a tight budget, and so often find themselves working with only one or two colors. The knowledge of how color behaves is most important if the graphic designer is to get a single color to function or appear as many.

Photography

The photographer works in black-and-white or color. Black-and-white photography relies on value changes from dark to light. Color photography, in both print and transparency forms, is made possible by a film that consists of an **integral tripack** made up of three layers of a gelatin (**fig. 4.9**). Each of these layers takes care of a different color. The top layer comprises silver halide which is sensitive to blue light; a yellow filter

beneath the silver halide layer blocks the blue light from passing to the second and third layers. A second layer is sensitive to green and blue light, and the third layer is sensitive to red light. These sensitizing dyes, therefore, are the primaries red, green, and blue. The camera exposes the tripack layers to the light mixtures it records, and the developing process activates the dyes. The result is a full color print or transparency. Photographers also have the option of attaching a colored filter to the lens which will impose the desired color reaction onto the tripack.

Concepts to Remember

- Coloring agents are the means by which the artist imposes color on an image or object.
- Additive color principles apply to the media of film, video, television, and computer graphics, and utilize the light primaries of red, green, and blue.
- Subtractive coloring agents depend upon colors being created from pigments (powders plus a binder) and dyes (pigments dissolved in a fluid).
- Pigments are of three types—dry, liquid, and combination—and are derived from either natural or artificial sources. The ideal pigments do not

- react to being mixed, have permanence, provide good coverage, and retain brilliance. Pigments are usually mixed with binders, which are classified as dry or liquid.
- Four-color process printing uses layers or screens of yellow, magenta, and cyan which optically mix to form colors. The Pantone Matching System (PMS) is also used for printing and relies on nine colors, black, and transparent white to create the desired color of printing ink.
- Photography is of two types—black-and-white and color. Color photography employs a tripack of three light-sensitive layers combined on the film.

Exercises

- 1 Collect or create color-chip examples of one color from various media (oil paint, pastels, yarn, photography, printing, and so on) and observe the different effects of that color.
- 2 Collect examples of photographs and the objects photographed, and examine the color changes between them.

PART II

Dimensions of Color

We have looked at how we perceive color scientifically and reviewed the different systems by which color can be organized. The varied contexts in which color is used can lead us to the conclusion that each color use requires an individual approach—the painter's mixing of pigments and the reactions that these paints have when placed next to each other (subtractive and partitive); the theater technician's deployment of colored lights (additive and partitive); and the weaver's dyeing of yarns and the effect of the yarn placement (subtractive and partitive). Despite their varied uses, however, colors do share some common characteristics: the properties of colors, which we will call their dimensions, their placement reaction or position (how they interact with other colors), and their psychological effects.

Every color has four dimensions—hue, value, intensity, and temperature. Color works as a combination of all these dimensions. Artists, architects, and designers must develop each of these dimensions for their own individual purposes and the requirements of any particular project.

The Dimension of Hue

The first **dimension** of color is hue. Hue is simply the kind or name of a color. Red, for instance, is red without any orange or violet in it. A hue without any white, black, gray, or complementary (which is the opposite hue on the color wheel) in it is termed a **pure hue**. The hue name is the term used to describe a particular wavelength. The labeling of hues can be one's personal choice, but "Color-Aid" papers (see Appendix 6) provide the easiest reference for determining hues. What is most important is that a hue be recognized. When asked to identify pure hues, students usually choose a red-orange-red for pure hue red and a green-yellow-green for pure hue green. When

trying to get colors to react and interact, they find that red-orange-red imparts different reactions from those achieved when pure hue red is used (fig. 5.1).

MIXING HUES

Let us look at the colors that result when hues are mixed in various ways. In order to obtain our pure hues we must put into practice our first method of acquiring a new color, which is the mixing of two primaries. Let us review the primaries of the various color wheels that work with color mixing.

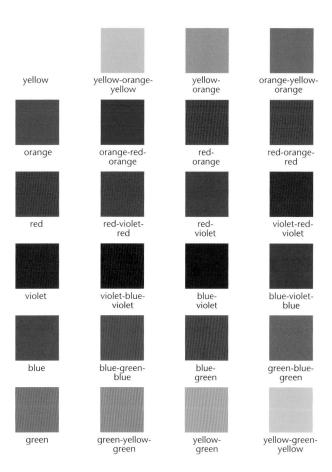

5.1 Pure hues. This chart broadly follows the principal color wheels (see figs. 2.2, 2.3, 2.4) in listing twenty-four pure hues from yellow through to yellow-green-yellow.

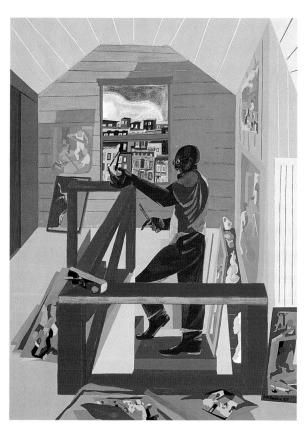

5.2 Jacob Lawrence, *The Studio*, 1977. Gouache on paper, 30×22 in $(76.2 \times 55.9 \text{ cm})$. Courtesy Seattle Art Museum. The orange rectangular frames are examples of subtly mixing pure hues (red and yellow) to create a secondary one (orange); the visual partnership is such that one cannot tell which of the pure hues is the parent. The warmth of the orange forces it toward us; its lack of shading flattens the foreground. Perspective is thereby reduced (aided by non-converging ceiling lines) and a stagelike effect is created.

Pigment Wheel

- red + yellow = orange
- vellow + blue = green
 - blue + red = violet.

Mixing these primaries results in secondary hues, which should be such that you cannot tell how much of a primary is present, or which primary is the **parent**. They should be in an equal *visual* partnership, even though unequal proportions of the primaries will be required to achieve this result (**fig. 5.2**).

Munsell Wheel

- yellow + green = yellow-green
- green + blue = blue-green
- blue + violet = blue-violet
- violet + red = red-violet
- red + yellow = orange.

Here again we are mixing primaries to obtain secondary hues that also should be an equal visual primary partnership.

Light Wheel

- red + green = yellow
- green + blue = cyan
- blue + red = magenta.

Now we are projecting colored lights to obtain new hues.

Process Wheel

When we use the process-wheel hues and mix a primary hue with another primary hue *in equal proportions* a secondary hue results. If we vary these proportions we find a system developing much like that of Alfred Hickethier, whose system is used by printers and color photographers (see page 20) (fig. 5.3).

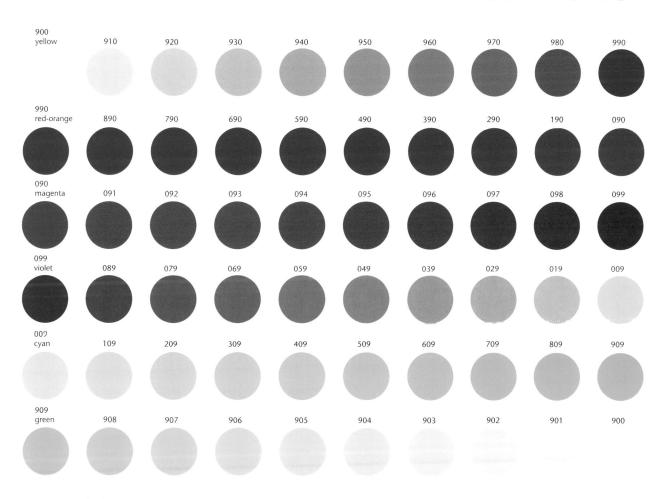

5.3 Process-wheel hues. These hues are generated using the Hickethier numbering system, which offers precise proportions for creating colors. If, for example, a fiber artist mixes various batches of dyes in identical proportions, each batch mixed will reveal exactly the same result.

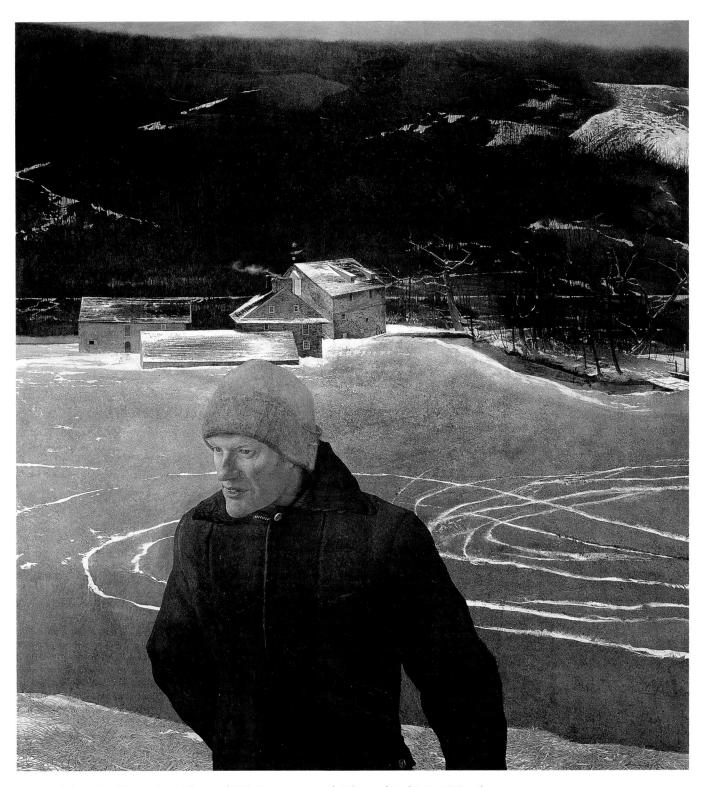

5.4 Andrew Wyeth, *The Battleground*, 1981. Tempera on panel, $49\frac{1}{2} \times 45\frac{5}{8}$ in (125.7 \times 115.9 cm). Nelson-Atkins Museum of Art, Kansas City, Missouri. Gift of Enid and Crosby Kemper Foundation. The broken hues (earth colors) used in the field, buildings, and woods beyond add great depth and richness to the composition, especially when seen in conjunction with the dominant slightly broken blue of this figure's hat.

Hues can be mixed in three different ways:

- 1 Two primaries, in equal or unequal proportions. A visually equal mixture produces a secondary.
- 2 Two adjacent colors in equal or unequal proportions. The visually equal mixture of a primary and an adjacent secondary produces a tertiary. The visually equal mixture of a primary and a tertiary produces a **quaternary**, and the mixture of a secondary in a visually equal proportion with a tertiary produces a **quinary**.
- 3 Two complementary colors in equal or unequal proportions (see Chapter 7, pages 49–55).

BROKEN HUES

A **broken hue**, or broken color, is a combination of unequal proportions of all the primaries (**fig. 5.4**). The broken hues found in nature, such as russet, gold, or ecru, are known as **earth colors**. In painting the most commonly named earth colors are known as ochers. Because we are working with unequal proportions (if the proportions were equal, the result would be black), we can develop an infinite number of broken hues that can be related to a particular primary (the parent

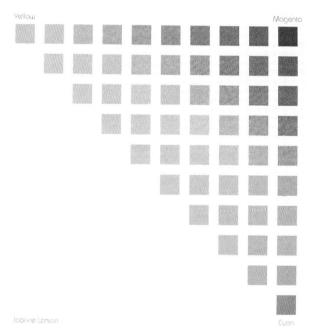

5.5 A computer-generated color triad showing the development of broken hues. The outer chips forming the triad's edges reveal mixtures in varying proportions of the primary hues, while the inner chips show the results of mixing just the primaries yellow, magenta, and cyan. The inner chips get duller as their hues become more and more broken. Courtesy Joanne Larson.

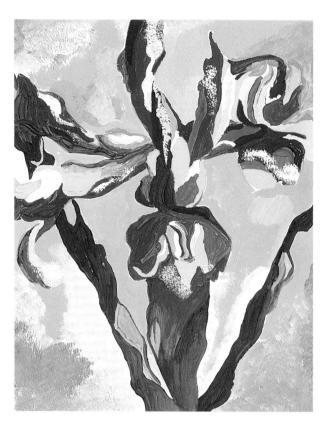

5.6 Broken hues. This composition displays a considerable amount of yellow hue, broken with small amounts of red and blue. The reds and blues are also broken using the other primaries, with the exception of the red on the iris petal at the very top. Courtesy Jessica Niemasz.

hue), depending on the amount used. If we use nine parts yellow, five parts cyan, and one part magenta, the resulting broken hue, a pea green, would have as its parent yellow. Subtractive mixing is at work, because the light rays imparted from each hue are canceling each other out and the result of this war depends on which is the strongest—the parent hue. Since they contain some of each of the primaries, the resulting broken hues have the wonderful facility of going with every other color. Note that it takes just a touch of the primarics to create a broken hue (fig. 5.5). You will also observe that broken hues are usually warmer and more opaque as well as being less intense than other hues. In a composition of pure hues, broken hues add a quality of richness (fig. 5.6).

HUES IN COMPOSITIONS

Compositions often work best when there is a dominance of one hue at work: few hues over a wide area generally create a more intense lasting impression

5.7 Secondaries, tertiaries, and pure hues. In this detail of a rendering for a theatrical set, the hues are mostly secondaries and tertiaries except for the touches of pure hue yellow at the top of the door knocker. Courtesy Jennifer Kievit.

than many hues over a narrow area. When one hue is dominant we term that hue as working for the tonality of the piece.

Primary, secondary, and tertiary hues provide us with different visual reactions when used. The primary hues attract the eye; they are the most stable and the most easily recognized of the hues, and they offer the greatest contrast. We see all other hues in relation to primary hues. The primary hues red, yellow, and blue function well when used in small quantities on small areas in the upper portions of objects or compositions, because eye flow is normally from top to bottom. If used in the middle or bottom of a composition, these primary hues can impart a jarring effect and eclipse everything around them, causing the viewer to take a second or third look in order to comprehend the imagery. When primary hues red, yellow, and blue are used over large areas they overshadow everything else and the color ends up being seen before the imagery.

Secondary hues are less stable than primary hues and are compatible with other colors. Secondary hues function well in large masses and in the lower portions of objects or compositions. Tertiaries are the least stable of the hues and they impart the least contrast. When used in a two-color composition,

tertiary hues can become stable by using them in greater proportion to the primary hues or by dulling the primary. Tertiary hues, like secondaries, work well in large masses and on the lower portions of objects or compositions (figs. 5.6, 5.7).

It is extremely advantageous for artists to be able to recognize Munsell primary, secondary, and tertiary hues, and to capture pure hue recognition in their memory.

Concepts to Remember

- The hue of any image determines the color interactions that occur. A color can be a pure hue, a mixture of hues, a neutral such as black, white, or gray, or any combination of these.
- Partitive, additive, and subtractive mixing of colors produce different results. In order to predict a color's reaction, we must be able to identify its predominant pure hue, or parent. Broken hues are extremely important to any work.
- Hue dominance imparts tonality. The quantity and placement of primary, secondary, and tertiary hues in a work produce important different visual reactions.

Exercises

- 1 Create one-inch squares of each of the hues in the color medium of your choice. The hues created must match the pure hues of "Color-Aid" paper. Refer to the layout used in figure 5.1.
- 2 Develop a color-sample chart that has pure hues on its outside edges and broken hues elsewhere. Refer to figure 5.5. You must be able to show which broken hue relates to which parent hue.
- 3 Do a simple composition employing broken hues and the pure hues red, blue, and yellow. Make sure the composition satisfies the principles of pure hue placement and quantity, as seen in figure 5.7.

The Dimension of Value

The second dimension of color, value, refers to the lightness or darkness of a hue. The values of a specific hue can be changed only by adding black or white; the resulting color is called a tint. White is the lightest value, black is the darkest, and middle-value gray is neither white nor black. When no black or white is present in a color it is a pure hue. Red is a pure hue. whereas pink is a light value of red or a "tint of red" (see Color Content Identification charts, Appendix 1). When imparting light or dark values in a composition. the artist must consider the various properties of different art media. For example, use of softer pencils will result in darker values, and addition of water can lighten inks or watercolors, which will increase their transparency. The photographer controls value by use of lens openings, shutter speeds, and type of film, in addition to the obvious variables of time, atmospheric conditions, and lighting, as well as during the development phase in the dark room.

THE VALUES OF HUES

The pure hues vary in value. Pure hue yellow, for example, has a lighter value than pure hue violet. Therefore, yellow and violet must be adjusted by the addition of black or white in order to be of equal value. Here are the pure hues ranked from lightest to darkest: yellow, yellow-orange, orange, yellow-green-yellow, red-orange, yellow-green, green-yellow-green, red, green, red-violet, green-blue-green, blue-green, blue-green, blue-green-blue, blue, violet, blue-violet. This ranking of hues by relative value shows us that when two hues are mixed, the resulting hue will be darker than the lighter hue of the partnership and lighter than the darker one.

It is important for artists to recognize when hues are of the same value. As a rough visual test, two hues placed next to each other are the same value when you squint at them and they blend together as one. Do not confuse value and brightness. We are only looking at the lightness and darkness of the hue, not its intensity. We start by working out a scale that ranges from black to white in equal intervals visually. The middle of this

scale will be a gray that is neither white nor black, and this is known as middle-value gray. Munsell's value chart uses the notation 9/ to denote white, 1/ to denote black and 5/ to denote middle-value grav. It is helpful to punch a hole in the center of each value on your scale with a paper punch to enable color samples to be placed beneath for viewing. Now we take our pure hues and add black and/or white to them and match these hue values to our gray scale. Lighting also has a great bearing on matching values. Red, orange, and yellow appear darker in reduced light, while blue and green look lighter. In strong light, lighter pure values will seem more intense; in dim light, darkvalued pure hues will seem more intense. Keep these points in mind when selecting the values for a work (fig. 6.1 and see Appendix 1).

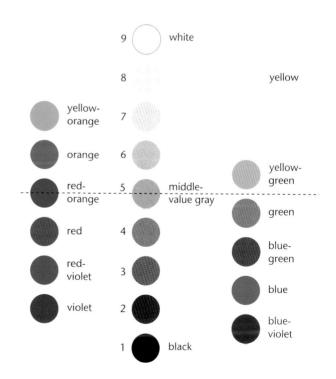

6.1 The values of hues. This diagram shows the relative values of hues at full intensity. The horizontal broken line corresponds to middle-value gray.

When pigments of equal value are mixed together, the resulting color will be a darker value. This is the result of subtraction (more wavelengths are absorbed and less light is reflected). When mixing pigments, we find that adding black makes orange appear brown, while yellow becomes olive. When we add white to a pure hue it will make it lighter in value and cooler. Gray can also be added to alter a hue. In fact, if the correct gray is added to a pure hue it can change its intensity without changing its value. This gray must be exactly equal in value to the hue it is mixed with. The resulting color is termed a **colored gray**.

Black, white, and gray are almost impossible to find in nature, for the natural grays that can be seen in most landscapes contain pure hues; these are known as **broken tints**. In the last chapter we defined broken hues as hues that contain some of each of the pigment primaries. Broken tints are simply broken hues that have had a varying amount of black and white added to them. In essence they are much paler (or darker) earth colors.

Discords

The effect obtained when the value of a hue is opposite to its natural order is called **discord**. For example, violet is a naturally dark hue; to discord violet we would add white to obtain a resulting lavender. Therefore, lavender (a light tint of violet) is a discord of violet. Naturally light-valued hues such as yellow are discorded by adding black, which reverses their natural order.

Discords play a supporting role in artists' work. They are easily overshadowed by colors that are not discorded, but they do stop the tendency of hues to "spread" visually. Large areas done in light discord (pastels) should be avoided, because large areas of light discord tend to weaken a composition. Small amounts of light discord, on the other hand, reduce monotony.

Light discords also generally provide the best highlights (the lightest value on a surface or object). The discord chosen should be based on the primary color closest to the object featuring the highlight. (However, if the object in question is painted in a primary color, the highlight should not be a discord of that color, but the next closest primary.) On an orange, for example, the highlight would not be pale orange but a very pale red. Looking again at the orange, we see that the closest primaries are yellow and red. Yellow is

Discords (lighter) Pure (darker) Highlights

Hues Odderward Highlights

6.2 Discords and discord highlights for each of the pure hues. A highlight is the area of an object that receives the greatest amount of direct light. Red has a pale blue highlight, because that will be a discord of the closest pigment primary—yellow or blue—but of the two only blue can be discorded by adding white. Blue has a pale red highlight, because the nearest pigment primaries are green and violet, but of the two only violet can be discorded by adding white.

discorded by adding black, and red is discorded by adding white or black.

Light discords must be accompanied and supported by lighter tints of hues that are naturally lighter on the pigment wheel. Lavender, for example, would require pale red, pale orange, or pale yellow. Dark discords must be accompanied and supported by darker tints of hues that are naturally darker on the pigment wheel. Dark orange (which is a discord) needs darker red, darker violet, or darker blue (which are not discords). Red and green can be discorded by adding either white or black. This is because pure-hue red and pure-hue green are close to being of middle value. Triad color schemes (see Chapter 9, page 76) can become more pleasing when discorded hues rather than pure hues are employed. Luminosity works with discord when the hues are of exactly the same value

(fig. 6.2). For example, when red and blue-green colors both have white added to them and are of the same value, the visual reaction is one of vibration as well as a glowing sensation of luminosity.

VALUE AND SPATIAL CLARITY

Value clarifies space and the form of an object in five ways: two-dimensional forms are made to appear solid as a result of shading; value creates pattern and texture; value imparts emotion; value can give definition and emphasis; and a difference in values imparts contrast.

Shading

One cannot deal with value without exploring shading. Chiaroscuro is the traditional form of shading

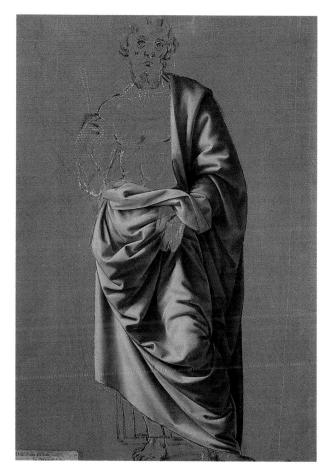

6.3 Lorenzo di Credi, *Drapery for a Standing Man*, late 15th–early 16th century. Brush and gray wash on brown paper, $15\frac{1}{4} \times 10\frac{5}{8}$ in (38.8 \times 26.9 cm). Louvre, Paris. The robe's folds are enhanced with various shadow effects. The deepest shadow areas (core of shadow) are juxtaposed with highlights in the arm, hip, and knee areas that suggest the smooth, shiny, luxurious quality of the man's garment.

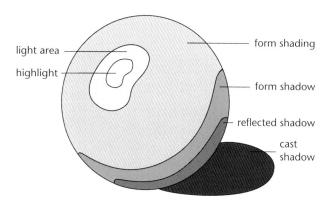

6.4 Highlights, shading, and shadow effects. As the light source strikes less and less of the ball's surface, those areas of the ball become increasingly dark. Eventually it blocks out the light to cast a shadow, which is then reflected back up onto the ball's surface.

that relies on systematic changes in value resulting in highlight, light, shadow, core of shadow, reflected light, and cast shadow (fig. 6.3). The highlight is the lightest value on a surface. These intense light spots usually denote smooth or shiny surfaces. A composition or an object does not have to have highlights. Light and shadow are the intermediate values that define the areas between highlight and core of shadow. Core of shadow is the most concentrated area of darkness. Reflected light is the light that is bounced back from nearby surfaces. This area clarifies the shadowed portions of a form and the artist must take into account the hue of the object as well as the hue of the plane by combining the local color of the object with the hues being reflected onto the surface. Cast shadows are shadows thrown by the object onto an adjacent plane and they, too, must take into account the hue of the object and the hue of the plane (fig. 6.4).

Let's look at an orange. We know its surface is orange. Now let's say it is resting on a green table. Our light area is going to be a lighter value of orange. Our shadow is a darker value of orange. Next we have the core of the shadow. We know this is going to be darker but it is also duller, for addition of a hue's complementary color will dull that hue. We must therefore add some blue (orange's complement) to our orange and black mixture. Our next area is that of the reflected shadow. We know that the surface area is a dark dull orange but it must now contain some dull green (green with its complement red added) because the green table hue is reflecting up onto the orange.

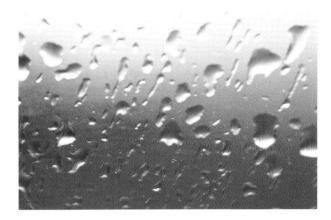

6.5 Raindrop patterns. Raindrops are influenced by the wind, here blowing from right to left and resulting in a left-slanting pattern. The top of a raindrop striking a transparent surface will be dark in value compared with its much lighter part extending downwards, because the lower part is denser and will be raised so that light will hit it first and create the highlight.

That brings us to the cast shadow. The table hue is green so the shadow will be a dull green with orange in it, but as the shadow goes farther away it gets weaker. At this point we have one area left to consider—the highlight. We know it is going to be a very light value but it is not going to be orange. It is going to be a discord of red. Orange's nearest primaries are red and yellow. To discord yellow we must darken it, so that's no good. But we can discord red by lightening it, so the palest red possible will be

6.6 David Ligare, Landscape with a Specific View (Veritas, Utilitas, Venustas), 1988. Oil on canvas, 79×115 in (200 \times 292 cm). Private collection, Greenwich Connecticut. While this painting is in broken neutral colors, the contrast in values imparts closeness to the viewer and the close values create contrast.

our orange's highlight. As we see in fig. 6.2, extremely pale red and extremely pale blue are our highlight choices. When we have the option of using pale red or pale blue, we use pale red for natural objects and pale blue for man-made objects. Pale red is a warm color and natural objects are usually warm in temperature; pale blue is a cool color and man-made objects (steel, plastic, etc.) are usually cool in temperature.

When shadows are cast, the surface colors of the depicted objects are affected. Color reflects onto the planes surrounding it. A room with a red rug and a white ceiling should be rendered with the ceiling having a pale dull red tinge to it. The farther away from a reflective surface we go, the weaker the reflective power becomes. A brown tree trunk may be greener at its base than at its top due to the reflection of any green grass at the base.

Pattern and Texture

Because differences in value provide contrast, value also creates texture and pattern. Contrast delineates shapes as well as space, providing both obvious and subtle pattern and texture. In nature we see this concept at work when we observe the patterns created by raindrops falling on a surface or observe an animal's fur and record the contrasts created by the light and dark values that are present (fig. 6.5). Rough texture is created by a wide contrast between light and dark values across the surface. When there is less contrast the texture will be subtler.

Emotion

Because pure white and pure black produce the greatest clarity, sharp contrasts produce the effect of precision, firmness, objectivity, and alertness. Close values, on the other hand, produce feelings of haziness, softness, vagueness, indeterminacy, quiet, rest, introspection, and brooding (fig. 6.6 and see fig. 6.15). Dark compositions give feelings of night, darkness, mystery, and fear, while light compositions impart feelings of illumination, clarity, and optimism. Dark values seem quiet and subdued. Compositions with middle values seem relaxed, less demanding, and form combinations that go unnoticed.

Definition and Emphasis

Contrast in value can be used to create emphasis. Light values will seem more active, increase distance and spaciousness, and make objects seem larger.

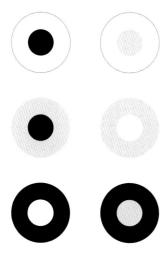

6.7 The effects of value contrast on visual size. Although the small circles are the same size and the backgrounds are the same size, extreme contrasts between circles and backgrounds reveal the illusion of size differentials. The white circle against a solid-black background appears larger than the other circles. The white background with a solid-black circle appears larger than the other backgrounds.

Value is extremely important to artists' work, for without light or dark we are unable to see anything. Light and dark help to move the eye around a composition, much as line does, and in doing so create a sense of movement. Changes in value also delineate objects or parts of objects in the same way that line defines the edges of an object. The greater the contrast of the values used, the more pronounced the delineation will be.

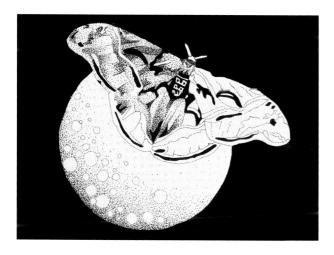

6.8 Notice how the solid areas of heavy black create the moth's details while the finer black lines and dots create gray areas to give the shapes form. Courtesy Cathy Dikun Cosgrove.

Contrast and Toning

The wider the difference there is between values the greater the contrast will be. Wide differences in contrast-the widest being black and white-can make objects stand out and increase their perceived size (fig. 6.7). When black and white alone appear on a surface, optical mixing may take over-the intermediate grays we observe are the result of the proportions of black and white that are present. For instance, a very fine black line on a white surface appears to be lighter in value than a very wide, bold, black line. The closeness of the lines or dots will also affect the value perceived. This is the principle on which printed photographs work (see pages 28-29). The size of the dots, and their distance apart, determines the relative lightness or darkness perceived. In short, the greater the proportion of white to black that is present, the lighter the value perceived will be (fig. 6.8).

Contrast can also affect the balance of a piece. The greater the contrast there is between values the smaller is the amount needed to achieve balance. On a white ground we would need a smaller amount of black than gray to achieve balance. When a composition is worked on a mid-value surface, as opposed to a very dark or very light surface, the procedure is called **toning**. Toning forces the artist to use correct values in order to create space. The novice can easily employ illogical value relationships when using toning.

VALUE IN COMPOSITIONS

Light values tend to blend together when used in a composition. This is also true of compositions composed of middle values and those of dark values. Elements from compositions of related hue and similar value are difficult to distinguish at a distance, and when working with these types of composition, proportion becomes very important. When analogous hues (hues adjacent to each other on a color wheel) of the same or near value are placed next to each other they tend to blend into each other. This blending means that boundaries disappear. When equal-value broken related hues are combined the resulting effect is one of dissolving boundaries. Disappearing boundaries are caused by analogous hues; dissolving boundaries are caused by broken hues (fig. 6.9). In order to accomplish these evocative, mysterious effects we must be sure that the hues used are adjacent or nearly adjacent on the color

Disappearing Boundaries

Dissolving Boundaries

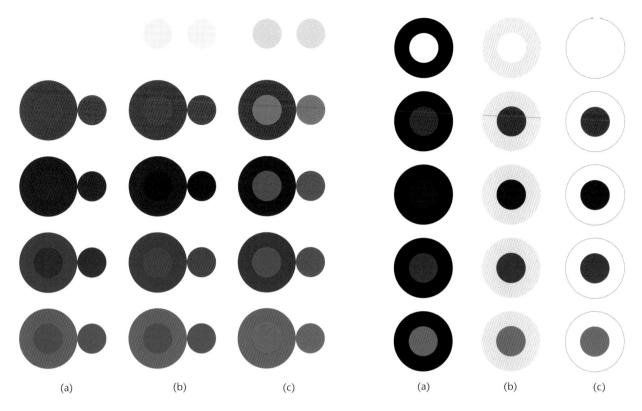

6.9 Disappearing and dissolving boundaries. The five pure hues in the big circles correspond to the five Munsell primaries (the same hue in each row). The two small circles in column (a) feature identical analogous colors cooler than the colors in the large circles (moving counter-clockwise on the Munsell wheel). The small circles in column (b) feature identical analogous colors warmer than the colors in the large circles (clockwise on the Munsell wheel). In both columns (a) and (b) the closeness of analogous hues causes boundaries to disappear in varying degrees. The small circles in column (c) feature identical broken hues of the hues in the large circles, causing boundaries to dissolve in varying degrees.

6.10 Hue values and backgrounds. When placed in column (a) on black backgrounds, the five Munsell primaries appear to be richer than they are and yet remain well-contained by the black; when placed in column (b) on neutral, gray backgrounds, they appear to advance forward, spread outward, and imbue their backgrounds with their complements; when placed in column (c) on white backgrounds, their luminosity is weakened, and they appear darker than they are.

wheel and are exactly the same value. When working with values that are close the edges of objects seem to be fuzzy. This can be combated by using hard edges on objects of hues that are close in value or by outlining.

Every color is seen only in relationship to another color or colors. One must be able to predict how a color will be influenced or changed by its surroundings. White weakens the luminosity of hues adjacent on the color wheel and makes them appear darker. Red is dark on white, but warm and luminous on black. We also find that middle gray or middle-value hues are those most strongly influenced by the hues around them. A middle-value gray or neutral will

make hues adjacent to it appear stronger; in fact the gray or the neutral will become tinged with the complementary of the hue. Therefore a hue surrounded by gray will seem more colorful (fig. 6.10). Light-value colors tend to expand and wash over an area while dark-value colors tend to contract and pull within themselves. Remember, too, that white or black can be added to any mixed shade (a combination of complementaries). The value of the shade will thereby be changed, but it will still relate to a particular parent hue (fig. 6.11).

As we have previously noted in our discussion of hue, a composition of few hues is generally more

6.11 Mixed shades with gray. This two-part composition shows the effects of adding gray (left) to the mixed shades (right). Courtesy Lorraine Spontak Moreno.

pleasing than one of many. A composition of few hues that are executed in many values tends to be even more appealing. In fact, when using a wide range of values in a composition, it is best to limit yourself to as few hues as possible.

As it moves through a composition the eye naturally notices the white or light-value hues first, then the gray or middle-value hues, and finally the black or dark-value hues. This eye movement becomes much more fluid when the white or light values are on the right-hand side of the composition progressing to the black or dark-value hues on the left. We also find that our eye is most satisfied with black or dark values at the bottom and white or light values at the top.

Order

When colors or shades of gray are sequenced within a composition, order is achieved (fig. 6.12); and imposing orders can thereby achieve harmony. Value plays an important part in establishing such an order. We find that the eye is most comfortable with naturally progressing value relationships:

- 1 background black, followed by gray, then white, or
- 2 background white, followed by gray, then black.

When we change the sequencing from natural value order, the effect is visually jarring:

- 1 gray background, followed by white, then black
- 2 gray background, followed by black, then white

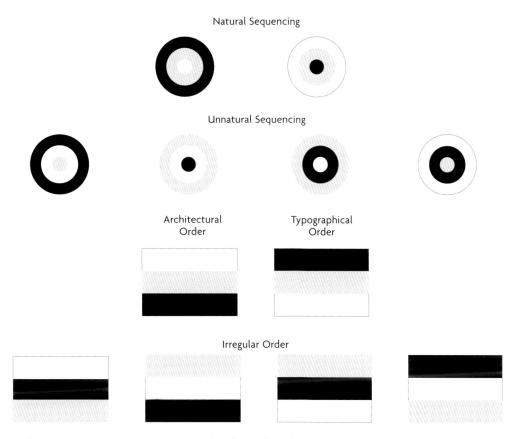

6.12 Natural and unnatural sequencing; architectural, typographical, and irregular order. Natural sequencing, architectural order, and typographical order are harmonious to the eye. Unnatural sequencing and irregular order are jarring to the eye.

6.13 Rembrandt van Rijn, Self-Portrait on a Sill, 1640. Oil on canvas, $40 \, \% \times 31 \, \%$ in (101.9 \times 80 cm). National Gallery, London. In order to capture the richness and texture of dark velvet and fur, Rembrandt employs predominantly dark-value hues and black. Dark values also occupy much of the background and sill, while broken hues emphasize the figure's outline. Minute touches of pure hue can be observed in the trim of the hat, collar, and undergarment.

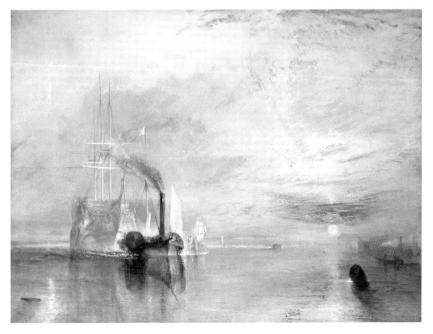

6.14 Joseph Mallord William Turner, *The Fighting "Téméraire," Tugged to Her Last Berth to be Broken Up*, 1838. Oil on canvas, $35\sqrt[3]{4} \times 48$ in (90.8 \times 121.9 cm). National Gallery, London. Turner highlights the luminosity of twilight by creating a dramatic triangular contrast of light and dark hues. As if pointing toward the bright but dying sun, he positions two elements rendered in very dark hues—the tugboat and what seems to be a bobbing log. By focusing attention away from the *Fighting Téméraire* and yet toward the notion of death, Turner portrays the ship as a ghostly apparition.

6.15 El Greco, *View of Toledo*, c. 1597. Oil on canvas, $47\sqrt[3]{4} \times 42\sqrt[3]{4}$ in. (121.3 × 108.6 cm). Metropolitan Museum of Art, New York. H.O. Havemeyer Collection. Bequest of Mrs H.O. Havemeyer. El Greco achieves pictorial order and supernatural drama by his careful arrangement of blacks, grays, gray-blues, and whites in the background sky, and by the blacks threading their way into the foreground. The abundance of green has a counterbalancing restful influence. The overall sense of color harmony fights with the turbulent feelings generated by the composition to create in the viewer a strangely jarring effect.

- 3 white background, followed by black, then gray
- 4 black background, followed by white, then gray.

Now let us assign the letter A to white, B to gray, and C to black and investigate what happens when the sequencing order changes. When they are arranged horizontally the first and simplest order is A, B, C, or white, gray, black. Here we find ourselves going from dark at the bottom up to light in a logical order that is termed architectural order. Architectural order is usually associated with landscapes. If we invert the relationship to get C, B, A, or black, gray, white, we have what is known as typographical order. Typographical order, as the name implies, allows text to be noticed and read comfortably. Here we see that having bold, darker, or heavier text at the top of the area results in better eye/brain comprehension. The remaining sequences are referred to as irregular order and are relatively unstable. All of these sequences can be converted to light-value, middle-value, and darkvalue hues or combinations of hues.

A different kind of order can be brought to compositions that consist primarily of pure hue, darkvalue hues, and black (see Appendix 7). Rembrandt was a master at painting with this type of palette (fig. 6.13). Sometimes a work is composed of a range of lightvalue to dark-value hues. Renaissance artists employed such combinations in their chiaroscuro shading. The pre-Impressionist painters such as Turner used the combination of light values and black to achieve luminous effects (fig. 6.14). An order with a more jarring and emotional effect employed a range of dark-value hues to white. This was the type of color composition that El Greco used (fig. 6.15) as well as the Impressionists. A combination that utilizes pure hues, light-value hues, and white gives the glowing impression of light (fig. 6.16). Employing any of these value orders brings harmony to a work.

A composition could also range from white, through pure hue, to black, and the visual impression created would rely on the proportions of the value ranges used.

6.16 Value orders. This three-part composition has been rendered in the same colors using different value orders from left to right: light balancing dark values; dark dominating light values; light dominating dark values. Courtesy Michael Bailey.

Any composition rendered only in blacks, whites, and grays that is pleasing and visually correct can be matched to hues by value matching, and the composition usually is visually resolved. Therefore, it is advantageous to work on a composition in blacks, whites, and grays, adjusting until it pleases the eye, and only then matching the desired hues to these values. This exercise helps to offset the overriding influence that hues can impart. Values are creating harmony. In the initial absence of color, the eye-brain reaction to color is eliminated so that the execution of imagery can remain the fundamental goal. When colors are matched up afterwards, color and imagery will be seen simultaneously.

Concepts to Remember

- Value refers to the lightness or darkness of a hue. The medium employed affects the value of any color just as much as variations in color placement and illumination. Value also creates space, turns shape into form, and delineates objects.
- The pure hues all have different values, and it is important to know where on a value scale any color falls.

- Discords are the effects obtained when the value of a hue is opposite to its natural order. Discords can be used to provide emphasis and can bring impact to any work.
- Value clarifies space and form through shading, creating pattern and texture, imparting emotion, and giving definition and emphasis.
- Different values create contrast, which plays an important role in the clarification of imagery as well as in the balance of a piece.
- A composition of few hues but with a wide range of values is often visually appealing. Arranging values in an ordered sequence provides harmony as well as clarifying space within the work.

Exercises

- 1 Generate an achromatic value scale of thirteen steps—white will be chip #1, black will be chip #13, and middle-value gray will be chip #7—in the artistic medium of your choice. The chips should be mounted so they butt together and no white lines appear between the values.
- 2 Generate chromatic value scales of thirteen steps each that are equal to your achromatic scale. Make sure the chips butt together and no white shows. Refer to figure 6.1.
- 3 Do a simple composition using only black and white which employs optical mixing that results in visual grays. Refer to figure 6.8.
- 4 Do a composition that employs shading.
- 5 Choose a painting by an artist of your choice and render it in blacks, whites, and grays, matching the values to those of the painting.

The Dimension of Intensity

Intensity, or saturation, defines the degree of purity of a hue, or, more simply put, how bright (as opposed to light) or how dull (as opposed to dark) a hue is. All pure hues are fully saturated, so for example, pure hue red is red with no white, black, or complementary hue in it. When no hue is present the color is achromatic and has an intensity of zero. We would see this as gray.

Black, white, and gray can, however, impart intensity effects. Gray may be described as more saturated than white, leading to the observation that black is fully saturated. Gray is also considered to be more luminous or bright than black, and white is the most luminous. Thus when pure black or pure white are used in a composition they are noticed before the other hues and colors present (fig. 7.1).

CHROMA

A term often used in association with intensity is chroma, which is synonymous with saturation. Chroma is a measure of a hue or color's purity or brightness. All pure hues are at their full chroma, but these pure hues differ among themselves as to **chroma strength**. If we examine the complementary combinations on the pigment wheel, we see that pure hue yellow has a stronger chroma than its complementary hue violet, pure hue red is stronger than its complementary hue green, and pure hue blue

is weaker than pure hue orange. If we look at the Munsell primary complementary combinations, we find that pure hue yellow has a stronger chroma than pure hue blue-violet, pure hue red is stronger than pure hue blue-green, pure hue blue is weaker than pure hue orange, pure hue violet is weaker than pure hue yellow-green, and pure hue green and pure hue red-violet are about equal in chroma strength. From this we can conclude that lighter-value pure hues have a stronger chroma than darker-value pure hues.

COLORED GRAYS

Hues may, however, be diluted by a number of means. We saw in the last chapter how a hue's value may be changed by the addition of black, white, or gray. As we added white to a pure hue it became lighter; the addition of black caused the pure hue to become darker. The addition of gray to a pure hue, however, can result in a dulling of the pure hue when the gray added is the *same value* as the pure hue that is receiving the addition. The result is termed a colored gray.

The concept of colored grays comes to the fore most emphatically when working with the Munsell color system. As we have previously noted, the threedigit notation of the Munsell system corresponds to hue, value, and chroma. The first datum tells us the

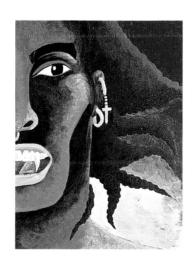

7.1 Adding pure black and white. The contrasting blacks and whites in the right-hand composition give this version more depth. Courtesy Deborah Scott.

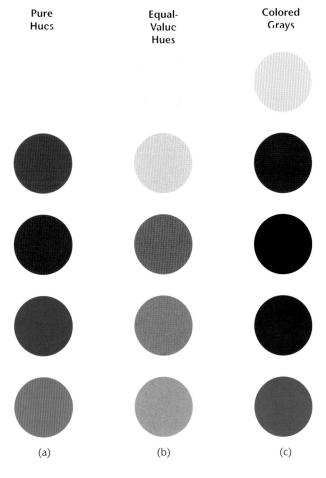

7.2 Munsell primaries, equal-value grays, and colored grays. Column (a) shows the Munsell primaries. Column (b) shows the value of gray equal to the intensity of each primary. Column (c) shows the result of combining the gray value with the primary.

pure hue, such as 5R, and the next denotes the value, or how much white or black has been added to the hue. With the third datum, which relates to chroma, the Munsell notation allows us to adjust the intensity of each hue by adding varying amounts of an equal-value gray to create colored grays. Let's say our notation reads 5R3/4. This would mean that the pure hue red has had black added to bring it down to a dark red or value of 3, then a proportional amount of gray 4 has also been added to change the dark red's intensity (fig. 7.2).

COMPLEMENTARY HUES

Hues are termed complementary when they are directly across from each other on the color wheel. A hue can be changed by adding its complementary hue and the resulting dull color is called a **shade** (see Color

Content Identification Charts, Appendix 1). This complementary addition makes a hue duller or less intense. We find that these shades are similar to broken hues in that they always go well with each other and other colors. Bear in mind that the addition of the complementary to a hue also changes its value. On the intensity scale an equal mixture of complementary hues results in a muddy neutral color. Working out from this middle, neutral mixture the shades begin to favor one or other of the parent hues on the scale. The "Color-Aid" papers labeled "shade" are pigment combinations. For example, "yellow shade 1" is a mixture of pure hue yellow and a small amount of pure hue violet; "yellow shade 2" is a mixture of pure hue yellow and a larger amount of pure hue violet.

Complementaries on the Different Wheels

Remember that we are actually mixing pigments to obtain these mixtures, and that the complementary hues on the pigment wheel are different to those on the other wheels—namely, yellow and violet, yellow-green and red-violet, green and red, blue-green and red-orange, blue and orange, blue-violet and yellow-orange. The shades obtained when mixing pigment wheel complementaries are the result of actual pigment mixing in either paint or dye form. On the process wheel, the complementary mixtures are:

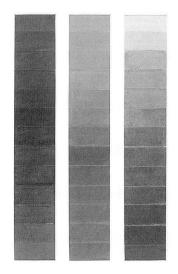

7.3 Intensity scales using colored pencils derived from the pigment wheel. As more and more of a complementary hue is added to each parent hue, the resulting shades become duller. Courtesy Melinda Beavers.

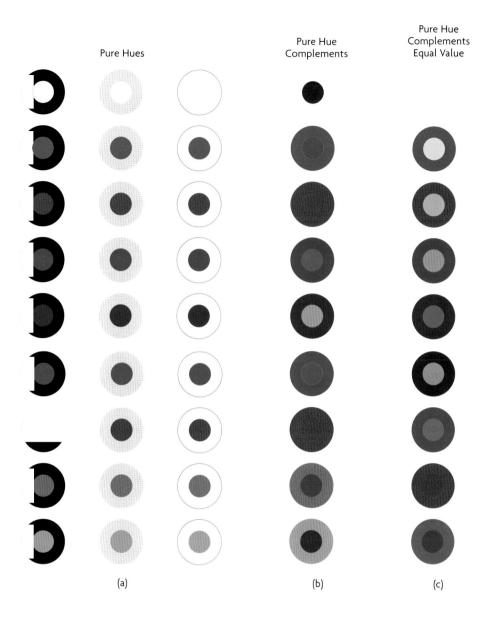

7.4 The Munsell complementary hues side-by-side in pure-hue and equal-value settings. Lighter hues become brighter when surrounded by black, as shown in column (a) (*left*). Complementary hues around pure hues in column (b) serve to intensify those hues. When complementary hues are rendered in equal value, as in column (c), a visual vibration occurs.

yellow and blue, red and cyan, and magenta and green. The resulting dull shades can here be achieved by using either pigments or percentage printing screens (fig. 7.3).

The Munsell wheel allows the artist to view the reactions of complementary hues when they are placed side by side (partitive color), since the Munsell wheel complementaries are the result of afterimaging (fig. 7.4). We see how these complementary combi-

nations enhance each other, in that each color appears more intense or brighter. These combinations do not need to be pure hues only, but can consist of tints of pure hue complementaries.

False Pairs

A neutral gray is a color obtained by mixing black and white together to achieve middle-value gray. Neutral grays can also be obtained by combining **false pairs**, something that the artist Paul Klee investigated at the Bauhaus. The false pairs are: orange and green, green and violet, and violet and orange. These grays, however, tend to favor one or the other parent hue. Reactions obtained from false pairs are similar to those seen when combining complementary hues, but tend to be less powerful (**fig. 7.5**).

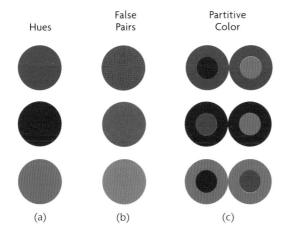

7.5 False pairs. Column (a) shows orange, violet, and green hues. Column (b) shows in descending order the false pairs created by mixing orange with violet, violet with green, and green with orange. Column (c) shows orange, violet, and green in various partitive combinations.

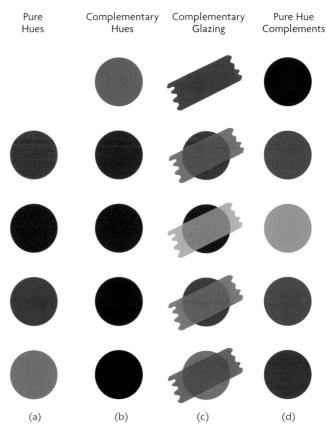

7.7 Pigment mixing versus glazing primaries and their complementary hues. Column (a) shows the Munsell primaries and column (d) their complementary hues. Column (b) shows the result of mixing primaries with complementary hues, and column (c) of glazing primaries with complementary hues.

Glazing

Complementary hues can be mixed in another way—by **glazing**, which is the layering of transparent hues. This is how the great Dutch and Italian masters such as Leonardo da Vinci obtained the shades seen in their paintings (**fig. 7.6**). The pure hues were glazed with layers of their pigment wheel complementary hues rather than the shade being mixed on the palette (**fig. 7.7**).

INTENSITY IN COMPOSITIONS

For a pure hue to be at its most brilliant it must be used in a setting whose value is equivalent to its natural value. Pure red is most brilliant in a relatively dark composition, while pure yellow is most brilliant

7.6 Leonardo da Vinci, $Mona\ Lisa$, c. 1503–1505. Oil on panel, approx. 30×21 in (76.2 \times 53.3 cm). Louvre, Paris. Leonardo covered selected painted areas of the $Mona\ Lisa$ with a thin glaze to help create the indeterminate, smoky effect known as sfumato.

7.8 Turkish Iznik dish, c. 1580. Fritware, diameter $14\frac{3}{2}$ in (36cm). British Museum, London. This dish shows two partitive complementary pairings—the yellow dish background and the blue-violet flowers and portions of the center motif as well as the use of red flowers with green foliage that tends to blue-green.

in a relatively light composition. When the complementary hues of either the Munsell or visual wheels are used in partitive combination (side by side) they intensify rather than dull each other (fig. 7.8). Complementary hues from the pigment and process wheels partitively paired will all intensify each other but to a lesser extent. Side-by-side complementary hues also make each other more luminous. Near complementary combinations produce the same effect but to a lesser degree. When there are great extremes in value, however, color intensity is inhibited.

Complementary colors, when paired, produce startling contrasts. This is because they sometimes exist in wide-value contrast (for example, yellow and blue-violet), or wide-temperature contrast (for example, blue-green and red). No matter how complementaries are used in combination they are unstable. Any hue will appear more intense beside a duller one and vice versa (see fig. 7.4). High-intensity backgrounds also increase an object's intensity; high intensities attract and give feelings of energy and activity. Low intensities are quiet and subdued and are usually less easily noticed. Moderate intensities are also relaxed and undemanding.

Balance

Complementaries create balance in a composition. Complementaries in pure hue placed side by side do not alter each other's hue, except to brighten each other. Balance is also achieved by contrasting intense and dull colors. A small amount of a pure hue, for example, may be used to balance a large area of a dull one. Here the contrast of intense versus dull provides the balance. If two complementary hues are used throughout a piece they will usually provide unity. However, if two complementary hues are placed side by side or used only in a limited area they will most likely turn their back on everything around them and enhance each other. Contrasting color schemes exert greater balance than more related ones (fig. 7.9).

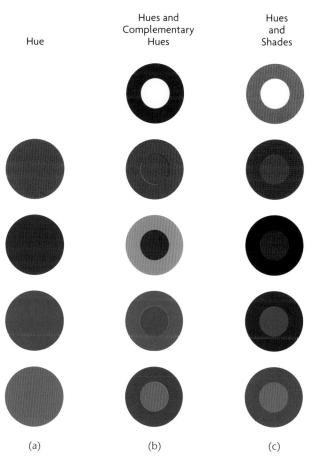

7.9 A partitive comparison of complementary pure hue combinations and shade and pure hue combinations. Column (a) shows the Munsell primaries. Column (b) shows them with their complementary hues and column (c) with darker, duller shades of themselves. Columns (b) and (c) reveal different ways of achieving balance in compositions.

7.10 Equal-value complementary hues and vibrating boundaries. The complementary colors are a light tint of red and a light tint of blue-green, and when equally valued they cause a visual vibration. The light tints of blue and blue-green are analogous hues, and when equally valued they cause boundaries to disappear (see also fig. 6.9). Courtesy Melinda Beavers.

Intensity and Value

Intensity combines with value to alter our perception of hues. The most startling of these effects occurs when equal-value complementary hues are placed side by side. The effect is one of visual vibration and excitement, a reaction that is very useful for creating emphasis. It is imperative that the complementary hues used are equal in value to obtain a visual vibration (fig. 7.10).

Effects of Depth

Intensity can produce effects on objects in space. High intensities make an object seem large, and the more intense a hue is the more it pushes an object forward in the visual field. Light pure hues on a black background will advance according to their value; pure yellow advances the most. Light pure hues on a white ground will recede according to their value; here pure violet advances the most. A pure hue advances more than a duller one of equal value. Low intensities reduce an object's size and increase distance and spaciousness. Objects that are rendered in light-value pure hues (yellow-related) appear larger than objects rendered in dark-value pure hues (blue-related). This is the result of the spreading effect of light-value pure hues (see figs. 6.7 and 7.10).

Proportion

Small areas of a composition usually function better done in brighter hues, while large areas are better done in duller hues. This is an important concept to remember, for we must strive to have color and imagery in a composition seen simultaneously. In most visual situations, color is seen before imagery, so the artist must work to counteract this effect. To this end, one must keep in mind that the brighter or more intense a hue is the more it will predominate over what is being depicted. But when pure hues are used in small amounts, they attract and draw the viewer into the composition. Large areas of a complementary hue tend to intensify its counterpart, whereas small areas or amounts of a complementary hue tend to give a neutral effect; equal amounts of complementary hues give a brownish-gray result. Therefore, we see that the proportion of a hue used affects its intensity. When

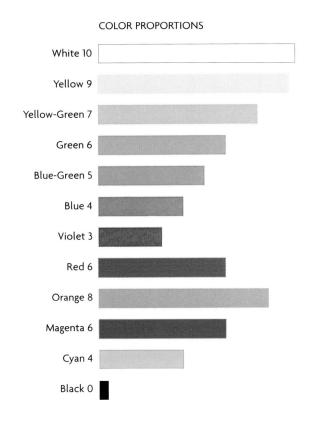

7.11 The relative proportions of computer-generated hues showing the notations devised by Goethe. White and the warm hues have greater strength than black and cool hues. One way to use color in satisfying proportions is to employ white and warm hues over small areas, and black and cool hues over large areas. Courtesy Dreux Sawyer.

complementary hues are used in proper proportions the effect is one of fixing the image in time and space.

The assignment of light (or strength) notations to hues will aid in using them in correct proportion. Let us employ notations devised by Goethe (see pages 14-15) as a basis for our ratios: white 10, yellow 9, yellow-green 7, green 6, blue-green 5, blue 4, violet 3, red 6, orange 8, magenta 6, cyan 4 (fig. 7.11). The complementary combination of yellow and blueviolet (according to the Munsell wheel) produces a ratio of 9:3 which means that yellow is much stronger than violet. Red and blue-green produce a ratio of 6:5 which shows that red is marginally stronger than bluegreen. Red and green produce a ratio of 6:6 which means they are equally strong. Within a composition a small amount of red and a large amount of green would result in the red becoming very active. When used in their exact proportions (for example, yellow 9, violet 3) hues give quiet, static effects. When the stronger hue in a combination is used in the lesser proportion it becomes vivid. But when the stronger hue in a combination is used in the greater proportion it overwhelms the composition. To achieve perfect balance between two hues one must invert their respective proportions (as yellow is 9, blue is 4, so you would use four parts yellow and nine parts blue to achieve perfect balance). The inversion of hue ratios also leads to a neutral gray when pigment mixing complementary and near-complementary hues. When complementary pairs are positioned abutting each other, their intensity is enhanced. As they become farther apart this intensity, while still present, weakens, but a greater sense of balance is created.

Concepts to Remember

- The brilliance of a bue is dependent on its purity. Pure hues are the brightest possible.
- When complementary pigment hues are mixed (subtractive color) they dull the resulting mixture and this is known as a shade. These mixtures are similar to broken hues and afford rest to the eye.
- When complementary pure hues are in a partitive setting the greatest impact results. Placing complementary colors side by side enhances a color, while complementary color mixing dulls a color. It must be noted that partitive complementaries are different from subtractive complementaries.

Intensity affects spatial feelings. The more intense a color appears, the closer to the viewer it will appear to be.

Pure hues also have a relative strength, as noted in the proportional scale. It is important to employ correct proportional color usage in any work.

Exercises

- 1 Create an intensity scale of thirteen steps with complementary pure hues as chips #1 and #13 in the medium of your choice. Chip #7 will be an equal *visual* mixture of both hues so that you cannot tell which hue is the parent. The complementary hues are to be taken from the *pigment* wheel. The chips should butt together so no white shows. Make sure your intensity scale is mounted in the center of your matte board. Refer to figure 7.3 and Color Content Identification Charts, Appendix 1.
- **2** Do two identical compositions, using black and white in one and *no* black or white in the other. Refer to figure 7.1.
- 3 Do a composition that employs vibrating boundaries. Refer to figure 7.10.
- 4 Do two identical compositions using the same colors in both. Render them in two ways, changing the quantities of the colors used. The two "identical" compositions should look different.

The Dimension of Temperature

Temperature refers to the warmth or coolness of a color. Research has shown that certain colors stimulate us and increase our temperature slightly, and some colors relax us and decrease our temperature. The warm hues are yellow, yelloworange, orange, red-orange, red, and red-violet. The warm hues are therefore usually related to red, with the warmest hue being red-orange. The cool hues are yellow-green, blue-green, blue, and blue-violet—in other words, they are usually related to blue, with the coolest hue being blue-green. Green and violet appear to be neither warm nor cool. Within these various categorizations, the same color can sometimes be warm, sometimes cool. So it is possible to speak of a cool red, yellow, or gray. Warm colors attract the eye more readily, but one must concentrate to recognize cooler hues and colors.

MIXING

The addition of black, white, or the complementary hue to any pure hue can alter its temperature. As we darken a hue by the addition of black, it becomes warmer. White, however, has a cooling effect. The addition of the complementary to the pure hue will cause its temperature to reverse. Yellow, a naturally warm hue, will become a cool shade when its pigment complementary, violet, is introduced into the mixture. Blue, on the other hand, will turn warmer when its pigment complementary, orange, is introduced. From this we may conclude that when a cooler hue is added to another hue the resulting color will be cooler, and, conversely, when a warmer hue is added to a hue the resulting color will be warmer (fig. 8.1).

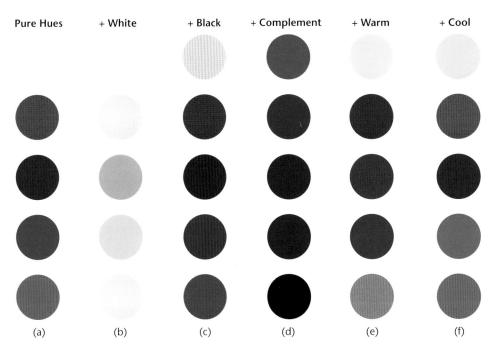

8.1 Adding white, black, complementary hue, warm and cool hue to Munsell pure hues. Columns (a)–(d) show the effects on pure hues of adding white, black, and complementary hues. Columns (e) and (f) demonstrate that adding close analogous colors from either side of each pure hue achieves warmer and cooler results respectively.

8.2 Warm and cool blacks and grays. The left-hand composition is rendered in warm blacks and grays and the right-hand one in cool blacks and grays. Courtesy Elly Madavi.

NEUTRALS

Grays and blacks may be warm or cool. When white is mixed with a commercially produced black, the resulting grays will look cool because the black is cool (see Color Content Identification Charts, Appendix 1). However, when black is the result of the subtractive pigment mixture of red, yellow, and blue, it is warm and the grays produced by this mixture with white

will also be warm. Warm blacks and warm grays are best used for natural objects, while cool blacks and grays are best adopted for inorganic or man-made objects. For instance, a black car would be rendered in cool black and a black piece of clothing would be rendered in warm black. The warm blacks and gravs are called chromatic—these are the "neutrals" used by the Impressionists. Whites may also be warm or cool depending on the binder and pigment manufacturing process used. Flake white is derived from pure white lead, which imparts a slightly gray cast. Titanium white imparts a slightly pink cast and zinc white imparts a faint yellow tinge. Ivory black (bone black) is cool, lamp black (India ink) is cool, and carbon black and Mars black are without discernible temperature (fig. 8.2).

"RELATIVE" TEMPERATURES

A hue's temperature changes not only when it is mixed with another hue but also when the hue or color surrounding it changes (fig. 8.3). If a warm hue is surrounded by a warmer hue it will appear cooler; when this warm hue is surrounded by a cool hue it will seem warmer. The key to this phenomenon is what occurs in afterimaging. The warm hue yellow's afterimage is cool blue-violet. In most cases a hue afterimages its opposite in temperature, thus either warming up or cooling down its surroundings. There

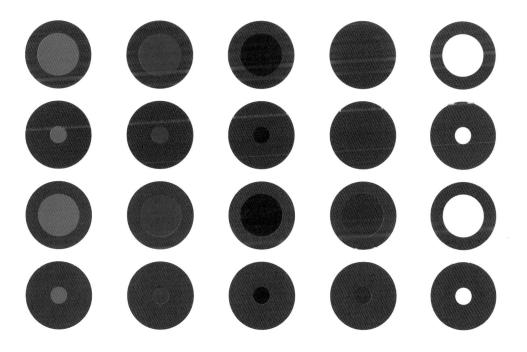

8.3 The effects of warm and cool surroundings on Munsell primaries. The primaries (central circles) are in two different sizes, surrounded in the first two rows by a red-hued (warm) circle and in the last two rows by a bluegreen-hued (cool) one. The afterimaging between inner and outer circles induces either a warming or a cooling of their temperatures

are exceptions to this rule—if the area of the huc is very small the opposite will happen. So, for example, a very small quantity of yellow on a large field of blueviolet would result in a cooler, more luminous yellow. Thus proportion is another factor affecting the perceived temperature. A two-color composition made up of a warm and a cool hue would be cool if the cool hue were dominant and vice versa. So if the *range* of colors or hues used in a composition is warm the

composition will appear warm; if the range is predominantly cool the composition will appear cool.

From this we may also conclude that every pure hue can be part of either a warm or a cool range depending upon the direction taken on the color wheel that provides the range derivation. Let's look at yellow—when the range used is yellow, yelloworange, orange, red-orange, the resulting range will be warm. If, however, we work with a range of yellow,

8.4 Paul Cézanne, *Pink Onions*, 1895–1900. Oil on canvas, 26×32 in $(66 \times 82$ cm). Louvre, Paris. The background colors are predominantly cool greens and blues, which make the wall recede from the viewer, lending the painting depth. By contrast, the foreground colors are mainly warm reds and oranges, which make the table and fruit advance quite dramatically toward the viewer. The violet on the wall is not as warm as it would be in isolation because of the mass of cool green and blue around it; and the green on the tabletop is not as cool as in isolation because of the amount of warm red and orange around it. The white tablecloth becomes a barrier between the contrasting temperatures of green-blue and red-orange, seeming to heighten both.

yellow-green, green, blue-green, we find that the range imparts a cool temperature and even the very warm yellow will take on a cool quality.

THE EFFECTS OF BACKGROUNDS

The background of any piece is essential to the advancing (warm) and receding (cool) effect of any hue placed on it. Also, keep in mind that the temperature of a color depends upon its relation to other colors with which it is seen (fig. 8.4). Warm hues tend to make grays seem cool, and these warm hues remain brilliant on a dark or black background. On a white background warm hues spread and will make the white appear bluish. Warm hues are opaque and dense and when used as a background tend to bring together whatever is seen on them. The eye focuses more quickly on warm hues, which also make objects seem larger. Warm hues also make edges seem less sharp.

Cool hues tend to make gray seem warm and will merge with a dark or black background. On a white background cool hues remain firmly outlined. Cool hues can be made to advance by darkening the warm hues surrounding them. Cool hues appear transparent and weightless. Yellow, which has the lightest pure value, is warm on white, cool on black. Coolness tends to reduce the apparent size of an object and increases the sense of distance. In landscapes we find that distant objects are cooler and more blue-gray (this is the effect of atmospheric perspective). The illusions of space or distance are most easily created by imparting a blue-gray tonality to distant objects (fig. 8.5 and see fig. 6.6). When this is not done the result is a very flat, one-dimensional feeling.

TONALITY

Compositions often work best when one hue predominates. Similarly, few hues over a wide area tend to create a more intense lasting impression than many hues over the same area. When one hue is dominant we describe it as working for the tonality of the piece. When tonality of color is employed, the result is color unity and, therefore, design unity. Let's say we had a warm design done in red, red-orange, orange, red-violet, violet, blue-violet, and green; the tonality imparted by this composition would be red since red is a component of all the hues used except the green. Adding a touch of red to the green would further enhance the red tonality.

8.5 The effect of adding one color to all the colors in an artwork. In these nearly identical airbrushed pieces, the addition of blue in the top composition gives it a cooler effect, while the addition of orange in the composition below gives it a warmer effect. Courtesy Glenn Mason.

Putting the concept of tonality into practice will help you determine what colors to use in a composition. Let us look at a fall landscape. The trees and ground are usually in browns, rusts, oranges, yellows, golds, reds, and dull yellow-greens; but what type of blue should be used for the sky? Since the predominant tonality imparted is yellow and warm, we might add a touch of yellow to the blue sky; thus the sky will tend toward blue-green rather than blue-violet. When the same colors are set against various hued backgrounds, the background usually governs the tonality of the work. Tonality—and therefore unity—can depend a great deal on repetition. If a small amount of one color is added to all the colors

used in a piece, true tonality takes place, and the eye perceives color and imagery simultaneously. Remember that this color addition must also be done to any blacks and whites appearing in the work (fig. 8.6).

PROPORTION

When using warm and cool colors in a composition, we have already seen that **proportion** plays an important role. If Goethe's color proportions are applied to a composition it will usually be predominantly warm or cool. But when warm and cool colors are balanced so that neither visual temperature predominates, we find that the resulting composition becomes dynamic. This is accomplished by bringing the warm and cool hues to an equal or nearly equal proportion. Let's look at the warm orange, which has a notation value of 8, and the cool blue, which has a notation value of 4. If we invert these proportions the result will be twice as much blue as orange. Now we see that the blue spreads and expands, providing distance and spaciousness, while the warm orange becomes brighter, more active, and leaps forward, resulting in a kinetic effect. The kinetic effect is greatest when the warm-cool contrast is greatest. At any time when a warm-cool balance is present, a sense of depth is imparted. The kinetic effect of warm color advancement can be reversed when the cool hues are intense or pure and the warm hues are shades, or dull

This feeling of temperature affects our interpretation of a composition. Warm hues advance and suggest aggression, sunlight, heat, blood, arousal, stimulation; they are earthy, near, heavy, and dry. Cool hues, on the other hand, recede and suggest sky, water, distance, foliage, shadows; they are quiet, restful, far, airy, and light. As stated, warm hues appear heavier than cool ones and, when placed side by side, these differing visual weights influence their surroundings. Orange appears heavy and is warmer

8.6 Left: Ambrosius Bosschaert the Elder, A Bouquet in an Arched Window, c. 1620. Oil on panel, $25^{1/4} \times 18$ in $(64 \times 46$ cm). Mauritshuis, The Hague. Bosschaert achieves a sense of distance in the landscape seen through the window by using atmospheric perspective. Notice that the nearer hills are green while those further from the viewer are more neutral blues and grays. The flowers and other objects in the foreground are shown in more intense hues; the far-reaching distance is created by the use of cool blue-gray tonality.

Warm Dominant

Equally Warm and Cool

Cool Dominant

(c)

8.7 The kinetic effects of warm-dominant, equal warm-cool, and cool-dominant compositions. Notice how in version (a) the dominant orange advances toward us, whilst in version (c) the dominant blue recedes away from us. In version (b) the dynamic tension between equal amounts of orange and blue makes depth and distance more difficult to perceive.

than yellow, for example, so that when it is used in a partitive setting the yellow will not only appear cooler but lighter. The sense of weight imparted by hues or colors leads us to the conclusion that warm, dark hues or colors function best on the lower portions of a composition while cool, light hues or colors are best utilized in the upper portions of a work.

METALS

Metals must be discussed as a part of temperature since their relative brilliance is often interpreted as being warm or cool. The major consideration that must be addressed is the quality of the metal. These materials reflect and are totally influenced by their surroundings while simultaneously retaining their own metallic quality. We will confine our discussion

to gold and silver. Gold appears warm in comparison to silver and can function in much the same way as yellow-orange does. The introduction of light onto a metallic gold surface results in varied reactions. When in clear light the top, smooth surface of gold will appear yellow-greenish, while the side of the object will be warmer and, as the background is approached, take on a red cast. Flat gold will not warm up but rather take on a blue-green cast that is cool. Within a composition, the metals will have the highest impact or chroma reaction because of the light reflected from them, which is almost total. So when metals are used on a white background their chroma will be diminished because white is the total reflection of light. On a black background, the gold will be brilliant and very warm because the gold reflects the light

8.8 Anonymous, *Virgin and Child*, 14th century. Mosaic tesserae on wood, $52\frac{3}{4} \times 36\frac{3}{4}$ in (134×93.3 cm). Byzantine Museum, Athens. Metallic gold has here been used in the background, haloes, hair, and drapery. Subtle outlines in bright silver contrasting with darker red separate the background from the haloes, while the figures are outlined in black against the background.

8.9 The interactions of gold and silver with dark-gray, light-gray, white, and with Munsell primaries. A black outline can be placed around gold or silver (the last two columns) to prevent them from spreading.

while the black absorbs it. Gold will appear warmer on black and cooler on white.

Silver is cool and becomes even cooler when on a white ground. On white its brilliance is also diminished. Black, on the other hand, enhances the brilliance of silver and warms it up, especially when seen in warm, incandescent light. Silver is more strongly influenced by its surroundings than gold; it takes on and reflects everything around it in the same manner as a mirror. Gold and silver interactions can be halted by outlining them with black. This is especially important to consider when they rest against a colored background. Outlining on a black or white ground, however, is unnecessary. On a light ground gold or silver objects will appear larger due to the spreading effect; on a dark ground they will seem smaller and their edges will remain defined and sharp.

Metals can also be used as background. This is a common feature in Byzantine icons (fig. 8.8). When

using a metal as a background it is advisable to outline hued objects with a darker value of the object or black. This serves to restrict the spreading effect that results from the metallic light reflection. Metallic backgrounds must be handled most carefully since they are middle-value but highly light-reflective (fig. 8.9).

Concepts to Remember

- Hues can be referred to as warm or cool. Warm hues are those hues related to red and cool hues are those hues related to blue.
- The addition of black will warm a hue, white will cool a hue, and the addition of the hue's complementary will reverse its temperature.
- Blacks and grays can be visually warm or cool depending on the procedure used to create them. Cool blacks and grays are achromatic and are best used on inorganic objects; warm grays are chromatic and best used on organic objects.
- We must always keep in mind that temperature is a relative concept. A color or hue's temperature changes depending on the warmth or coolness of the adjacent hues and colors.
- The background color temperature influences the temperature of any hue placed on it. Use of bluegray tonality on distant portions of landscapes results in atmospheric perspective. Temperature also influences our perception of space.
- It is important to impart unity to any work and this is most easily accomplished by the use of tonality. The proportions of the colors used play an important part in achieving unity.
- Metals also have qualities of warmth and coolness.
 Gold appears warm in comparison to silver.

Exercises

- 1 Do a series of color additions to each primary hue forming a scale that shows how the temperature of the color changes. Refer to figure 8.1.
- 2 Do a composition creating a kinetic effect that is the result of utilizing warm and cool hues and colors.
- 3 Using the same composition and the same colors, make one warm and the other cool. Refer to figure 8.5.

PART III

Color in Compositions

Color must have a purpose within any project, and one's choice of color is the primary method of conveying one's message. Color can reflect mood, emotion, and time frame, and provide the symbolism. These aspects work in conjunction with the principles and elements of design, color interactions, and illumination to impart what the artist, architect, or designer wishes the viewer to see and feel. Whether we are artist or viewer, any project poses a series of guestions about the effect of color in the composition. How does color affect the purpose of the piece? Is the color usage universal or suited to only one situation? How does the color fit into the setting in which it is to be displayed? Does the color reflect the personality and background of the artist executing it? Does the color reflect the culture and events in force during its creation? How does the artist wish color to convey the message or statement of the piece? Does the color usage communicate in its totality to the viewer? The chapters in this section will provide the tools for us to answer these questions.

Color and the Principles of Design

While color is an important element of design, we must also be aware of how it interacts with the other principles and elements of design, such as rhythm, balance, proportion, scale, emphasis, and harmony. This chapter examines color within these contexts.

RHYTHM

The principle of **rhythm** imposes order and unity on a design, and the rhythmic use of color is crucial in imparting a coherent result to any work.

9.1 Richard Anuszkiewicz, Entrance to Green, 1970. Acrylic on canvas, 108×72 in (274.3 \times 182.9 cm). Collection of the artist. The green lines are identical throughout the painting but appear to change depending on their partitive setting. The repeating color provides unity and the hue progressions provide motion to the piece.

Repeating hues are extremely important to any piece. Works that lack hue **repetition** will also lack unity. The repeating of a hue can also impart the feeling of movement, as is seen in many Op Art compositions. In such cases repeating hues, contrast in values, and color choice combine to impart vibrating motion (**fig. 9.1**).

Let us look first at what happens when only unrelated pure hues such as yellow, red, violet, blue, and green (the Munsell primaries) are used (fig. 9.2). Our eye/brain function must take a "second" or even a "third" look to sort out the impression. Now let's look at the impression imparted by a single hue's repetition. Even more unity results when the hue being repeated is put into an orderly sequence, and now we see that the hues are alternately sequenced. Keep in mind that each pure hue is functioning as a separate element in our repeat. These stripe repeats show how the spatial interval between hues also

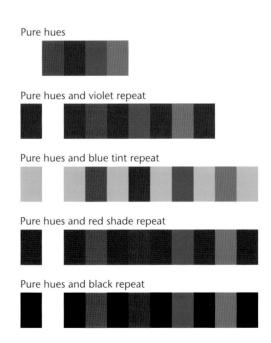

9.2 Repeating pure hues with tints, shades, and blacks. Notice the difference in perception once one color is repeated in a regular pattern. The eye is more comfortable viewing the repeat sequences than the pure hue sequence.

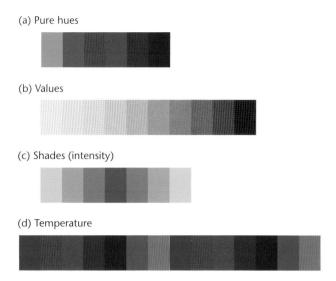

9.3 Hue, value, shade, and temperature progression. Row (a) shows pure hues progressing from light to dark. In row (b) one hue moves slowly from a light to a dark value as black is added in small amounts. Row (c) shows the quicker progression from intensity to dullness and back again, as greater shades of black are added at each step. In row (d) hues are sequenced from warm to cool temperatures

9.4 Rhythmic movement. Following the motions of this diver, the eye is led smoothly through progressive analogous hues—yellows to oranges, reds, violets, blues, greens, and ending again with yellows. Courtesy Grace Kennedy.

affects our comprehension of them. The eye is rested when pure hues are sequenced with tints, shades, broken hues, or neutrals. Again we must stress that the use of fewer hues is preferable for visual unity.

Hues that are put into a sequence or **progression** allow the eye to move comfortably within a composition. The sense of progression imparts motion. We can achieve this color progression with hues as we have already done with analogous hues. Progression from light to dark is another method, as is traveling from intense to dull. Also do not discount having a temperature progression. This can create a push/pull spatial effect when used correctly (**figs. 9.3** and **9.4**).

The use of a monochromatic (single hue) or analogous (adjacent hue) color scheme is rhythmic in itself, in that the limited palettes necessitate the repeating of hues in various forms (fig. 9.5). Tonality can depend a great deal on repetition.

9.5 Monochromatic and analogous rhythms. The monochromatic pattern shows different shades of the same hue. The analogous pattern progresses through four steps of Munsell secondaries and primaries and increasingly warmer temperatures (see also fig. 2.4).

The background of a work should be integrated with the images of any work. One of the simplest methods of accomplishing this integration is to repeat hues in the background that are also used in the foreground. Repeating the hues in this way forms a visual link between the background and the images by allowing the eye to move back and forth. Putting the concept of repeating color to work imparts overall unity to a project. If we are using a white ground, the use of black, white, or gray will lead to a visually resolved work because they are all neutral as well as contrasting. When using color and/or hues, employing a colored ground (even if it is a pale tint) or a brokenhued background (such as ecru) will better serve to impart visual unity. The colored ground should repeat or echo one or more of the hues being used in the piece (fig. 9.6).

BALANCE

Balance concerns itself with the overall visual effect of the components of a composition. Color is crucial in imparting the compositional effect we wish to convey. Color can determine if a composition is to be flat or pictorial. When color is used in a manner that provides the illusion of space or depth, the result is a pictorial composition. The use of value, intensity, and

9.6 Background and foreground integration. The blues and violets of the central image are repeated in varying degrees behind and around it, thereby lending visual unity to the composition. Courtesy Arna Arvidson.

9.7 Flat and pictorial compositions. The left-hand work has a flat appearance due to the predominantly pure hues and the lack of much background gray in the standing figure. By contrast, the right-hand work has more depth and a more pictorial appearance because of the different hue values and more background gray in the figure. Courtesy April Hill.

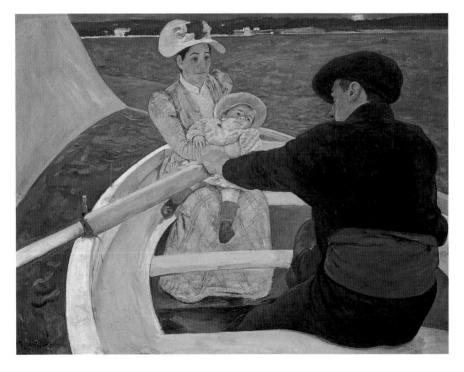

9.8 Mary Cassatt, *The Boating Party*, 1893–94. Oil on canvas, $35\frac{1}{2} \times 46\frac{1}{8}$ in (90 × 117 cm). Chester Dale Collection, National Gallery of Art, Washington, D.C., Chester Dale Collection. Here we see Cassatt's masterful asymmetrical balance of light versus dark and warm versus cool which imparts a feeling of movement.

temperature all contribute greatly to the success of a pictorial composition, as all these dimensions coordinate to establish an image's location in space. **Flat compositions**, by contrast, rely mostly on hue changes, and they usually do not impart the deep space seen in pictorial compositions (**fig. 9.7**). If the work uses a ground that does not repeat a hue found in the

images, more often than not the composition will become flat even if varying values, intensities, and temperatures are used.

Balance can be achieved by placing compositional components either symmetrically or asymmetrically. **Symmetrical balance** is achieved when the composition employs "mirror imaging" of the components.

Symmetrical balance is greatly reinforced when the colors used also work as a mirror image. Activity now is "frozen"; the moment is static visually.

Asymmetrical balance is achieved when compositional components are not mirrored along a central axis, but the visual placement still produces a pleasing overall effect (fig. 9.8). A work whose lines, shapes, and spaces are asymmetrical becomes active, but its activity can be slowed down by symmetrically balancing the colors used. Conversely an otherwise symmetrically balanced work can be activated by asymmetrically balancing the colors utilized in the work (fig. 9.9).

As we have previously noted, contrast can also affect the balance of a piece. The greater the contrast between values is, the smaller the amount we need to achieve balance. On white we would need a smaller amount of black than gray. Compositions are generally color balanced most effectively by using unequal, or asymmetrical, amounts.

Balance is also affected by the proportion of hues. Contrasting color schemes exert greater balance than related ones; this leads us to say that compositions consisting of inverse proportions of warm and cool colors (small amounts of warm colors in comparison to large amounts of cool colors) or complementary colors would be balanced symmetrically. Pure hues must be offset by values or shades of the hues used in order to allow the eye rest. This is why it is so important to be aware of the color content of each and every color being used (see Color Content Identification Charts, Appendix 1).

When a pure hue is repeated across a surface, it will eclipse all the other colors and forms present. This can be disastrous if more than two pure hues are used: the result is confusion. The artist must be very aware of this effect when using overall patterning (fig. 9.10).

PROPORTION

The design principle of proportion concerns itself with the relationships formed between one part of a design and another part, one part and the whole piece, and all the parts and each other and the whole. We know that hue proportion affects a hue's intensity and temperature function. In our discussions of intensity and temperature we introduced Goethe's concept of color notation. The Goethe color notations were: white 10, yellow 9, yellow-green 7 or 8, green 6, blue-green 5, blue 4, violet 3, red 6, orange 8, magenta 6,

9.9 Symmetrical and asymmetrical color placement. The left-hand composition looks more harmonious due to its symmetry while the right-hand one looks more jarring but perhaps more interesting in its asymmetry. Courtesy Tricia Malecki.

Pure hue yellow Pure hue red Pure hue blue

Pure hue blue Yellow shade Red shade

9.10 Pure hue patterning. Despite their symmetrical balance, exclusively pure yellow, red, and blue hues in the top composition lead the eye in a frenetic and confusing dance. The identical symmetry with pure hue blue and shades of yellow and red in the composition below achieves greater contrast and allows the eye to come to rest through its sense of harmony.

cyan 4, black o (see fig. 7.11). Remember that these notations are assigned to pure hues. The complementary combination of yellow and blue-violet produces a ratio of 9:3, which means that yellow is much stronger than blue. Red and green produce a

9.11 Inverting color strength. In this painting a small amount of a stronger hue (orange) appears in a large area of a weaker hue (blue), adding force and balance to the whole. Courtesy Jo Motyka.

9.12 The triadic color system. In order to balance warm against cool colors, parts of yellow (warm) and red (warm) are used against parts of blue (cool). The common denominator for yellow, red, and blue is 36; for orange, green, and violet it is 24 (see also fig. 9.13).

ratio of 6:6, which means they are equally strong. Using a little yellow with a lot of blue-violet means that the yellow becomes very active. From this we can conclude that white, which has the highest rating, is most effective when used in very small amounts. When used in their exact proportions hues give quiet, static effects. When the strongest hue in a combination is used in the least proportion it becomes vivid (fig. 9.11).

At the beginning of the twentieth century educator and color theorist John Goodwin developed the triadic color system which states that there should be an equal balance between sunlight and shadows in a composition, which entails the use of three parts of yellow to five parts of red to eight parts of blue. While mainly used for landscape compositions, Goodwin's triadic color system can be adapted for use in any type of composition. This leads us to conclude that warm colors should be equally balanced by cool colors. When working with more than two hues, we must find the common denominator for the proportional notations and use the numerator from each fraction for the hue notation (fig. 9.12). Let's say we are using red, yellow, and blue. Red has a notation of 6, yellow a notation of 9, and blue a notation of 4. The common denominator for these three would be 36. Red 6 goes into 36 six times, hence 6/36; yellow 9 goes into 36 four times, hence 4/36; blue 4 goes into 36 nine times, hence 9/36. When this is done, we find that the hue that has the lowest Goethe notation will now have the highest number (fig. 9.13).

The proportion of a hue affects its intensity. When complementary hues are used in proper proportions

9.13 Pure hue combinations as Goethe notations and their inversions. The notations on the left are Goethe's; those on the right are inverted. For example, an artist would need to use three times as much violet as yellow to achieve harmony in a yellow and violet composition.

the effect is of a statically fixed image, so that any composition is greatly affected by the proportions of the hues used.

Compositions of related hues and hues of similar value are difficult to sort out visually at a distance. When working with these types of composition, proportion becomes very important. Always view your work from other than its working distance, for similar hues can be sorted out at a short eye range but when viewed at a distance the differences between them will disappear.

The area occupied by a color can also affect its perception. Larger areas of a color appear brighter than smaller areas. Here viewing distance becomes important. As observers, the further away from a color area that we are the duller that area becomes, and its delineating edges of color become correspondingly less sharp.

A study of proportion shows us that when an area is divided into unequal parts the entire area or surface becomes vitalized. So it is with color. Let's say that we are working with red in a composition; three areas of

red would be better for color vibrancy and harmony than two. Two equal areas would provide a visual rest and serve to calm down the effect of a color. Therefore, when we wish a particular hue to impart vibrancy, we must use it in unequal parts across the composition. This concept becomes extremely important when we want a color to dominate a composition.

SCALE

The principle of **scale** encompasses the concept of size relationships. For color purposes we must investigate scale in two different ways: (1) the actual area of color used, and (2) the boldness of the color used. The size of any surface influences the intensity of any color. The larger the area is, the less bright and slightly darker it will appear (**fig. 9.14**). This reaction to object size is linked to the fact that the entire surface of any area is not exactly the same distance from the viewer's eye. The closer an object is, the lighter it will appear. One should therefore attempt to use smaller areas of those pure colors that one wishes to remain

9.14 Size of area comparisons. Notice the intensity and value differences between the small and large inner circles. Intensity is heightened when these circles are paired as complementary hues.

pure and fully saturated. We also find that the more intense a color is (pure hue being the most intense), the bolder the color will appear (see fig. 8.1). These concepts coupled with the use of color proportion notations allow a hue to impart its maximum boldness. Once a hue has been altered, its boldness is also altered and weakened. The addition of white or black (changing a hue's value) imparts a less drastic alteration in boldness than changing a hue's intensity (adding the complementary hue) or breaking a hue (by adding two other primary hues so that all three primaries are present in unequal proportions) (see fig. 8.1).

EMPHASIS

The principle of **emphasis** is concerned with the creation of areas of importance for the viewer to focus upon. Color plays an important role in attracting attention, for it is seen before form. The artist can and should predetermine the **focal points** of the work in order to convey the message intended.

Pure hues are more dominant than tints, shades, or broken colors, which can serve as subdominates or subordinates. We find that the more intense or pure a hue is the greater its impact will be. Any hue will appear more intense beside a dull one and, conversely, any hue will appear dull beside a more intense one. Intensity connotes action and should, therefore, be used for emphasis (fig. 9.15). Value (the lightness or darkness of a color) also creates impact. Here again, the wider the contrast is the greater the impact will become.

An in-depth study of the principle of emphasis shows us that the visual center of any enclosed area or

9.15 The effects of pure hue and shade combinations. The background colors are steps in an intensity chart with yellow and violet as the parent hues. The small, pure-hue yellow circles get brighter as they move into the more violet background areas. All small, pure-hue circles are more visible when placed on a shaded (dull) background.

piece of work is above and to the side of the actual center of an area (fig. 9.16). The "golden rectangle" grid construction also shows how focal points can be effectively placed (figs. 9.17 and 9.18).

Once our dominant areas have been chosen we can implement these choices using a number of devices. The first we will explore is the use of color contrast. The wider the contrast there is between adjacent colors the greater the impact will be. These contrasts can be achieved by use of the greatest

9.16 The visual center. These diagrams show focal points placed at the visual centers. If the circles were positioned exactly at the center of each diagram, the effect would be static and less emphatic.

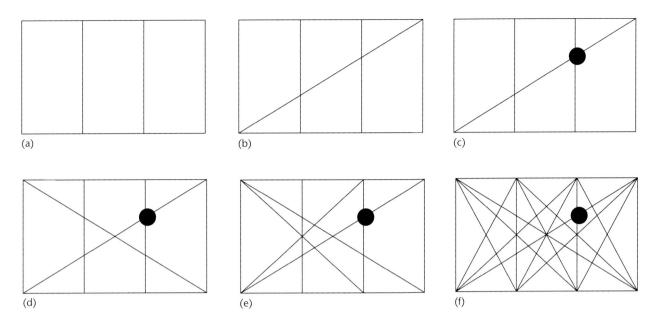

9.17 The "golden rectangle" grid showing focal-point placement. The "golden rectangle" is constructed (a), then a diagonal is drawn across it (b). The main focal point lies in (c) where the diagonal intersects with the second vertical line. If we continue to add diagonals (d-f), the resulting intersections of lines can serve as a guide for placing images.

contrast pair, which is black and white. Use of contrast in value as a tool for emphasis results in **lost-and-found contour** (when only part of an object is outlined or shown). Lost-and-found contour is most easily achieved by using dissolving or disappearing boundaries. A pure hue paired with its complementary also results in emphasis. Equal-value complementary hues placed side by side produce a vibration that can be used for emphasis (see fig. 7.10). Contrast can also be achieved when a pure hue is paired with a neutral or shade that is an equal visual mixture with its complementary hue (see fig. 9.10).

The size and shape of images can also create focal points. Large areas of pure hie can become very powerful. The greatest emphasis occurs when the proportional notations used for color are inverted, as we have previously seen. Color used in a hard-edged mode also provides more emphasis than soft, subtle color transitions or gradations.

Texture has long been used to create emphasis. The rougher a texture is the greater the impact on the eye. Rougher textures make colors look darker. Therefore, the more the surface of a color is fractured the darker in value it will appear.

Emphasis can also be created when arbitrary color is chosen for an entire work or a part of a work. Arbitrary color usage refers to color that seems

9.18 Focal-point placement following the "golden rectangle" grid. Focal points in warm, pure hue orange have been placed on the diagonal against a cool sea of analogous blues. The position of the orange circle above and to the right of center makes that orange circle the main focal point. Courtesy Pamela Muller.

9.19 Robert Minervini, *Apology not Accepted*, 1994. Brass and plexiglass acrylic, 3×3 feet (91×91 cm). Collection of the artist. The use of color creates excitement in Minervini's piece while the employment of transparent color allows the sculpture to change with the background it is set in.

illogical, subjective, or distorted (see fig. 1.8). When objects have an unexpected or abnormal color, our eye gravitates to them, thus creating a focal point.

Unusual detailing is another method of gaining impact. When a work contains mainly flat, solid colored areas, focal points can be created by the addition of many-hued, highly detailed areas. Such detailing should be used sparingly. An entire piece covered in an array of colors and patterns would lose impact, because of the presence of too many focal points to concentrate upon.

Color usage that sets up a contrast with its surroundings allows the color to become emphatic in itself. Sculptors such as Alexander Calder, George Sugarman, and Robert Minervini use pure hues in their works, which are usually positioned in a neutral setting such as a park or city plaza (fig. 9.19). Both depend on bright hues rarely found in nature to create a high contrast with the setting.

HARMONY

The principle of **harmony** refers to the visual agreement of all parts of a work. The successful application of harmony results in unity, which is achieved by using the principles of design.

Repetition is the easiest way to achieve harmony, and color is the most common and important means of repeating. Works that lack hue repetition will also generally lack unity. The layering of colors over a constant color also achieves harmony because the underlying color influences the entire composition.

A study of the design principle of harmony also shows us that similarity works much like repetition, but adds the element of variety. Adjusting values, for example, can create variety—red and pink are not the same visually, but are similar in that pink is red with white added. We can thus achieve similarity by using values of a pure hue as well as shades of a hue that relate to the parent hue.

9.20 Monochromatic color comparisons. The left-hand work has been rendered in Goethe's notations and the right-hand one in inversions of them. The latter is a more recognizable image. Courtesy Elly Madavi.

9.21 Analogous color comparisons. The presence of three closely analogous hues (a secondary blue-violet, a primary blue, and a secondary light blue) lends harmony to these compositions, which employ Goethe's and Goodwin's principles. The primary blue adds emphasis to each work. Courtesy Michele Nolan.

Harmony can also be imparted through the use of tonality. Even within a composition that employs a very diverse palette of colors, the addition of the same color to each palette color can give a tonality that results in a harmonious composition. Only a very small amount of additional color is necessary to achieve the tonality required (see fig. 8.5).

Two or more hues are harmonious if their mixture yields gray; combinations that do not yield gray have high visual impact. Hues can be made harmonious by surrounding them with a neutral.

The term "color schemes," or "color harmonies," is often used in the world of interior design. Color schemes are nothing more than time-tested recipes, as it were, for colors that work well together, be they related or contrasting. Related color schemes impart harmony and unity to the eye. One related scheme is called the monochromatic color scheme and consists of one hue varied in value (from light to dark) or intensity (from intense to dull; in this case, the dull hues must relate to the parent). Such color combinations impart feelings of unity, harmony, peace, and quiet with an emphasis on spaciousness and continuity. For a successful result, we must be careful to use color proportionately. When working with a monochromatic harmony that is based on value, a rating of 10 on white and 1 on black will allow us to impose a proportion notation on each of the values to be used (fig. 9.20). Again the use of Goodwin's triadic color system (see page 70) will allow us to determine the proportions of each tint of the hue to use. If

we are using a monochromatic scheme based on intensity, the pure hue will be ranked 10 and the dullest 1.

The second of our related schemes is the analogous color scheme, which is based on three or more hues located next to each other on the color wheel. Analogous schemes usually have one hue in common, such as yellow-orange, yellow, and yellowgreen, with yellow as the common hue. Analogous schemes become most emphatic when the common hue is a primary hue. They offer visual unity and a sense of calm, and they are most harmonious when the middle hue is the primary. An analogous scheme consisting of red, red-orange, and orange would not be as harmonious as one of red-orange, red, and redviolet. Applying Goethe's color notations for proportion of color, coupled with Goodwin's system of triadic use, allows analogous schemes to function harmoniously (fig. 9.21).

Contrasting color schemes exert greater balance than related ones. The **complementary color scheme** is built on two hues directly opposite each other on the color wheel. This combination offers the most intense hue contrast, and we find that each wheel offers a different pairing (see pages 9–12). Using color in the correct proportions is important when utilizing any of the complementary color schemes (**fig. 9.22**).

The **double complementary color scheme** is based on two sets of complementary hues and affords less contrast than complementary, split complementary, or triad schemes (**fig. 9.23**). When the

9.22 Complementary pairings. Complementary hues such as orange and blue exert considerable contrast and balance. The right-hand photograph provides the more correct proportion between the hues, because within it the warmer orange occupies a smaller area than the cooler blue. Both compositions employ Goethe's and Goodwin's principles. Courtesy James McGinnis.

9.23 Double-complementary color schemes. These compositions show Goethe's notations on the right and their inversions on the left. They illustrate different combinations of the double complementary colors violet with yellow-green and orange with blue. Courtesy Xin Xu.

hues are spaced equidistant on the color wheel the scheme is called a **quadrad color scheme**. **Split complementary color schemes** are formed from any hue and the two hues at each side of its complementary. Here the contrast is less intense than in the complementary schemes but more intense than

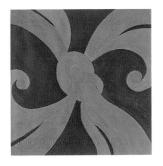

9.24 Split-complementary color schemes. These compositions, showing Goethe's notations on the right and their inversions on the left, feature combinations of the split-complementary colors orange with blue-green-blue and blue-violet-blue. Courtesy Arna Arvidson.

9.25 Triadic color comparisons. There is a dramatic difference in emphasis here between Goethe's notations on the left and their far more successful inversions on the right. The works show colors equidistant from each other on the pigment and visual color wheels—namely, yellow, blue, and red (see figs. 2.2, 2.7). Courtesy Carol von Achen.

in the double complementary. Such schemes provide interest and variety (fig. 9.24).

The **triad color scheme** offers the next most obvious contrast to the complementary. The hues for each triad scheme are equidistant from each other on the color wheel. Triad color schemes result in a dominance of warm or cool. The combinations are as follows:

- **Pigment**—yellow, blue, red
- yellow-green, blue-violet, red-orange
- green, violet, orange
- blue-green, red-violet, yellow-orange
- **Process**—red, yellow-green, blue-violet-blue

- yellow, magenta, cyan
- Light—red, green, blue
- yellow, cyan, magenta (fig. 9.25).

We are able to rank color schemes as to their impact, in that some provide more contrast than others. In order of most contrast we find the following color schemes: complementary, triad, split complementary, double complementary, analogous, and monochromatic.

When working with the various color schemes we have covered, do not limit yourself to pure hues, but rather use tints and shade of the hues to further ensure greater contrast and depth, more visual interest, and a harmonious result.

Concepts to Remember

- Color should not be chosen for a composition simply because it is "pretty." Color must serve the artist's purpose.
- Repeating colors imposes unity and often a sense of movement. This is employing the principle of rhythm in a composition.
- Be aware of the type of balance that the imagery within a composition provides and employ the color balance accordingly.
- Color has an impact on the way the parts of a design relate to each other (proportion). Goethe's color notations have to be inverted to work.
- Pure hue mustn't overwhelm a composition. A pure yellow background would allow one to see little else. However, dull the yellow with some violet, say, and the composition's full color range becomes apparent.
- The scale of a design is affected by both the area and boldness of the color used. Distance affects how a color is perceived.
- Emphasis can be accomplished by using color in a number of ways: (1) color contrast (bright/dull, light/dark, warm/cool), (2) area size (large areas of a color versus small), (3) gradation (soft versus hard), (4) texture (rough versus smooth), (5) use of arbitrary color, (6) unusual detailing, and (7) contrast with surroundings.
- Methods of achieving color harmony are varied: (1) repetition, (2) similarity, (3) use of tonality, and (4) surrounding a color with a neutral color. Several different kinds of color schemes are

possible: complementary schemes have the strongest contrast; monochromatic the least.

Exercises

- 1 Do a series of simple compositions based on progression of hue, progression of value, progression of intensity, and progression of temperature. Refer to figure 9.3.
- **2** Using two identical compositions based on a single hue, render one in a monochromatic format and the other utilizing analogous colors. Refer to figure 9.5.
- 3 Using the same composition, render it as a pictorial composition and a flat composition. Refer to figure 9.7.
- 4 Using the same composition, render it in a symmetrically balanced color mode and an asymmetrically balanced color mode. Refer to figure 9.9.
- 5 Do an overall pattern in color that is unified and pleasing to the eye.
- **6** Do an example of triadic color system balance. Refer to figure 9.12.
- 7 Using identical compositions and colors, render one in an equal mode of color use and the other in an unequal mode of color use. Refer to figure 9.13.
- 8 Do an example of employing contrast to create emphasis. Label the type of contrast used.
- **9** Do an example of employing proportional inversion to create emphasis.
- 10 Do an example of employing fracturing a surface or unusual detailing to create emphasis.
- 11 Do a composition in a monochromatic color scheme. Reter to figure 9.20.
- 12 Do a composition in an analogous color scheme. Refer to figure 9.21.
- 13 Do a composition in a complementary color scheme. Refer to figure 9.22.
- 14 Do a composition in a double complementary color scheme. Refer to figure 9.23.
- 15 Do a composition in a split complementary color scheme. Refer to figure 9.24.
- **16** Do a composition in a triadic color scheme. Refer to figure 9.25.

Color and the Elements of Design

In the previous chapter we discussed the ways in which color relates to the principles of design. We will now explore how color works with the elements of design, which are space, line, form/shape, texture, and light. The elements of design utilize the principles to create the desired visual effect.

One must observe and analyze all the factors that contribute to the rendering of an image. Predicting and determining in advance what you want to happen entails making notes concerning the use of color before you start any work.

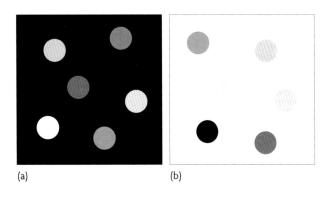

10.1 The effects of dark, light, and middle-value backgrounds on objects with similar values. The circle that we see first in the black background (a) is the white one, while the one we see first in the white background (b) is the black one. In the two gray backgrounds (c and d) we perceive first the circles that are at the furthest extremes from gray, namely, black (c) and white (d).

SPACE

Throughout this book I have stressed the importance, when creating compositions, of having color and form seen simultaneously. To this end, a working knowledge of color's spatial effects is imperative. We use the term "surface color" to denote the hue of an object, such as the red barn, the green grass. However, when objects are viewed in **space** certain visual transformations then take place.

Value helps to determine the relative position of an object in space, whether it is close up, in the middle distance, or far away. An object's position is also influenced by the value of the background on which it rests. If the background of a composition is very light (white, or almost white) the objects seen first will be very dark (black, or almost black) (fig. 10.1). The same effect occurs when one is in a dark forest looking out toward the light. In order to create space, we must not only adjust the values within a composition but the contrast in values as well. In naturalistic works that have great depth of field we must attend to atmospheric, or aerial, perspective (see fig. 8.6). When choosing the colors for a project, keep in mind that those objects farther away will not only require lighter values of hues but duller ones as well. Colored grays can work very well in this instance, but for creating deep space we must use colors that have a blue-gray tonality imposed upon the desired hue. Colored grays are most easily recognized when compared to the "chromas" in the Munsell system. Look out your window and analyze the contrast and hues provided by those objects near at hand as opposed to those in the distance.

If the background of a composition is a very dark value (black or almost black) the objects seen first will be very light (see fig. 10.1). This effect can often be seen in the still-life paintings of the seventeenth century (fig. 10.2).

The middle-value background (neither light nor dark) is the most difficult situation to handle. Generally a middle-value background should be used in a composition only when overlapping of planes is

10.2 Willem Kalf, Still-Life with the Drinking-Horn of the Saint Sebastian Archer's Guild, Lobster, and Glasses, c. 1653. Oil on canvas, $34 \times 40 \frac{1}{4}$ in (86.4 \times 102.2 cm). National Gallery, London. Against the very dark background, the colors that clamor most immediately for our attention are the whites and yellows of the lemon, lemon peel, and drinking horn; the white highlights on the background cloth; the white reflections off the drinking glasses, table edge, plate, and lobster; and the bright red lobster itself.

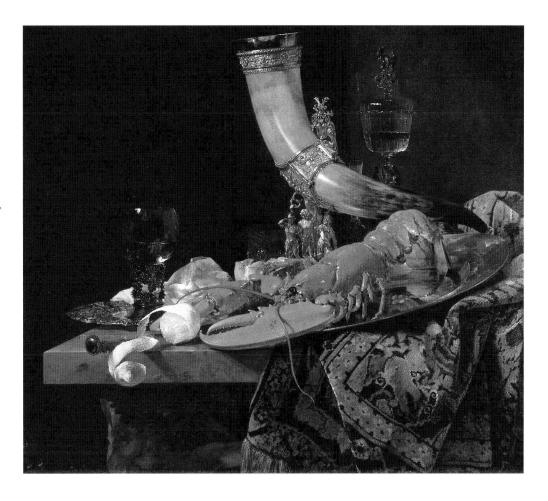

distinct, because it does not impart a spatial feeling and the overlapping planes will reinforce where the images are in space. Much experimentation is required to ensure that the objects' positions in space are clear when working on a middle-value background. One solution might be to say that the middle-value background should be treated as a dark background and to proceed with the objects placed in a sequence getting progressively lighter. Conversely,

the middle-value background could be said to be light with objects sequenced to dark (see fig. 10.1).

Keep in mind that the background of any piece is essential to the advancing and receding effect of any hue placed on it. In landscapes we find that distant objects are cooler. Thus the illusion of space or distance is most easily imparted by imposing a bluegray tonality on distant objects (fig. 10.3). Coolness tends to reduce the apparent size of an object,

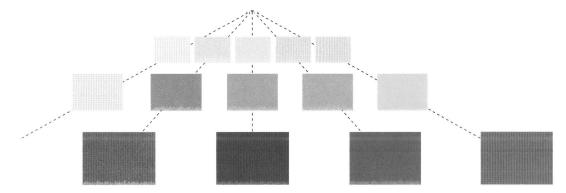

10.3 The illusion of distance. In their landscapes, artists use cooler colors with grays to gain atmospheric perspective and suggest distance. In this example, the foreground colors are warmer than the background ones.

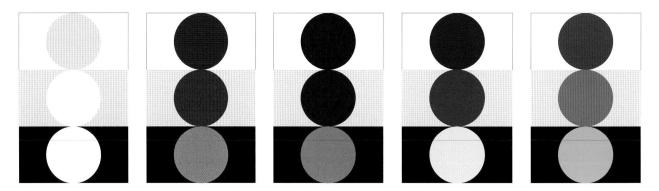

10.4 The influence of background values. Light backgrounds tend to darken objects, while dark backgrounds tend to lighten them. The artist must lighten or darken object areas to capture the effects of light, less light, and no light. Pure hues are here in the gray backgrounds; shades of the hues (plus black) are in the white backgrounds; and tints of the hues (plus white) are in the black backgrounds.

increasing dimensions and distance. Without the illusion of deep space the effect is flat and one-dimensional.

Objects resting against opposing areas of value must change their values within themselves. Let's say we have a tree trunk that comes up from the ground against a dark brick wall but whose higher portions are seen against a light sky. Where the tree trunk is seen against the wall it will be lighter in value than where it is seen against the light sky (where it will be dark), but it is still the same tree trunk with the same surface color—it is the value that is changing (fig. 10.4).

We know that distance between any object and the observer involves change in color perception. As distance increases gray tonality results because the color weakens. Trees in summer are a warm green close-up, but at a distance they appear cooler, tending toward green-blue.

The element of space controls the distance, void, or interval between objects in our work and provides interaction between line, shape, color, and texture.

10.5 Shallow, medium, and far-reaching space. As we move from left to right across these images, increasingly greater value contrasts within each group of rectangles give the impression of greater depth, or space.

Interval can cover the change between warm and cool and/or dull and bright; these can create space as well as distance and void. The types of **illusionary space** that can be created are shallow (near), medium (moderate), and far-reaching (deep or infinite). **Shallow space** is usually created by simple shading of forms and/or simple overlapping. The images appear to be close to the viewer. **Medium space** is the depth that is conveyed by ordinary vision. Objects or images are within a reasonable distance—neither very close nor very far. **Far-reaching space** is the kind seen in panoramic photographs or landscapes, when we appear to look out to the horizon. This type of space usually extends far beyond the picture plane (**fig. 10.5**). The value of an image helps to place it in space.

The Illusion of Transparency

Transparency occurs when objects overlap but are still seen in their entirety. Here confusion can begin to take over unless transparency is carefully handled, but it has the benefit of allowing the eye to go in and out of space simultaneously. This is called **equivocal space**; it conveys the feeling that the space is changing as we view it. Equivocal space is the basis for most Cubism. Color is a most important factor in establishing equivocal space.

The illusion of transparency is dependent on the changes in hue and value that occur when objects overlap each other. If a light hue or value is placed on top of a dark one, the value of the overlap (the transparent value) will be darker than the light value but lighter than the dark value. Conversely, if a dark value is placed on top of a light value, the transparent

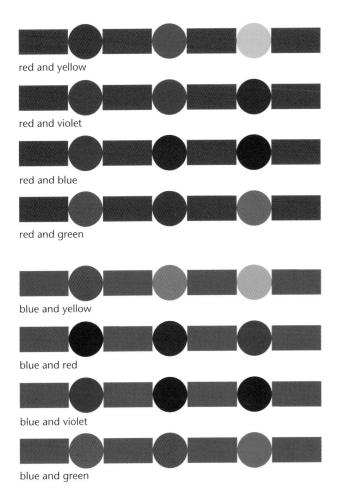

10.6 The illusion of transparency. The two outermost red and yellow circles (first row) show the colors needed when applying red over yellow and yellow over red respectively to achieve an illusion of transparency and space. The single central circle (first row) shows the visual middle mixture (orange) of red and yellow so one cannot tell which is on top (no illusion of space between them). This principle lies behind all the rows (see also fig. 10.7).

value will be lighter than the dark and darker than the light. The hue change of the **transparent** area is as important as the value change. The tonality of the overlap area is that of the area doing the overlapping. Let us say we had a yellow area overlapping a red one. The transparent area would not be orange but rather an orange-yellow-orange, yet a value of orange-yellow-orange darker than that of the yellow. It is important to show the various planes when using transparency so the viewer knows what goes where (fig. 10.6).

The illusion of space can also be employed when working with transparency. An illusion of space is accomplished when the value of the overlapped area is close to the value of the overlapping hue. The closer these values become the greater the spatial illusion will be. Transparency is also most convincing when the light source is coming as if from behind the imagery. The artist can accomplish transparency effects in one or more of three ways:

- changing the color to impart the desired effect
- producing the desired effect by optical mixing
- layering or glazing.

With the two latter methods, one should know the values of the components of the mixture. They should be close or exactly the same in value (fig. 10.7).

Space is also created by the tonality of the overlap area. If the overlap area is closely related to the overlapping hue (the hue on top), a greater sense of space is created than if the overlap area were closer to an equal mixture of the two hues. Let us again look at the vellow area over the red one. If very little space exists between the two, the overlap would be orangevellow-orange. To increase the spatial interval the overlap would become yellow-orange and even greater space between the two would result if the overlap were yellow-orange-yellow. In other words, the closer the overlapping area is in hue to the overlap hue (the parent), the greater the space created. Even more convincing space can be created when we apply the value concept of space to our transparency studies. Our yellow overlapping red study now goes a

10.7 The illusion of space in transparency. The transparent yellow of the smiling face is overlapped by the close value of the yellow-orange, creating the illusion of space. The transparent effect is enhanced by the light source originating as if from behind the composition. Notice how the red stripes of the flag appear to be behind the blue star field but in front of the yellow face. Courtesy Mark Hartnett.

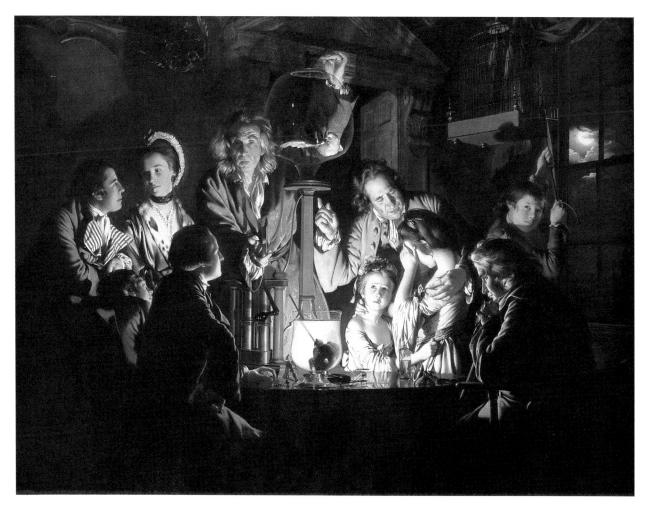

10.8 Joseph Wright, An Experiment on a Bird in an Air Pump, 1768. Oil on canvas, 72×96 in (180×240 cm). National Gallery, London. In order to convey the illusion of a rounded, transparent glass air pump (top), Wright painted the edges of the glass with great delicacy, and he rendered the enclosed bird extremely foreshortened and in the sharpest detail. He painted the colors of the man's hand, lace-edged cuff, and sleeve so that we perceive them to change subtly between our observations through the glass and just outside the glass. The dark background, the minutest glass reflections, and some refraction of the man's arm complete the effect. The illusion of the foreground glass jar containing the human skull is enhanced by the back-lit liquid it contains.

step further. If the red area were mixed with white so it is lighter than the pure yellow, it would appear farther away than the yellow if a white ground were to be used. We see that we must first determine where the hues are in space and then apply our mixtures to the overlapping areas, adjusting the values accordingly.

If an object is transparent, light can pass through the material and things within or behind the material can be seen clearly. Glass is a perfect example—it is clear and smooth. One must keep in mind the qualities of the transparent materials. The things seen through the transparent material are very sharp and in some cases even brighter and larger. When working with a transparent object the edges of the form are completely seen in all dimensions—front and back. In short the entire structure must be recorded. When attempting to impart the effect of a totally clear material such as glass, we find that the use of a dark-value background allows us to employ an extremely broad range of values seen through the glass as well as the reflective qualities seen on the glass as the result of light reflections (fig. 10.8). We must also keep in mind that this object (such as the glass) needs shading to put it into space and define its volume. When this has been determined, the object or objects within or

behind must have their color adjusted accordingly. Remember that the glass must have its color imposed upon the surface colors seen through it, and that the values and tonality of these mixtures must be convincing. It is important to make notes on what will happen to each color area before trying to execute these effects. These notes will enable you to work out logically the color solutions desired.

Translucency

A translucent object allows light to pass through, but the material is not entirely transparent—light is partially blocked and the things within or behind the material become fuzzy or diffused. A sheer window curtain is a perfect example—it is soft, flexible, and has a gauzy texture. Objects viewed through such a curtain look softer than they really are, with diminished details. Translucency depends greatly upon the effect created by the density and texture of the translucent layer. When working with a translucent object, one cannot completely see the edges of the form due to the relative opaqueness of the translucent material (fig. 10.9). As a general rule we find that translucency involves utilizing close values of color. It is handled in the same manner as transparency, but the values are adjusted to impart a softer, less clear visual image. In addition, when we attempt to achieve transparency through more than two layers, those areas begin to become translucent as well as transparent.

Volume Color

The volume of solid objects is fairly easily rendered, because their local color is affected in a simple way by their surroundings. The artist is faced with special problems, however, when dealing with the volume of transparent images, which require additional analysis. Water, for example, is clear; our rendering of water must tell us how much water is there. The sea reflects the blue of the sky as well as the ocean floor. The more water there is the darker or deeper should be the color used. Near the shore the sky's reflective action diminishes as the sand on the bottom nears the water's surface. Tinges of blue blend with the beigegray of the sand. However, because of the light reflected on the water the value is also changed. The deeper the water becomes the more the blue takes over (fig. 10.10). Similarly, as light reflects on a window pane, the values of the objects beyond it are also changed.

10.9 Translucency. In this example, the diaphanous veil blocks some of the light striking the bride's face and pearl tiara, lending them a darker, softer, and hazier appearance. The outlines to her cheek, neck, and shoulder are particularly fuzzy. A less translucent material such as a lace curtain would block out more light and render objects even fuzzier.

10.10 Volume color. As seen in this photograph by the seashore, ocean water reveals a very dark blue-violet color due to the massiveness of its volume and its reflections of the ocean contents, the ocean floor, and the sky. The color of the water near the shoreline is a much lighter blue, reflecting the shallow, beigegray sands below. Courtesy estate of M. Anne Chapman.

10.11 Local and film color. The light forming a layer upon the local color of the rabbit in the doorway becomes its film color. In order to convey that the light cast nearest the door should be more intense and lighter in hue than that cast toward us and away from the door, the artist has rendered the former as a light value of its local color and the latter as a darker value. Courtesy Michele Nolan.

Film Color

Let us now ascertain what happens to surface color when atmospheric conditions are imposed upon it. The open door with light streaming through affects the surface color of objects in that the light forms a layer upon their surfaces. This is film color. The light cast nearest the open door will be more intense and lighter in value. However, as we move away from this light shaft the intensity and the value weaken. We must, then, impart this information to the viewer. The areas nearest the light source will remain a light value of the surface color; however, as the light is projected it gets duller and darker, but the shades used still reflect the parent of the surface color. A film color will favor the surface color but this surface color area will be duller (contain the complementary hue of the local color) and have a tonality of the film color—the red light of a sunset, for example—that depends upon the strength of the film (fig. 10.11). When designing it is important first to determine the surface color or hues of the imagery. Then adjust these surface colors to impart the desired visual effects. In this way you will retain the tonality of the image.

Intensity and Space

Intensity can produce effects on objects in space. Strong intensities make an object large, and the more intense a hue is the more it causes an object to move forward. We find that small areas of a composition usually function better done in brighter hues while large areas are better done in duller hues (see fig. 7.9). Light pure hues on a black background will advance according to their value, and pure yellow advances the most. Light pure hues on a white ground will recede according to their value, and here pure violet will advance the most. Thus, a pure hue advances relative to a duller one of equal value (see figs. 6.9, 6.10). Low intensities reduce an object's size and increase distance and spaciousness. When values and saturation of hues or colors in a composition are equal or close to equal, dimension is lost and the surface will appear flat.

Presentation

The presentation of any art work affects the spatial effects that are imparted in the work. Remember that the final presentation of the piece is an integral part of the entire design. It is a good idea to think about the framing, matting, and mounting at the outset of any project, and the color to be utilized must become one with the art work. If this is done the spatial effects one wishes to convey will be reinforced and not destroyed by any framing, matting, or border.

While each work is unique, there are some guidelines that can help to enhance any piece of art. Borders surrounding a work serve several purposes:

- protection
- emphasis in comparison to its surroundings
- interaction with the design to control its impact.

Matting, which is the most common type of border, serves as a barrier especially if the piece is to be handled. The mat can also set the piece apart from its surroundings and get rid of the distractions that might be present such as those seen on a wall. A mat can also clarify what is occurring within a non-representational work by cementing the figure/ground relationship. In a black-and-white non-representational flat composition, the choice of either a black or white mat will determine what is figure and what is ground. For representational compositions a white mat is the safest bet since colored mats can interfere with the color relationships within the piece.

Neither frames nor mats in color should intrude upon the work. Colored frames should exactly repeat a color that is found in the piece and preferably should be a light value. In this way the frame becomes part of the figure/ground relationship. When in doubt a white mat will always serve as the best choice, or a mat that exactly matches the background of the piece.

Colors that fill a space, as we see in interior design, affect the feeling of space that is imparted. A small room can seem larger if decorated in cool colors. A large room becomes visually small if it is presented in predominantly warm colors. A high ceiling is "lowered" when painted in a warm color.

LINE

Colored and neutral **lines** can have a strong influence on our work. We know that line imparts motion and contour to images, and when areas are delineated in colors that conform and enhance the area, the results are visually credible. This technique was used dramatically by Amedeo Modigliani (**fig. 10.12**).

Outlining

Observation shows that hues remain individual when separated by black or white lines. This becomes especially important when dealing with like or related hue areas. In order for the closely related hues to remain individual, black or white outlining must be used. Without this outlining the variations in hue will cause a feeling of depth because of visual fusing (fig. 10.13). Outlining creates closed areas and serves as a barrier between color boundaries, which halts interactions and simultaneous contrast effects (fig. 10.14).

Outlining an area of a color with black tends to deepen it, making it richer and more jewel-like. This is one of the principles of stained glass (fig. 10.15). Dark or black outlining can add a glowing, luminous quality to an object. White outlining, on the other hand, spreads and washes the hue over an area. The spreading effect of white outlining will lighten and weaken the color energy of the area.

Outlining can affect value by adding excitement to areas of like values by delineating them from one another. Outlining, if used sparingly, can also be used to define focal points—points of emphasis. When complementary hues touch, it can be desirable to outline the object with a light value of its hue. This will halt a vibration effect. For instance, a red flower

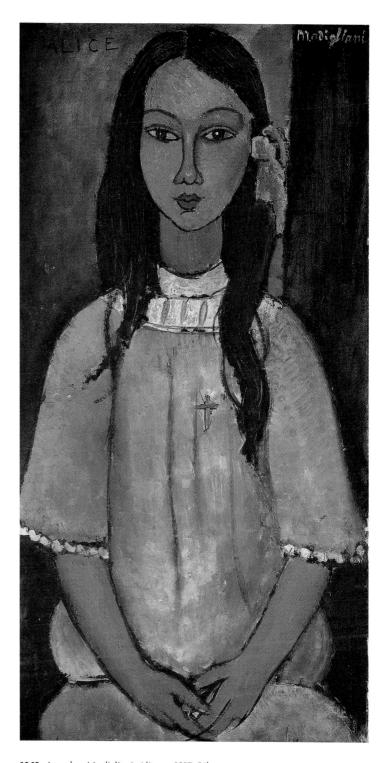

10.12 Amedeo Modigliani, *Alice*, c. 1917. Oil on canvas, 31×15 in (78.5×39 cm). Statens Museum for Kunst, Copenhagen, Denmark. Modigliani's portrait *Alice* is a superb example of the use of outlining. Notice that the orange face is outlined in its complementary hue blue, the red lips are outlined in their complementary hue blue-green, the blue dress is outlined in a darker value of blue, and the arms are outlined in black. Modigliani's use of varying colors of outlines has resulted in the figure's parts being correctly positioned in space.

10.13 Types of outlining. Complementary outlining attracts attention to the outline, strengthening the complementary hue. Black outlining deepens a hue and forces it to advance, making it more luminous and individual. White outlining diffuses a hue over a seemingly larger area, making it weaker yet still individual. Surrounding a hue with a darker shade of the same hue can force it to recede yet enhance its luminosity. Doing the same with a lighter tint can advance a hue and also prevent a vibration with a neighboring complementary hue.

10.14 Outlining and no outlining. The outlining on the left defines shapes and creates space around them. The lack of outlines (right) serves to open up areas of color to more visual fusing and to give the composition more depth. Courtesy Arna Arvidson.

on a blue-green background might be outlined in pink. Complementary hues attract attention to outlines and an area becomes stronger when surrounded by its complementary. When a light value is used on a dark background no outline is needed, but when a dark value is used on a light background it is necessary to outline the object with an even darker value of the hue (see fig. 10.13).

Now we see that we have five methods of outlining: outlining with the complementary hue (use the Munsell wheel complementary); outlining in black; outlining in white; outlining in a light value; outlining in a dark value. When combined in a composition, these outlinings help to create space: objects outlined with the complementary hue will be seen first, followed by those outlined in black, then white, a darker value, and a lighter value (see figs. 10.12, 10.14).

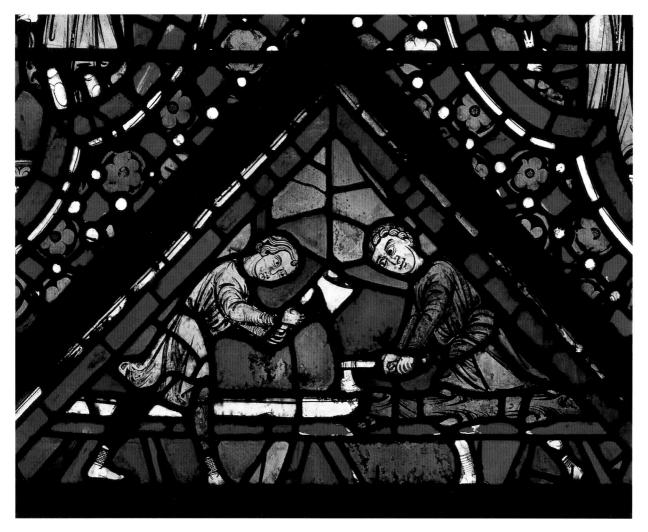

10.15 Carpenter's Guild Signature window (detail), Chartres Cathedral, France, early 13th century. The use of gray-black lead to separate panes of stained glass was more than just a practical tool to hold such compositions together. Lead was also a powerful visual aid. Its neutral color served to reinforce the luminous, jewel-like quality of the glass within it and to stop the colors spreading.

Legibility

Contrary to popular belief, the most easily read combination of colors is not black on white. Walter Sargent (a Chicago art educator) and M. Luckiesch (a Swiss psychologist and color consultant) did research on color legibility during the middle and late twentieth century and compiled a set of rankings for color legibility (see Appendix 8). The most legible combination of colors proved to be black on yellow, followed by yellow on black; black on white is only fifth on the list. Green on orange is number 30 on the list. Color legibility rankings allow the graphic designer, printmaker, fiber artist, and embroiderer to impart clarity to their work.

Other Types of Line Formation

Often thin-to-thick lines can appear to be lighter (thin) to darker (thick). We can also actually change the value of a line in its trajectory and achieve even more convincing illusionary space or volume (fig. 10.16).

When the scale of lines becomes overly bold, the line loses its identity and functions as a shape. This effect is greatly enhanced in compositions where boldness of color and thickness of line are coupled (see figs. 9.11, 10.16).

Adjoining color areas can also create line. So we see that lines can be the result of the meetings of areas of color and value, the meeting of surfaces, and the intersecting of surfaces. When diagonals meet

10.16 Henry Moore, *Sheep #43*, 1972. Black ballpoint and felt pen, $8 \times 9^{3/4}$ in (20.3 \times 24.8 cm). Courtesy of Mary Moore. The use of thin to increasingly thicker lines down the sheep's body suggests its rotundity. The heavier use of lines around the shoulders and down the front helps accentuate the turning of the head and suggests the greater amount of wool in those areas of the body.

another line, the angular area formed can result in a spontaneous interaction. This is especially true when the angles are repeated. We will see gray areas where there is only black and white, due to the optical mixing that is taking place.

FORM AND SHAPE

Color is generally seen before form. The artist can, however, alter this sensation so that color and form are observed simultaneously. When this is done, color is used to its fullest capacity. In the following section "shape" refers to a bounded, flat area; form in this context is treated as three-dimensional.

The simplest method of implying form is through shading, or through the application of graduated values. Chiaroscuro is one possible method of shading that allows color and form to become one. Artists developed this most realistic shading system during the Renaissance. The premise behind chiaroscuro is that light affects an object's volume and its position in space and time. In this system the transition from light to dark areas is gradual and therefore smooth. These smooth gradations impart sensations of light and atmosphere or space. When dealing with an object to be rendered in chiaroscuro, we must first

determine the parts of the object in relation to its shading:

- The highlight—this is the area where the light source is striking the object. It appears on that part of the object directly facing the light source, and the light is at its most intense. Keep in mind that the highlight should be the lightest value discord of the nearest primary hue.
- The light area—this area surrounds the highlight and appears rather light in value. It appears to be the result of light radiating from the highlight, which weakens as it spreads. The parent hue of the light area is the surface color of the object. Therefore, the light is the surface color plus white.
- The cast shadow—this area relies upon the light source to impart its direction and strength. It must contain some of the color of the object as well as of the surface on which the object rests. Thus the cast shadow is composed of the surface color of the object plus its complementary, as well as the surface color of the casting surface or ground plus its complementary, with the ground surface color dominating.
- Reflected shadow—this is the light that is being reflected back from the ground surface area. Here we also see colors blending, in that the color of the ground mixes with the color of the object. We must therefore create a color that is a mix of the object's surface color plus its complementary with the ground surface color plus its complementary. The object's surface color should dominate.
- The form shadow—this is the darkest part of the object that is farthest from the light source and usually is positioned next to the reflected shadow. Form shadow is composed of the object's surface color plus black.
- Form shading—this describes the gradual transition from the light area to the form shadow area, which gradually changes its value from light to dark, producing a smooth transition between the areas. This is composed of the object's surface color, plus white and/or black (see fig. 6.4).

Psychological research has shown that there is a definite relationship between color and shapes. In visual terms, certain colors seem to have a natural correspondence with particular shapes:

- red—squares, cubes, 90-degree angles, structural planes
- orange—trapezoids, rectangles, sharp or hard images, fine details
- yellow—triangles, inverted triangles, pyramids, acute or aggressive angles, pointed sharp forms
- green—rounded triangles, hexagons
- blue-green—liquid
- blue—circles, spheres, rounded angles
- purple—ellipses, ovals, flowing forms.

TEXTURE

The texture of a surface also influences color. The rougher a surface is, the darker it will appear to be. Moreover, the actual texture of a surface affects the color applied to it. If a surface is rough or porous, it will absorb a greater proportion of the lightwaves hitting it, so the color will be perceived as darker. A shiny surface, on the other hand, will reflect more of the light and the color will appear lighter. Obviously, the reflective qualities of a shiny surface also mean that the colors of the surrounding surfaces will be mirrored.

Value and intensity of hue can combine to imply a rough texture on a flat surface. Contrasts of light and dark across an area allow that surface to be perceived as having highs and lows. Dark values often denote shadows within forms. These shadow areas must not just be dark (hue plus black) but duller (hue plus black plus complementary) as well. The dull colors (shades) used must relate to the parent color, which is also the surface color. An implied rough textured surface should impart the feeling that the surface is all the same color but that the texture is in some way irregular. The greater the contrast between the values used, the rougher the surface will appear (fig. 10.17). We also find the more the surface is fractured the rougher the texture will appear.

Temperature also can impart a textural feeling. A smooth, shiny surface is usually rendered in a cool temperature, while warm color usually imparts a smooth napped texture such as velvet (see fig. 8.1). From this we may conclude that a textured surface is usually warmer than a smooth surface.

Also keep in mind how texture changes in space. Areas close to the viewer must be rendered in more detail and/or rougher than those seen at a distance. As distance becomes greater, texture becomes less discernible. Therefore, the closer the texture is to the viewer, the more intense is its color.

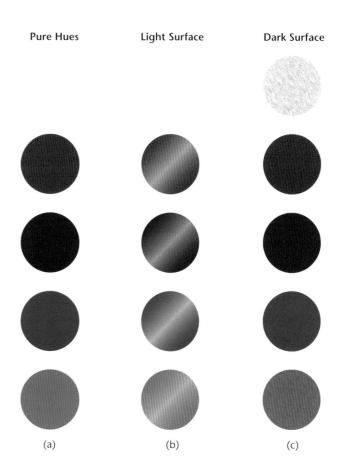

10.17 Implied smooth and rough texture. Column (a) consists of the Munsell pure hues. Column (b) shows their application to a smooth surface and column (c) an application to a rough surface.

Reflective Surfaces

Most reflective surfaces are smooth and shiny. In order to denote this type of texture, the artist can apply a light source to the area. As we saw in our study of chiaroscuro, the highlight is a very light value of the discord of the closest primary to the parent surface. If we had a red surface, the highlight would assume a blue tonality that is very light (pale, almost white, blue). We must now denote the shading that the form requires. Once the surface light and darks have been determined, we must analyze what is being reflected by that surface. Here we must impose upon the surface its surroundings. If our red surface were to reflect an orange, this orange would be seen on the surface (in refracted form, if necessary), but shown with an overall tonality of the red surface imposed upon it. Keep in mind that the red surface's values (including the highlight) change across it and the form of the orange must mix with these to impart the illusion that

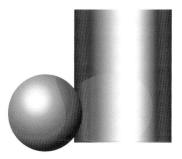

10.18 The effects of reflected color. The highlight on the orange is a discord of red and the reflected shadow at its base is a dark, dull orange with a dark, dull red. The highlight area near the top and center of the rectangle would be a discord of blue and the reflection highlights to the left and right of center would be discords of red and blue.

the orange is being mirrored by the red surface (figs. 10.18, 10.19). Make notes while studying the visual problem so that all color combinations are thoroughly analyzed.

The combination of intense light reflection and color reflection is the major visual clue that we are observing a metal surface. When working with metal forms we must take into account the value modeling (chiaroscuro) that will define the form as well as the

value modeling of the forms reflected onto the metallic surface. These reflected colors must have a tonality of the metal surface but still find their parent color from what is being reflected. The one major color usage change we find here is that the highlight area of the metal surface is not the lightest discord, as previously seen in our handling of chiaroscuro. On metal the highlight area should be white, or the palest value of the hue describing the metal. Keep in mind that the reflective qualities of metal are greater than those of other surfaces, so the highlight and shadow areas will be in great contrast. While working with chiaroscuro we found that the gradations of value were very gentle; with metal surfaces the intervals between values are exaggerated. Different metals have different hues and different reflective qualities (fig. 10.20).

Water is usually a clear, transparent liquid and as such the areas beneath water droplets must be treated as transparent color. Usually water droplets are rendered in a gray-blue tonality and, because they are rounded, the artist must show this as volume color. Therefore, this gray-blue tonality must incorporate shading with pure white highlights. Because these droplets are concave the surface imagery beneath them will be magnified and have a gray-blue tonality.

10.19 Richard Estes, *Woolworth's*, 1974. Oil on canvas, 38×55 in (96.5 \times 139.7 cm). San Antonio Museum of Art, San Antonio, Texas. Lillie and Roy Cullen Endowment Fund. Estes highlights the reflective surface of most of the neon "Woolworth's" letters in various shades of white, gray, light-blue, and orange. He emphasizes just the second and third "o" of the name with a pure red-orange hue to suggest that electricity is only functioning in these letters. With great skill, Estes paints the display windows in such a way that one can see through them into the store and the reflection of the other side of the street.

Metal	Hues	Reflective Qualities
gold	yellow	cool, clear, highly reflective, white highlight, shadows sepia (burnt umber)
silver	neutral, delicate blue-gray (cobalt blue-gray)	cool, highly reflective
brass	smoky, warm yellow (earth yellows—raw sienna, yellow ocher, indian yellow, sepia)	white highlight
iron	heavy, grainy, dense gray	medium reflection, cool gray highlights, blue-grays dark—black
chrome	cool blue-gray (indigo and green)	sharp contrast, highly reflective, influenced by surrounding colors, highlight white surrounded by blues, blues and greens in shadows
pewter	beaten appearance, warm blue-gray	low reflection, no white highlight, no black, blue highlight
copper	orange-red	highly reflective, can have a green patina, brown shadows, light orange highlight
steel	cool gray (ultramarine blue-gray)	medium reflective, no black or white, pale gray highlights

LIGHT

One cannot deal with light without exploring shading. The depiction of light on a flat surface is most easily achieved by the use of shading, which also adds realism to shapes and translates them into forms. First, however, we must determine the light and dark areas

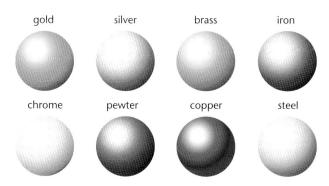

10.20 Achieving metal color usage. It is advantageous to be able to render metallic surfaces without the use of very expensive metallic inks. Highlights should be all-white and shading gradations in sharp contrast.

on the object. Keep in mind the light source hitting the object as well as the shape of the object. Within a composition there is usually a single light source. When no apparent light source is present objects seem flat, whereas the shadows cast from a light source impart depth and dimension to an image. The lightest area will be where the light source hits the object and is the most intense. Study photographs and your environment to see how light hits an area or object, observing how the values and hues can change. Changing the direction of a light source can greatly alter our perception of the composition. Light sources can emanate from the front, the sides, the top, the bottom, the back, or from within. Each type of lighting will reveal the object from a totally different aspect (fig. 10.21).

When no definite light source is noted, the shading is termed **logical shading**. Because no light is present, there are no cast shadows and the shading only defines forms. The areas closest to us are lightest and vice versa.

10.21 Effects of different light sources. Left–bottom light source; center–front light source; right–side light source. Courtesy Steve Cummings.

In addition to the shading of individual objects within a composition, thought must be given to the overall light quality of the piece. A crisp delineation of all forms is known as **linear composition**. If we were to trace such a composition, the result would be a clear, outlined composition much like a "coloring book" drawing. However, when only parts of shapes and forms are visible with the remaining visual information melting into the background the effect is known as lost-and-found contour. Here the viewer is asked to fill in the remaining visual information from the minimal images supplied. The simplest way to achieve lost-and-found contour is to have parts of objects bathed in light while the rest of the object is of quite dark values on a dark background.

The ground on which an object is placed also affects how it is to be shaded. On a dark background those areas seen first will appear to be very light. The areas farthest away from us will meld into the dark ground. As we look, the light areas will advance while the dark areas recede. On a light background, however, the areas seen first will be dark. The light/dark contrast pushes the dark areas toward the viewer. One must keep in mind how the individual components of a composition are shaded in this situation. The darkness of a forward object causes it to stand out. When a middle-value (neither light nor dark) background is used, the objects become static and calm. We are not exactly sure where they are in space. Most of the form of individual objects is lost and the result can be one of mystery.

How light is used within a composition can convey emotions. Very little light can impart feelings of fear, mystery, intimacy, and night—to mention but a few. A very light composition can impart joy or warmth. Light, therefore, can impart emotion, time, and space to any composition.

Types of Lighting

The type of light that plays on a color greatly influences it. It is crucial to try to replicate white daylight when attempting to reproduce colors. In the United States, as well as the entire northern hemisphere, the ideal condition in which to work is in natural light from the north, because it undergoes the fewest changes as the sun moves and the day progresses. But this ideal is not always practical. Cloudy days and working at night, for instance, necessitate other solutions.

Artificial light can be divided into three types: incandescent or warm (candles, light bulbs, flash lights, torches, gas lamps), electric arc (sodium vapor lights), and fluorescent. Incandescent lights give us white wavelengths that warm the surface, so that warm surface color hues appear brighter, cold ones duller. Incandescent light bathes the area in a yellowish glow. Electric arc lights use various gases that impart a variety of film colors to the surface. Sodiums, for instance, give a yellow-orange glow. Xenon produces white light and is best for viewing hues. Fluorescent lights usually contain a lot of blue film color that greatly alters hue. However, if we can pair it with a pink fluorescent light we can achieve a fairly consistent white light. The best option here is a Dalux fluorescent, which provides the least distortion among this lighting type. The optimal white light is provided by quartz halogen lights. Warm white light is best for viewing inorganic or plastic materials but is less good for organic objects, since it tends to weaken warm colors, making them appear much bluer.

Types of lighting create very different effects; we must remember that, for example, Renaissance works of art would have been painted and viewed by natural light, oil lamp, or candlelight. How would the colors of Michelangelo's Sistine Chapel have appeared in candle or oil-lamp light? When we look at all the great paintings that fill our museums, we must remind ourselves of their original settings. How would the change of scene and lighting affect our perception of them?

We must also be conscious of the type of lighting and surroundings that will be home to our finished works. The optimum would be to have an art work function as the artist intended it to, no matter what the setting.

We also find that while the rods of the eye's retina help us to see in dim light, the greater the contrast present in the object, the more distinguishable it becomes. So, for example, black on a dark background is harder to distinguish than black on a light background, even when the light is dim.

Finally, let us look at the quality of light that is illuminating an object. Certainly bright noon sunlight imparts a different illumination than if the object is lit by candlelight. The brighter and stronger the light source is, the greater the contrast of values that results from that illumination. We also find the closer the light source is to the object, the greater is the contrast in value.

Concepts to Remember

- Color works with the elements of design—space, line, form/shape, texture, and light—to create the desired visual effect.
- We must be very aware of the changes in color that help us to depict an illusion of space. Values of color can determine the relative position of an object in space; and value placement and sequencing of imagery impart this concept. The overlapping of transparent objects in a composition, and the degree of space formed between these objects, relies on careful modulation of hue and value. Translucency weakens the color of the non-transparent material that lies beneath the translucent image. Cast light creates a film of color change across a surface. This film will weaken as the light moves farther away from its source.
- Presentation of a work is most important: attending to the proper color usage of mat and frame color for two-dimensional works and surroundings for three-dimensional works. Outlining serves to delineate objects from each other, halt color interactions, and allow a color to remain stable. Use of the five types of color outlining can also help to create space. Different color combinations are legible to different degrees. Where surfaces of colors meet lines are created. When working with any type of texture one must first determine the surface color of the image as well as the surface colors that are being reflected onto any surface. From these basic color choices, the nuances of value, intensity, and temperature are imposed upon the imagery to determine the

desired visual texture effect.

Shading is dependent upon light and one must think about the light source so that shading is convincing. Light also creates space and to this end the values used within a piece must satisfy the desired spatial illusion. The light in which a piece is presented affects how the color is perceived.

Exercises

- Do a composition incorporating a background. Render the same composition three ways:

 (1) background light, (2) background dark,
 (3) background middle value. Refer to figure 10.1.
- 2 Do a composition that shows transparency and equivocal space. You may use any color medium. Refer to figures 10.6 and 10.7.
- 3 Do a composition that shows translucence. Refer to figure 10.9.
- 4 Do a composition showing film color usage. Refer to figure 10.11.
- 5 Do a composition showing volume color and film color usage. Refer to figure 10.10.
- 6 Do two identical compositions, one that has no outlining and one that utilizes at least three different types of outlining. Refer to figures 10.13 and 10.14.
- 7 Do a line composition that incorporates value by changing the line quality. Refer to figure 10.16.
- 8 Do a composition in color using chiaroscuro. Refer to figure 6.4.
- 9 Do a composition that contains areas of the same hue, some that impart smooth texture and some that impart rough texture. Refer to figure 10.17.
- 10 Do a composition showing the reflection of color onto a surface. Refer to figure 10.19.
- 11 Render a surface as being a metal surface. Refer to figure 10.20.
- 12 Render an object with varying light sources: from the front, from the side, from the top, from the bottom, from the back, and from within. Refer to figure 10.21.

Color Interactions

We know that every color is seen only in relationship to another color or colors. Therefore, one must be able to predict how a color will be influenced or changed by its surroundings.

Twentieth-century art broke down conventional barriers in art. Both Futurism and Cubism abandoned the concept of backgrounds and positive/negative space relationships in favor of having the beholder move in and out of space randomly as the work is viewed. To accomplish this one must experiment with the effect of light and dark values on each other and the whole work to impart the desired visual reaction.

AFTERIMAGES

Hues all have afterimages. These afterimages affect adjacent colors, especially white. A white surrounded by hues cannot easily remain white. Let's say we have a red circle on a white background—the white will take on a blue-greenish cast because green to blue-green are the hues that red afterimages; they are red's complementary hues (fig. 11.1).

11.1 Afterimaging. The negative afterimage of each big circle seen against a white background will be a pale version of its complementary hue which can be seen in the smaller, surrounding circles: (a) yellow and pale blue-violet; (b) red and pale blue-green; (c) violet and pale yellow-green; (d) blue and pale orange; (e) green and pale red-violet. The negative afterimage of gray against a white background (f) will be a paler gray, and of gray against a black background (g) a darker gray—again, as seen in the smaller, surrounding circles.

Successive Contrast

Successive contrast is the afterimage reaction that colors impart when the eye views them one after the other. What happens is that as the eye moves rapidly across a work it sees not only what it is viewing but the afterimage of the color previously seen.

We have two types of afterimages—positive and negative. When the afterimage is the same as the color viewed it is termed a **positive afterimage**. A positive afterimage usually occurs on immediate observation and is the result of different colored lights. When the afterimage is seen as the complementary hue of the observed color area it is termed a **negative afterimage**. A negative afterimage occurs immediately after a color is observed and requires more than an instant glance. It also occurs when viewing strongly colored surfaces and in this situation the reaction is more immediate.

The eye "looks for" the complementary hue of any color it sees, and this phenomenon serves as the basis for successive contrast and simultaneous contrast. The complementary hues that we see are those shown on the Munsell wheel. We know that each pure hue "demands" its opposite and that if this hue is absent the eye will produce it, so that any adjacent hue will be tinged by its complementary. In short, the adjacent hue will take on a tonality of the afterimaged hue. If two hues of extremely contrasting light and dark value are placed next to each other, as they move away from each other the light hue grows darker and the dark hue grows lighter. This interaction occurs only when hues are used; black-and-white images do not diminish each other because they are neutral colors.

Since a hue afterimages its complementary, a yellow object seen on a white background will make this background bluish. A yellow object on a green background will cause the green to be bluish-green and the yellow to be very cool. Also note that white will afterimage black, and black will afterimage white: afterimaging is the result of color seeking its opposite. However, if we outline an area in black or white the afterimage effect is reduced or completely stopped.

This becomes especially important when dealing with like or related hue areas. In order for the closely related hues to remain individual, black or white outlining must be used. Without this outlining the variations in hue will cause a feeling of depth because of visual fusing. When white or black outlining is used, it absorbs the afterimaging that occurs and allows the adjacent color to be unaffected. Keep in mind that only pure hues and their light or dark tints will impart an afterimage. Broken colors and broken hues will not afterimage because they contain some of all the hues of the color spectrum.

Middle grays or neutral colors are the most strongly influenced values. A middle-value gray or neutral will make hues adjacent to it appear stronger; in addition, the gray or the neutral will become tinged with the complementary of the hue. Therefore, a hue surrounded by gray will seem more colorful. When one attempts to change gray, the area covered plays an important part. When the gray is a large area surrounding a small area of pure hue, the gray will not change because there is not sufficient pure hue to impart a strong enough afterimaging effect. The smaller the area of gray, however, the more easily it will be influenced or changed (fig. 11.2).

Two or more hues are harmonious if their mixture yields gray or a neutral. An example of this can be seen at the middle mixture of an intensity chart (see fig. 7.3). Combinations that do not yield gray or a neutral have greater impact and visibility. Thus complementary combinations are harmonious because their result is neutral or gray. This fact makes sense because when complementary hues are employed, the color spectrum, from the eye/brain's point of view, is completed—nothing is missing, and this is what the eye seeks. Hues can be made harmonious by surrounding them with a neutral. When working with afterimages keep in mind that the reaction spreads to only a limited area. Therefore, quantity of color area plays an important role. The quantity of the color that is afterimaging must be larger than the influenced area.

Simultaneous Contrast

The eye requires the complementary hue of any color it sees, and this imposition and enhancement of color onto an adjacent area of color is known as simultaneous contrast. If we have green next to gray, the gray becomes reddish gray. Simultaneous contrast can also affect shading. Successive contrast is con-

11.2 The influences on gray. This composition shows how small areas of gray can be subtly influenced by larger areas of a surrounding hue. The grays on the shirts moving from left to right have taken on yellow-green, blue, and red tinges respectively. Courtesy Elaine Brodie.

cerned with afterimaging of hues; simultaneous contrast is concerned with the interactions that occur between hues, broken hues, and neutrals.

The eye compares colors with their surroundings and in the process colors are affected by these surroundings. Simultaneous contrast is the result of afterimaging and we may predict these afterimaged hues by equating them to the complementary pairs on the Munsell color wheel. When we do this we note that the same color will appear differently when it is surrounded by different colors. As with successive contrast, outlining halts the simultaneous contrast effect by creating closed areas and serving as a barrier between color boundaries. Interactions can also be stopped by adding the afterimaging hue to the color that is being influenced. Even a slight addition will usually work.

Achromatic Simultaneous Contrast

There are two types of simultaneous contrast—achromatic and chromatic. **Achromatic simultaneous contrast** concerns itself with black, white, and grays. We find that when grays are placed on black or white backgrounds their value undergoes a change. Middle-value gray is darker on a light background and lighter on a dark background (see fig. 6.7).

Light values, as well as hues, will appear lighter on a dark ground. When gray is placed on a white surface it appears darker, and in fact a value surrounded by a lighter value will always appear darker and vice versa. Black makes adjacent hues appear lighter. When we put white on a black ground we find that the white area appears to be larger than a black area on a white background because white spreads and black, by contrast, contracts.

White weakens the luminosity of adjacent hues, making them appear darker. Red is relatively dark on white, warm and luminous on black. Blue on white appears darker and the white becomes brighter, while blue on black makes the blue appear more brilliant.

Chromatic Simultaneous Contrast

Chromatic simultaneous contrast concerns itself with hue changes that occur due to the influence of the surrounding hues. Here similar concepts apply to those we have noted in our discussion of achromatic simultaneous contrast.

If one is knowledgeable about simultaneous contrast, it is possible to make colors behave in predictable ways. If, for example, we wish one color to behave as or appear to be two colors we should present it against two different backgrounds and make it a middle mixture of the two backgrounds. The separate areas of this "comparative color" should not be placed close together and should be rather small for the effect to work: if they were close together they could be more easily compared and seen to be the same (fig. 11.3). Now we see that the artist no longer has a limited palette of colors. A hue or color can be altered by placing it within another color ground. What color ground you use will depend on how you wish your hue or hues to change. This interaction is based on the fact that a surrounding color will subtract itself from any hue that appears on it. If we put orange on a yellow background and a red background, it will appear to be redder on the yellow ground and yellower on the red ground. This is because, in the first instance, the vellow is subtracting the yellow from the orange, resulting in a reddish orange; and in the second, the red is subtracting the red from the orange, resulting in a yellowish orange. Be aware that the color mixtures must be a middle-value mixture as well as a hue mixture.

It is also possible to make two different colors appear to be the same color by placing them on two different, carefully chosen colored grounds. This interaction is also based on subtraction (fig. 11.4). Using the same yellow and red backgrounds, for

11.3 (*left*) One color like two colors. In order for the small circles within each pair of large circles to appear different from each other in color, their color must be an *equal mixture* of the colors of their large circles (as shown in the single small circles below).

11.4 (right) Two colors like one color. In order for the small circles within each pair of large circles to appear the same in color, their color must be an unequal mixture of the colors of their large circles (as here shown in the pairs of single small circles below).

example, it is possible to have a yellow-orange on the yellow ground and a red-orange on the red ground appear as the same color when their mixtures are correct. Here the colors are mixtures of the grounds but favor one or other parent. The mixtures depend not only on the hue mixtures but their values as well.

The important point to remember here is that if you wish a hue or color to remain the same throughout a work, the grounds—the adjacent hues or colors or the surrounding hues or colors—must remain the same. When this is impossible, outlining should be used instead.

When working with intense versus less intense hues, the most intense color dominates and washes over the less intense color. If we put an intense or pure red on a dull green, the red will become more intense. Conversely, if we put a dull hue on an intense background it will appear less intense—it becomes duller (see fig. 7.9). It must be noted that when a shade is put on a pure hue, the pure hue will subtract itself from the shade, changing its appearance.

11.5 The Bezold effect. The yellow and orange colors are the same in all three compositions. The completely different effects created in the left-hand and middle examples by the simple addition of one extra color (in this case black and white respectively) is known as the Bezold effect. Courtesy Danielle Pompeo.

Bezold Effect

A nineteenth-century rug designer, Wilhelm von Bezold (1837-1907), found that he could alter the entire appearance of his rug designs by simply changing a single color. This concept became known as the Bezold effect. Ralph M. Evans termed this color interaction the "spreading effect." When black or white or a pure hue (at full intensity) are used in an even distribution throughout a composition, the changing of one results in a completely different perception of the composition overall. When white is employed the entire composition seems to take on a light tonality, since the white seems to "wash" over the area. Black produces a darkening tonality. Therefore, the use of a naturally light pure hue will impart a light effect and vice versa. We find also that light-value areas seem larger than when they are rendered in a dark value (fig. 11.5).

When unequal quantities of hues are employed, the greatest and most dramatic Bezold reaction occurs when the dominant color used in the composition is changed. Dramatic change also occurs when a contrast between hues and values of hues is present. The Bezold effect is most useful to interior designers when working with fabric, wallpaper, and rug designs. A review of the concept of orders in the chapter on value (pages 45–48) will greatly help in implementing this effect.

OPTICAL MIXING

Optical mixing is the result of two or more colors mixing visually to "become" another color. Optical mixing may most usefully be employed to expand a sometimes limited palette. It also allows one to impose luminous or glowing effects on a work.

Equal values of hues will visually merge and form visual mixtures. The lighter the value and the more contrasting the hue combination, the more difficult it will be to obtain an equal value merging. Similar or analogous hues can also merge, especially if they are close in value. These visual mixtures are usually

brighter than the brightest of the hues that are being visually mixed. These mixtures usually appear to be lighter in value as well.

When complementary hues are used the simultaneous contrast effect is not in play; the hues will not change but simply intensify each other, and a more intense color line of each of the hues will appear to form at their juncture (see fig. 7.4). When these complementary hues are the same value they will impart a vibrating effect, and a black line will appear to form where they meet.

In optical mixing, the separate colors are set side by side, rather than pigments being mixed together, and the eye blends or fuses them. This is termed **divisionism**. Divisionism, which can be executed with parallel lines or crossed lines of different hue as well as with dots, often has a ground beneath the colors other than white. Divisionism done in dots of color always has a ground other than white (**figs. 11.6**, **11.7**). When dots of color are used on a white ground, the divisionism is known as pointillism. In either case, the backgrounds alter our perception of the colors on them. Divisionism is the result of simultaneous

11.6 Optical mixing as divisionism. The artist has painted red, orange, blue, and white dots onto a flattened broken-red, black, and broken-yellow ground. The outline in white dots helps to silhouette the figure. Courtesy Deborah Scott.

11.7 Georges Seurat, Sunday Afternoon on the Island of La Grande Jatte, 1884–86. Oil on canvas, 81×121 in (207×308 cm). Art Institute of Chicago. Helen Birch Bartlett Memorial Collection. Seurat created his pointillist painting by scientifically choosing colors and building up layers of dots. In the process he intensified contiguous hues and allowed the eye to fuse the separate dots into broad areas of color. The result is a rich and shimmering painting

11.8 A pointillist composition. The artist uses the three pure hues of yellow, red, and blue as repeated dots against a white background. Different combinations of the pure hues reveal colors such as red-violet, orange, blue-violet, and green. Courtesy Elly Madavi.

contrast and optical mixing; pointillism is the result of optical mixing. The artist must be aware of the fact that "dots" can be individual shapes and do not have to be small circles (fig. 11.8). To achieve good results we must keep a number of factors in mind:

- the Munsell color wheel—here we are concerned with what happens when colors are placed side by side
- the value of the hues employed
- the intensity of the hues employed

- the quantity of the hues employed
- the viewing distance and lighting conditions.

When dots of hues are used, they tend to fuse together visually and take on a gray cast. Pointillism, a term derived from a Postimpressionist art style in nineteenth-century France, is most often seen in the works of Claude Monet, Georges Seurat, Paul Signac, and most recently Chuck Close and Arthur Hoener (figs. 11.9, 11.10). Pointillist pictures have white backgrounds. When dots of analogous colors (those

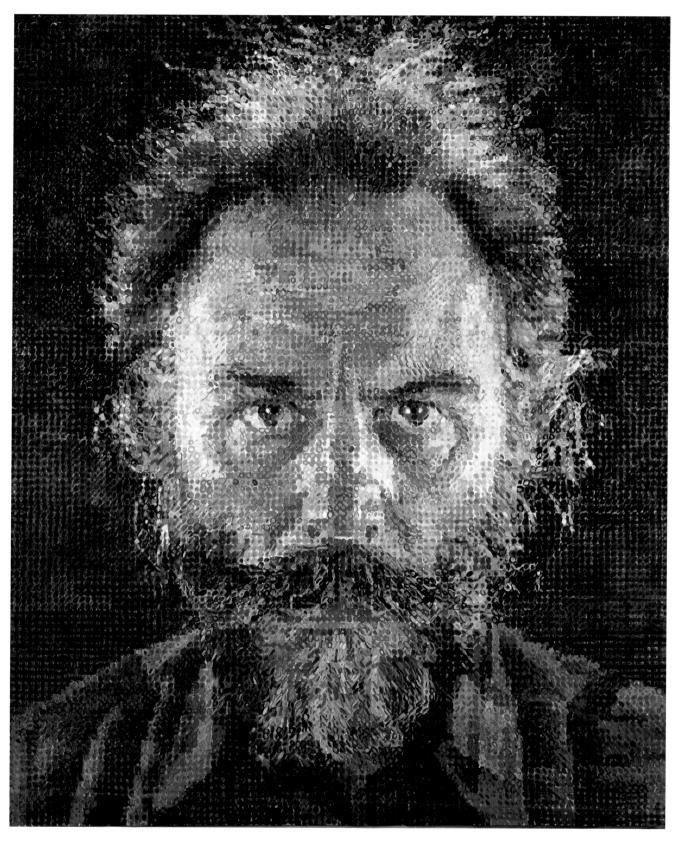

11.9 Chuck Close, Lucas I, 1986–87. Oil on canvas, 100×84 in $(254 \times 213.4 \text{ cm})$. Metropolitan Museum of Art, New York. Purchase. Gift of Lila Acheson Wallace and Gift of Arnold and Milly Glimcher, 1987. The direction of the elliptical "dots" imparts texture to the composition. As the distance between the viewer and the painting increases, so the optical mixing will become more apparent.

11.10 Detail of 11.9. Close divides his imagery into a grid system, which he then fills with colors. Over those colors he paints elliptical shapes consisting usually of two other colors.

adjacent to each other on the color wheel) are juxtaposed, luminosity and new hues result. When dots of complementary colors are used the resulting colors are luminous gray mixtures. The color dots that the Impressionists used were usually pure hues (see figs. 11.6, 11.7, 11.8, 11.9, 11.10).

When working in these styles keep in mind that the proportions of the hues used impart a variety of optical fusing effects. The proportional use of color is, therefore, important. If two hues are of equal intensity, reduce the quantity of the warmer of the hues. Red and green are equal in their proportional notation, therefore the red, as the warmer, would be used in a small quantity. If two hues are of unequal intensity, reduce the quantity of the brighter. Yellow has a notation of 9 while violet has a notation of 3; therefore the yellow, as the brighter, would be used in

a smaller quantity. The complementary pair of hues that are both the same brightness and are neither warm nor cool is green and red-violet. These can be used in equal quantities in optical mixing.

Let's look at what happens when we place two complementary hues from the Munsell wheel next to each other. We know that hues afterimage their complementary. As a result, we can often observe a third color appearing along the abutted edges of the two hues after staring at them for more than thirty seconds. Remember, these should be pure hues, not broken; the afterimaging illusions cannot take place between broken hues since they contain all the components of the spectrum (see fig. 7.4). We also know that if two complementary hues are of the same or similar value a vibrating illusion will occur. Along with this reaction we should see a third line of color

appearing at the juncture of the two hues. Let's say we use yellow-green and a light-value violet; the resulting color will be a blue that tends toward cyan. Orange and light blue will impart a light-value violet. The remaining Munsell complementary pairs will form a black line which will have a shimmering, luminous effect. Optical mixing occurs because the brain wants to get rid of the disturbing effect of the **visual vibration** and creates an outline to halve the vibration effect. This reaction works best when the quantities of color used are disproportionate.

Another approach to optical reaction was taken by Josef Albers in his "Homage to the Square" series (fig. 11.11). Albers often worked with analogous hues. The analogous grouping of orange, red-orange, and red gives us a parent hue of red for this grouping. If we were to use blue and green we would end up with a blue-green as the "middle mixture," so our analogous grouping here would be blue, blue-green, and green, with blue as the parent hue. Albers used this middle mixture concept to enable colors to interpenetrate each other. Let's suppose we had a square of redorange within a square of red that is within a square of red-violet. The red square will form a band around the red-orange, but where the red (which is the middle mixture) meets the red-orange an illusion of red-violet will appear along the edge, and where the red meets the red-violet an illusion of red-orange will appear along the edge. Here the laws of color subtraction are put into play. The color seems to be subtracting its own color from adjacent colors. We find that value comes into play here too. The middle mixture of a light value and a dark value will be a middle value. If we have a dark-value square (black) on a middle-value square (middle-value gray), which in turn is on a lightvalue square (white), we find that where the middlevalue gray outlines meet the white a dark outline will be visible, and where the middle-value gray meets the black a light outline will appear. Albers felt the quantity or area size of a color had a bearing—it must be considerable for interpenetration to happen.

Up to now we have dealt with *areas* of color next to each other. Now we will look at what happens when *lines* of color (divisionism) abut and/or intersect and *dots* of color (pointillism) are placed on or near each other. We obtain reactions only when these compositions are viewed from a distance. When unlike colors are placed near or on each other the resulting retinal fusing gives us a new color (see figs. 11.6, 11.7,

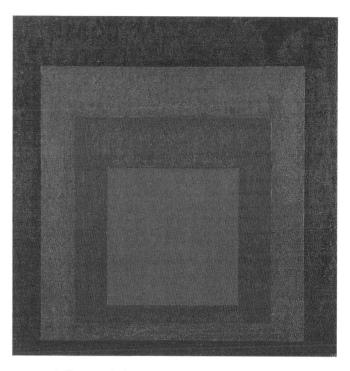

11.11 Josef Albers, Study for Homage to the Square, 1968. Oil on masonite, 32×32 in (81.3 \times 81.3 cm). The Sidney Janis Gallery, New York. In his Homage to the Square series, Albers explored the effects of interpenetrating colors. He carefully developed combinations of analogous hues. As he progressed with the series, he employed more contrasting colors.

11.8). The degree of believability of these newly formed colors is dependent on how close in value the two hues are. The closer the value is, the more credible the change will be. The ground hue that is beneath the hues should be light—white or close to white. Let's look at yellow and blue. Used at full intensity we find the yellow to be very light while the blue is dark. On a white background the blue takes over and the mix is not very obvious. However, if we discord the blue (reverse its natural order and make it lighter) we find that the optical mixing produces a yellowish green. Yellow and orange, on the other hand, mix very readily because they are naturally close to each other in value at full intensity. Quantity of color has a great bearing on this reaction—the quantity should be close to equal and in very small amounts that are repeated. The illusionary colors obtained from optical mixing have a luminous quality. This luminosity was the desired effect that the Impressionists found they could not achieve with pigment mixture.

As we pair hues with every other hue around the wheel we find some strange things happening with certain combinations. Arthur Hoener took this premise and applied it to his work. Like the color theorist Harald Kueppers, he proposed orange, green, and violet as primaries instead of the familiar red, vellow, and blue. He found that orange and green optically mix to produce yellow, green and violet produce blue, and violet and orange produce red. Hoener termed this optical mixing system synergistic color. However, the optical mixing with synergistic color relies on the proportion of the colors used. The new color or hue will be the result of the two hues visually fusing and this hue will tend to the hue that is in the greater quantity. The interaction occurs most easily when the two hues used are similar or equal in value, and when the two are light in value strong visual fusing occurs. This interaction also depends greatly on the ground color. If we put dark hues on white they will appear to be almost black and literally lose their color identity. If we put a medium-value hue on white, the hue stays stable and simultaneous contrast is the result. When a light-value hue is on a white ground the eye reaction is diminished and the color becomes energized. However, when light values and medium values are placed on a gray background the synergistic color interaction is at its best (see figs. 11.6, 11.8, 11.9).

Phantom colors result from spreading colors that tint neutrals with their hue. This interaction works best on a white background. The white ground will become a pale value of the hue, thus creating a phantom color. The phenomenon is most dramatic when lines of hues have a rough or serrated edge and there is little space between them. For this effect the colors must be repeated across the area (see fig. 11.8).

Optical mixing of colors can change the appearance of a background. The more a background surface is fractured by another color, the more it is altered. Therefore, if we use dots of one hue in one area and dots of another hue in another area, the backgrounds of the two areas will appear different, even though they are the same.

Concepts to Remember

Every pure hue afterimages its complementary hue and thus tinges any adjacent color with this afterimage. These interactions are based on Munsell complementary hues. Afterimaging, or successive contrast, can be halted by the use of

- outlining, which allows the pure hues to remain individual.
- Simultaneous contrast occurs when colors interact with each other, changing colors that are side by side. Outlining halts such interactions in a partitive setting, as does the addition of Munsell complementary pure hues.
- The two types of simultaneous contrast are achromatic and chromatic. As simultaneous contrast is based on subtraction, knowing the components of a color allows us to predict what will be subtracted from that color and the degree of change that will occur in both color appearance and value.
- The Bezold effect can allow for the same hues in a composition to impart a different visual result when one hue is changed in ensuing identical compositions.
- The interaction that occurs from optical mixing of colors relies on the values of the colors employed, their relationship to each other on the color wheel, their intensity, and the quantity employed. The effects of visual fusing can be predicted by employing the concepts of simultaneous contrast, especially when attempting to achieve divisionist effects.

Exercises

- 1 Do a composition consisting of gray and a hue or hues so that the gray appears to be a color other than neutral gray. Refer to figures 11.1 and 11.2.
- **2** Do a composition in which one color appears to be two. Refer to figure 11.3.
- 3 Do a composition in which two colors appear to be the same. Refer to figure 11.4.
- 4 Using the same design, render it in three colors identically, except that the third color in one is black, in one it is white, and in one it is a third hue or color. Example: (1) red, green, black; (2) red, green, white; (3) red, green, blue. Refer to figure 11.5.
- 5 Do a non-objective composition of lines, dots, or marks that employs optical mixing. Use a maximum of three hues.

Color and the Effects of Illumination

Color is the result of light, and different types of illumination—sunlight, twilight, candlelight, strip lights—create different color effects. This chapter examines how different effects of illumination—the creation of shadows, changes in time and the weather, the appearance of luminosity, iridescence, and luster—can be conveyed in artworks.

As we have seen in our discussions of value, light-value compositions impart feelings of illumination. Indoor and outdoor lighting has a great bearing on values and hues. Different lighting conditions affect hues in many different ways. Red, orange, and yellow appear darker in reduced light, while blue and green look lighter. Black takes on a gray appearance in bright white light or daylight. In strong light, lighter pure values seem more intense; in dim light, dark-value pure hues seem more intense. Keep this in mind when selecting the values for a work. Also keep in mind that fluorescent light not only distorts intensity but the actual hue as well. View your work in both intense

and reduced light to make sure it still imparts the reactions desired.

SHADOWS

To begin our discussion of shadows, we must first take a look at what shadows do to aid our perception of an object. Their most apparent function is to transform a shape, which is flat, into a solid object. While outlining can visually impart volume, it does not offer further information concerning light sources or the density of the object. To obtain this information we must add the detailing that shading and shadows provide. We have already seen how chiaroscuro accomplishes this (see page 41). Shadows also allow the artist to define space and spatial relationships as well as to create a mood. When working with shadows we must be aware of the fact that they are created by the absence of light. The depletion of light can be in various degrees, from deep to pale shadows (fig. 12.1). We also need to understand how the light angles affect

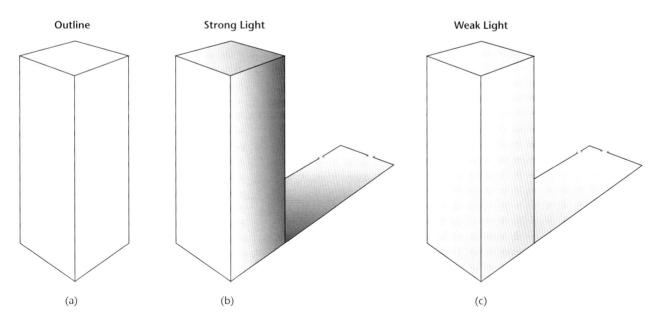

12.1 An object as an outline (a); strong light and deep shadows (b); and weak light and light shadows (c). We perceive volume in (a), while in (b) and (c) we detect volume, light source, texture, density, space, and mood in different degrees.

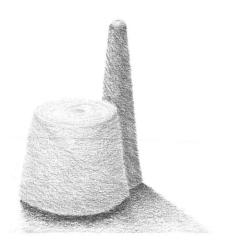

12.2 Light and shadow. The shadow hue (blue-violet) has been chosen as the complementary hue to its ostensible light-source hue, yellow. Courtesy Marianne Hauck.

the shadow angles, and how shadows are cast onto neighboring images and objects.

For the rendering of shadows to be believable, the color changes that occur must match reality. For example, the shadow takes on the complementary color, from the Munsell color wheel, of the illuminating light. Hence yellow sunlight will result in shadows with a blue-violet tonality (figs. 12.2, 12.3). This tonality must then be combined with the surface color that they are filmed over as well as the reflective colors of the objects. So the shadow cast by a red object must contain the complementary hue of the red—which should tend toward the red parent—as well as the color of the surface the shadow is resting on and the complementary hue of the illuminating hue. A red object resting on a blue table would cast a

12.3 Pierre-Auguste Renoir, Le Moulin de la Galette, 1876. Oil on canvas, $51\frac{1}{2} \times 69$ in $(131 \times 175$ cm). Louvre, Paris. Throughout this painting, Renoir has juxtaposed the yellow of sunlight with its complementary hue, blue-violet, for shadows. These combinations are especially noticeable on and around the dancing couple in the left foreground and on the hats of the men on the right.

shadow that would contain red plus blue-green plus blue plus orange. The more light that hits an object, the more the color of the surface will appear or favor the pure hue or the pure hue plus white. When the light is strong the shadow will be most like the complementary hue of the object casting the shadow. One may work in one of two ways to indicate the shadow's color—changing the hue by physical mixing of pigments, or optical mixing.

There are various types of shadows: cast shadows, perspective shadows, texture shadows, and fabric/fold shadows. Cast shadows are the result of an object blocking the path of the light source. The type of shadow cast depends on whether the object casting the shadow is solid or transparent. A transparent object does not block as much light; the resulting cast shadow is, therefore, a subtle echo or repeat of the overall form of the object casting the shadow. In this case gentle gradations in value are used, and the cast shadow is given a hint of the color of the surface that the shadow is cast upon. One must keep in mind that the purpose of a cast shadow is to impart to the viewer not only the contour or shape of the object but also its volume.

Solid objects cast stronger shadows because by their nature they are obliterating light. Furthermore, there is generally a difference between shadows cast by man-made objects and those by natural ones. The shadow cast by a man-made object is usually hardedged and sharply defined.

Other factors to be considered include not only the angle of the cast shadow but the strength of color used. For example, a shiny surface is indicated by wide contrasts between the object and the cast shadow (see figs. 10.2, 10.8, 12.3).

Lighting also affects how a shadow is perceived. Strong light that comes from overhead, such as a noon sun beating directly down, results in a shadow that is dark or heavy as well as truncated. In such cases the detailing on the object is more sharply defined. If, however, the light source is weak and coming from a low angle, such as at dawn or sunset, the shadow is not only extended but graduates from dark at the object to light at the termination of the shadow. When the light source is strong but coming from the side, the contrasts on the shadow as well as the object are weak and the shadow is composed of unevenly dispersed color (fig. 12.4). An object lit from below is lightest at its bottom (closest to the light source) and

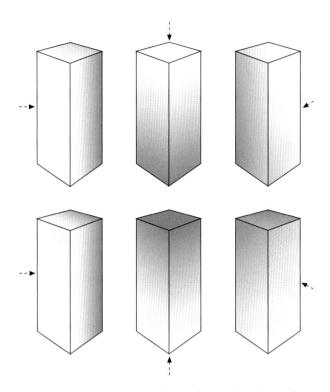

12.4 The way that shadows are dispersed around an object tells us about the source and type of light.

gets increasingly dark toward the top. These shadows are evenly dispersed, and while detail is lost, areas in relief become powerful. This arrangement can provide a very sinister or evil effect, especially when the object in question is a human face (see fig. 10.21).

Objects that are white, gray, or black cast gray shadows when they are on a white background; if, however, you wish to show that these objects are being illuminated with warm light, the shadows should take on a cool or blue tonality.

Perspective drawing serves to establish space within a work. In addition to having images and/or objects drawn in correct perspective, we must make sure that the same applies to the shadows they are casting. To this end, perspective shadows must be plotted by drawing guidelines from the light source across the horizon and through the object to establish how they are cast. The steps for accomplishing this are as follows:

- Mark the position of the light source (which may be in or out of the picture plane) and note its direction.
- **2** Draw a vertical line from the light source to the horizon line.

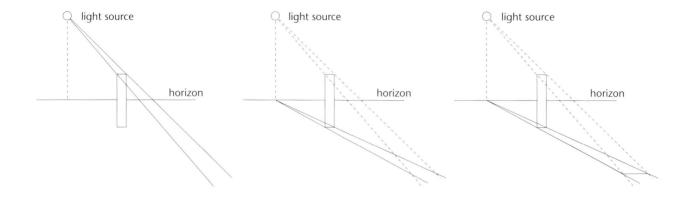

12.5 Shadow plotting steps. In order for shadows to look convincing, the steps in this diagram should be carefully followed.

- 3 Draw lines that connect the light source and the top of the object and extend these angled lines beyond the object.
- 4 Draw lines that connect the junction of the vertical line on the horizon and the bottom of the object and extend these angled lines beyond the object.
- 5 Plot out the correct angling of the shadow where the angled lines meet (fig. 12.5).

We must remember that the value of the shadow becomes lighter as it moves away from the object. Thus the darkest values of a shadow will be found close to the object and these values weaken as the shadow moves away from the object.

Not all shadows are cast across a smooth uninterrupted plane. Often shadows form a distorted silhouette of the object. These distortions can be noted most easily by using a large number of plotting lines when forming perspective shadows. The resulting intersecting lines will provide the amount of silhouette distortion needed. If we further distort any shadow by elongating or exaggerating it we find that spatial distance is greatly increased. A change in a shadow's angle usually results in elongation of the

shadow. This becomes most apparent when a shadow is cast across a flat surface like the ground and meets a right-angled surface such as a wall. In such cases we must revert to our design studies of drawing various objects onto changing grids:

- Plot the shadow as though it were cast across a flat surface.
- **2** Impose a simple grid onto the shadow.
- 3 Draw a second grid that shows the angle of change that the shadow will go through.
- 4 Plot the first shadow grid image onto the second grid, thus forming the angled shadow (see fig. 12.5).

Using this type of grid-plotting we see that we are able to plot shadows traveling across any type of surface, be it angular, curved, or a combination of the two, by employing rectilinear, curvilinear, or combination grids. Keep in mind that when a shadow is cast onto another object it follows the contour of that object.

In addition to depicting the shadows that an entire object or image casts, we must also be aware of the shadows that occur on the surface of that object. These texture shadows provide the additional

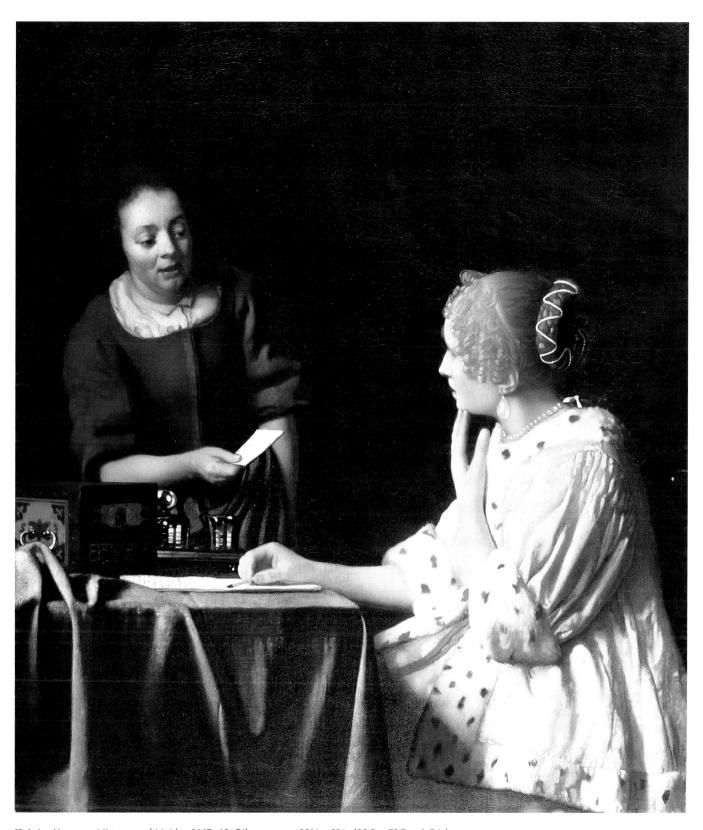

12.6 Jan Vermeer, Mistress and Maid, c. 1667–68. Oil on canvas, $35\frac{1}{2} \times 31$ in (90.2 \times 78.7 cm). Frick Collection, New York. The folds of the tablecloth reveal progressions of dark to lighter hues ascending from the base to the tabletop, from blue-violets to blues and grays. Similarly, the folds of the mistress's yellow garment reveal ascending progressions from darker to lighter values.

12.7 Stuart Davis, New York Mural, 1932. Oil on canvas, 84 \times 48 in (213.4 \times 121.9 cm). Norton Museum of Art, West Palm Beach, Florida. Purchase R.H. Norton Fund. Davis uses a number of pure hues and sharpedged shapes to convey the excitement of New York City on a bright day. A white wavelength predominates in the sky around noon, and the amount of white showing in the "sky," against the buildings, and in the foreground suggests that this is the time of day.

12.8 Paul Gauguin, *Three Tahitians*, 1898. Oil on canvas, $28\frac{3}{4} \times 36\frac{5}{8}$ in (73 \times 93 cm). National Gallery of Scotland, Edinburgh. The yellow background suggests that this is a hot, dry day on Tahiti. The warm violet and red hues contribute further to that feeling of timeless luxuriance emanating from Gauguin's Tahitian paintings.

descriptive information needed to impart the surface qualities of the object being viewed—its texture and any dips and folds seen in its form. For example, we must consider the contours of a human nose as well as the way it protrudes from the face. One good rule of thumb is that the greater the depth of a surface, the darker the values of the shadows will be.

When there is a wide difference or high contrast in the highlight on a fold, the eye tends to interpret the object as smooth and shiny. Rough fabrics would graduate more gently from the highlight to the light area surrounding the highlight. The lowest part of the fold has the darkest values and becomes lighter and lighter toward the top of the fold. The darker the value, the deeper we perceive the fold to be (fig. 12.6).

TIME AND WEATHER

How the time and the weather are conveyed in artworks is to a great extent a function of the lighting. Time encompasses a number of situations, such as time of day (sunrise, morning, noon, sunset, night) or season (spring, summer, fall, winter). Weather also covers different categories, such as conditions (sun, rain, sleet, mist, snow) and location (Southwest, Arctic, tropics, city, country). Our memories and experiences also come into play when imposing time and weather conditions onto a work. We tend to use color in a manner that we think is familiar to us. Stuart Davis employs brilliant, intense color to express his feelings about the physical and emotional atmosphere of New York City (fig. 12.7). He sees New York as exciting, with

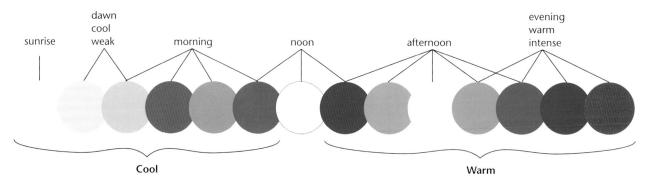

12.9 Light rays related to the time of day. Cooler green-blue colors predominate in the mornings, but warmer orange-red colors feature in the late afternoons and early evenings.

hard, sharp edges and shapes. If Davis had used the color relationships that Gauguin selected for his Tahitian paintings (fig. 12.8), the results would appear totally foreign. We do not think of New York in terms of the warm colors that Gauguin used in many of his Tahitian works.

Conditions of time and the weather change as the earth spins on its axis round the sun. The angle of the sun causes certain wavelengths to predominate depending on the time of day. Blue is dominant in the morning, going to white at noon and red in the late afternoon. Thus at dawn green and blue appear first, then a pale red appears, progressing to full-noon sun that pales colors and causes them to take on a white tonality. At dusk the blue and violet rays are weaker and red and yellow predominate, causing the clouds and sun to appear red or yellow. This in turn causes yellow-green objects to take on an orange tonality because they are reflecting the red and yellow rays. Blue and violet objects, on the other hand, appear to be darker and duller because they do not reflect the red or yellow rays. As time moves on to sunset, red becomes the dominant hue. These changes in wavelength dominance affect the surface colors we see (fig. 12.9). We must be careful not to let our memory take over and say simply, "The barn is red." We must observe what happens to the red barn in morning light, at noon, and in the late afternoon. In the morning the barn will be a bluish red, at noon a lighter red, and in the late afternoon red. Remember these conditions apply in clear daylight. You must also take into account clouds, rain, smog, and so on. Tonality plays a very important role in conveying your message.

Color is best seen in sunlight. But that is clear sunlight without any dust, smog, pollution, or water droplets (rain or snow) disturbing the light rays. This beautiful clear sunlight is probably what attracted Georgia O'Keeffe to the Southwest-colors remained vibrant, undisturbed, and true in this unpolluted atmosphere (fig. 12.10). Azure (blue) and violet—both short wavelengths-are absorbed by the dust and smoke in the atmosphere, making them difficult to see in a pollution-laden sky; whereas snow will reflect these two hues, making them highly visible. Therefore, a snowy sky will have a predominance of blue and violet in it. We find that an azure blue sky is the result of little or no water present in the air and a predominance of blue and violet rays. Large particles of moisture reflect white light, which results in the sky becoming a very pale or light-value blue sky.

Optimum daylight is not bright sunlight but rather a slightly gray day. Full, bright sunlight tends to diminish hues and the colors fade or wash out under a whitish veil. Such changes in color brightness caused by lighting variations are known as the Purkinje effect or Purkinje shift. Czech physiologist Johannes Purkinje (1787–1869) stated, "in moderately bright light the red zones of an object appear lighter than the blue, but in very dim light the blue zones appear markedly lighter, although colorless, than the red, which instead becomes almost black." As the light diminishes to darkness the surface will become black. In sunlight we find that red and blue have equal intensity, but as the light or illumination fades it becomes less easy to discern whether the hue seen is red or black. Blue, on the other hand, will become more visible in the diminished light. So in evening light we find that blue

12.10 Georgia O'Keeffe, In the Patio I, 1946. Oil on paper attached to board, $29\frac{3}{4} \times 23\frac{3}{4}$ in (75.6 \times 60.3 cm). San Diego Museum of Art. Gift of Mr. and Mrs. Norton S. Walbridge. O'Keeffe painted a brilliant azure-blue sky immediately over the patio and large areas of near complementary orange-brown and plain, creatily off white throughout the painting. She emphasizes clean, geometric shapes, especially within the inner window area. The combination of flat areas of color and geometric forms conveys a feeling of both atmospheric and spiritual clarity inspired by the arid Southwest.

is more visible than red, bright orange becomes black, yellow becomes greenish or bluish, and violet slowly changes to black.

Film color (see page 84) is used to impart the effect of weather and atmospheric conditions on a piece. The types of interior lighting impose an influence over the colors present in the lighting situation. Incandescent light (candles, light bulbs, flashlights, torches, and gaslamps) cast a warm tonality over the surface that results in warm surface colors appearing brighter and cool surfaces appearing duller. Incandescent light seems to bathe an area with a yellowish glow. Fluorescent light casts a blue film of color that greatly alters surface hues. The brighter and stronger the light source is, the greater will be the contrast of values resulting from the illumination. High contrast also occurs when the light source is close to the illuminated object (see figs. 10.8 and 12.6).

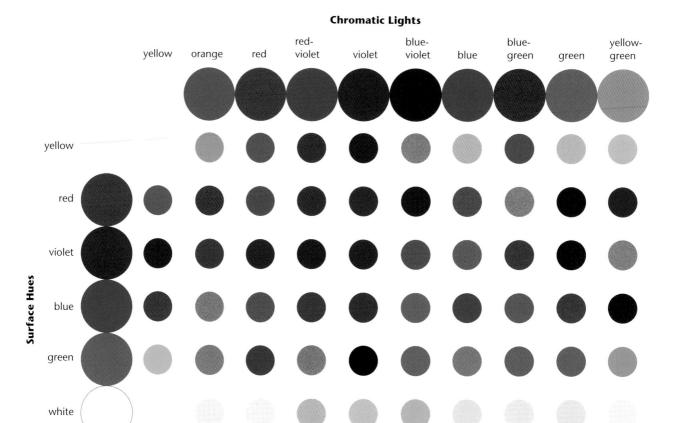

12.11 The effects of chromatic lights on different surface hues. Chromatic light mixtures change most dramatically when Munsell complementary hues are used.

CHROMATIC LIGHT

black

While simple solutions of tonality can serve to impart the sense of the time or weather that we wish to convey, we must also be aware of how colored, or chromatic, light can affect color on a surface, especially when that surface is the complementary hue (from the Munsell wheel) of the chromatic light. Mixing yellow and blue-violet paint results in a greenish color, but mixing yellow light and a blueviolet surface results in a neutral, or gray. The same applies to all the Munsell complementary hues. Figure 12.11 indicates roughly how the Munsell pure principal hues and secondaries are changed by various chromatic lights. It is most advantageous to make notes on how a surface color will be affected by chromatic light prior to rendering the imagery. Keep in mind that chromatic light may have varying

degrees of strength or weakness. When the chromatic light strength is very pure (strong), the surface colors will require a very strong tonality of that chromatic light for the effect to be realistic. If the chromatic light is weakened the surface color will become more predominant.

STRUCTURAL COLOR

Structural colors tell us what materials objects are made of. The same hue may take on many forms or modes of appearance—opaque, solid, filmy, atmospheric, three-dimensional, transparent, luminous, dull, lustrous, metallic, and iridescent, to name but a few. The artist tries to fool the eye into a familiar reaction or perception—it is an attempt to freeze and control one of these kinds of changing visual effects.

While it is true that these visual effects could be accomplished physically using such things as metallic foils, gems, and glass, it is not always practical or desirable to do so. Therefore, one must employ techniques that impart the visual illusions or perceptions desired.

Luminosity

Luminosity—the ability of color to give a glowing impression—might be seen as the effect of sunlight on snow; it can be seen in translucent objects, in water, sky, sunsets, in certain flesh tones, the glow of silk. The Impressionists were certainly striving for luminous effects in their works, and our studies of optical mixing showed that the technique of pointillism can often (but not always) reproduce this sensation.

Simple changes in certain hues can produce a luminous effect. The addition of black or white to red does not alter the fact that it is red. The same is true of blue—blue has little luminosity by itself and even the addition of a lot of white causes the blue to stay blue. Yellow, however, which is the lightest of the hues, does change its character when white is added—it becomes more luminous and radiant.

The luminous quality of a hue can be accomplished in several ways—one can, for example, surround a hue with dark values, or with its complementary hue. Dark or black outlining can add a glowing, luminous quality to an object (see fig. 10.13). Side-by-side complementary hues intensify and produce luminosity. Luminosity works with discord when the hues are the same value. We also find that to be luminous, areas need to be brighter than their surroundings. So contrasts between dull (less intense color) and pure hues will produce luminous effects. This should have become apparent from your broken hue compositions. We can set out the following method for achieving luminosity in a composition:

- 1 The area to be luminous must be smaller in size than its surroundings.
- **2** The area must be done in lighter values than those of its surroundings.
- 3 The highlight is the lightest value in the composition and the area is graduated in value from the lightest value.
- 4 None of the values used in the luminous area should be in great contrast to each other. Deep values should be avoided.

Luminosity with Neutrals

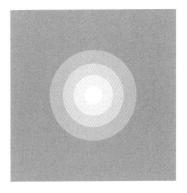

Luminosity with a Single Hue

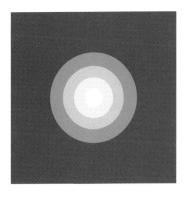

Luminosity with Multiple Hues

12.12 Achieving luminosity with neutrals, a single hue, and multiple hues. By graduating the gray and blue values from dark to light in versions (a) and (b), and by contrasting a bright but small area (white) with a dark but big one (dark-gray; dark-blue), the white circle and its nearest values become luminous. In version (c), although the small yellow area and the large green one constitute analogous hues, there is luminosity at the center through the strength of the yellow-white combination.

12.13 Claude Monet, Le Soleil dans le Brouillard, 1904. Oil on canvas, 25×36 in $(63.5 \times 91.4 \text{ cm})$. Lefevre Gallery, London. Monet achieves luminosity by contrasting the intensity and lightness of orange with its darker and less intense complementary hue, blue; rendering the sun and its reflections much smaller than the surrounding sky and sea; graduating the values of the sunlight from yellow-orange through to red-violet; and spreading the violet effects of the sunlight throughout the sky and sea.

12.14 Iridescence in nature. The artist achieves a sense of iridescence by employing a gray-light blue-dark blue background; outlining the butterfly in gray; highlighting its lightest areas in whites or off-whites; and silhouetting it against the darkest values in the background. Courtesy Deborah Scott.

5 The tonality of the area must appear to pervade the whole composition, as though such a light were casting its sheen upon the whole of it (figs. 12.12, 12.13).

White weakens the luminosity of adjacent hues and makes them appear darker. Red looks darker on a white ground, warm and luminous on black. Blue on white appears darker and the white becomes brighter, while blue on black makes the blue more brilliant.

When, as in divisionism, lines of color abut and/or intersect, and when, as in pointillism, dots of color are placed on or near each other, we should view them from a distance to obtain the correct reactions. The colors resulting from this type of optical mixing will have a luminous quality. The mechanics of this form of luminosity have been explained above (see pages 97–101 and figs. 11.6, 11.7, 11.8, 11.9, 11.10, 11.11).

Iridescence

Iridescence—a shimmering impression—is the second of the structural effects that we will explore. We think of iridescence in terms of opals, mother-ofpearl, soap bubbles, and butterfly wings. Iridescence involves the play of colors triggered by the movement of the object being viewed or by a change in the observer's position. It is usually caused by interference of light, but also by refraction and diffraction. An iridescent color appears to glitter with different colors according to the angle of vision, whereas standard colors look the same from any angle. In fact iridescence results from layers of color, and glazing can therefore be used to accomplish this effect. The largest challenge facing the artist is to reproduce this shimmering effect within a static framework (fig. 12.14).

Hues must have white added to them to achieve iridescence. The resulting tints, or so-called pastels, are associated with this effect, but require a gray field in order to work (fig. 12.15). The gray field is necessary because gray can (and often does) intensify a hue. (White is too strong and offers little contrast to pastels; black is too weak and offers too much contrast.) The largest area of the composition should impart an illusion of mist, which is accomplished by lightening and graying color. The hues placed on the field must be fairly close in value so that no great contrast exists. Using adjacent or analogous hues will further enhance the iridescent effect. Think of the

12.15 Achieving iridescence with neutrals, a single hue, and multiple hues.

green, blue, and purple hues in peacock feathers; and red hummingbirds that flash orange and violet. Broken hues generally do not achieve this effect.

One formula for accomplishing iridescence is as follows:

- the background is light gray or a hue equivalent in value;
- 2 the light area of the object is pure white or a very light value of a hue;
- 3 the object is outlined in mid-value gray or a hue equivalent in value;
- 4 the area within the object is graduated in value from white to mid-gray or equivalent hue values.

12.16 Achieving luster with neutrals, a single hue, and multiple hues.

Luster

Luster is the impression given by subdued light. The effect of luster can be seen by comparing various materials—silver is more lustrous than pewter, silk or satin is more lustrous than felt, polished wood is more lustrous than unfinished wood. To achieve this effect the artist needs to employ a dark field. When a dark field is used, the colors on top must appear to be very bright. Our previous study of color has shown us that when a hue is pure (when nothing is added) it is at its brightest. Luster can be easily created by contrasting pure hues with dark fields, which will make the hues appear brighter than normal (fig. 12.16). The effect becomes even more pronounced when the pure hues are surrounded by darker tints (pure hues with black added). In this situation the pure hues will appear to be brighter than they actually are and can take on a shiny, metallic quality. Luster also becomes more pronounced when the lustrous area comprises a relatively small part of the composition.

An arrangement of values that would result in luster could be similar to the following:

- 1 the background is medium dark gray;
- 2 the highlight is pure white;
- 3 the object is outlined in black;
- 4 the area within the object is graded in value from white to black (fig. 12.17).

Concepts to Remember

Shadows define the space of a composition and are capable of turning a flat shape into a three-dimensional object. There are various types of shadows: cast shadows, perspective shadows, texture shadows, and fabric/fold shadows. Shadows should contain the complementary (Munsell) colors of the object casting the shadow. The source of the light hitting an object influences the shading of an object, and the

12.17 Bruce Nauman, The True Artist Helps the World by Revealing Mystic Truths, 1967. Neon window or wall sign, $59 \times 55 \, \%$ in (150 \times 140 cm). Kröller-Müller Museum, Otterlo, The Netherlands. Nauman achieves luster by employing the pure hues of red, orange, and blue against the black background, and by allowing the properties of neon to reflect the hues off the wall so that they take on graduated light-dark values. The effect is one of tension between color trapped within a black vortex yet simultaneously defying and illuminating it.

- resulting shadows should be plotted to produce convincing results.
- An object's color does not remain constant; it is affected by time of day and weather. These conditions must be conveyed to the viewer of any work to provide the desired message. As the time of day progresses, the tonality of color added to the imagery's surface color also changes—cool in the morning, warm in late afternoon and evening.
- Chromatic or colored light is imparted by using a color mixture that changes the surface color of an image.
- Luminosity imparts a glowing effect or impression. This can be accomplished in a number of ways, for example by surrounding a hue with darker values, or with its complementary hue.
- Iridescence imparts a glittering, shimmering impression. This effect can be accomplished in a number of ways, such as glazing, layering, using pastel colors on a gray field, or grading the area in value.
- Luster imparts the impression of subdued light by contrasting brightness against a dark field, and by grading the object in value.

Exercises

- 1 Do a composition involving volume shading and shadows.
- 2 Choose an object and render it under five different conditions. These may be five different times of day, different types of light, or varying weather conditions. Label each.
- 3 Do a composition that imparts a time condition.
- 4 Do a composition that imparts a weather condition.
- Using the same composition, render it under three different chromatic light conditions.
 Refer to figure 12.11.
- 6 Using the same composition, render one achromatically and one chromatically imparting the sensation of luminosity.
- 7 Using the same composition, render one achromatically and one chromatically imparting the sensation of iridescence.
- 8 Using the same composition, render one achromatically and one chromatically imparting the sensation of luster.

PART IV

The Influence of Color

Color's most important functions are to provide visual and psychological information, and to generate reactions from a viewer. To this end, the artist, architect, or designer can provoke various responses and so become the controller of what that viewer perceives.

Man has historically represented intangible aspects to life with tangible imagery. An artist can influence a viewer's response very strongly through the use of color symbolism in religious imagery and in imagery reflecting nationalistic or cultural concerns.

Technological progress has accustomed us to superior color imagery wherever we look. We want to like what we see and technological breakthroughs have provided us with a visual utopia to match our dreams and desires.

Color Symbolism

Our emotions influence our perception of color. We often use expressions that include color to describe our feelings. We often say "I was so angry, I saw red," "I'm feeling blue," and "I was green with envy." Color even enters our business conversations, as in "red letter day," "in the red," "in the black."

HOW COLOR INFLUENCES LIFE

Colors can change their meanings over time with fashion, changing social awareness, and familiarity. Green used to be an unpopular color for automobiles. It was regarded as an unlucky color, which probably dates back to the nineteenth century when the arsenic-based pigment, Paris Green, a fashionable emerald green color, was found to have caused several deaths. People referred to the color as Poison Green. Modern-day environmental awareness has restored green's good name and brought it back into fashion, interior design, and packaging for commercial goods. Their names, too, can influence the ways in which a color is perceived. In 1962 Binney & Smith renamed the Crayola color Flesh as the less culturally charged Peach, and in 1992 the company introduced so-called "multicultural" crayons in many subtle variations of brown. Manufacturers of embroidery threads have stopped labeling their colors as "rose blush," "sky blue," and the like in favor of using numbers to identify colors. Familiarity can cause color changes in society. For instance, many road safety signs have been changed from yellow to fluorescent yellow or bright yellow-yellow-green to attract attention.

Color's most important function is to provide information, both visual and psychological. However, in providing this information color can create opposing reactions—the artist, architect, and designer must control what the viewer perceives. This influence on the viewer's perception allows the artists, architects, and designers to impart their messages be they aesthetic, commercial, or political. Providers of color images must keep in mind that color is seen by the viewer before, or it is hoped, simultaneously, with the imagery.

COLOR ASSOCIATIONS IN LANGUAGE AND EMOTION

Colors are not the same for everyone. Some languages do not contain separate words for green and blue, or for yellow and orange. The Inuit are supposed to have seventeen different words for white, as modified by different snow conditions. All languages, however, have words for black and white. If a third hue is distinguished, it is red. Next comes yellow or green—that is, the two hues can't be distinguished—and then both yellow and green. Blue is the sixth color named, and brown is the seventh. Finally, in no particular order, the colors gray, orange, pink, and purple are named.

Different colors have different associations for us.

Black, White, and Gray

These are the achromatic or neutral colors. Black is as dark as a color can get. It is also the absence of color (light) and all the colors combined (pigment) (fig. 13.1).

- Black's positive connotations include: sophistication (in fashion), power, the color historically worn by those who did not hold a rank or royal title but were respected members of society, being in credit (in business), space (infinity), and luxury.
- Black's negative connotations include: death, emptiness, depression, disapproval, foreboding, mystery, night, and bad luck. Black is used in the following expressions: black mark, things are looking black, black economy, black magic, blacklist, black sheep, blackball, black comedy, and black market.

White is the ultimate in lightness. It is all the colors combined (light) and, in watercolor painting, the absence of color, when the underlying paper shows through.

White's positive connotations include: purity, cleanliness, sterility, innocence, peacefulness, birth, and empowerment. It is used in the

13.1 Jean-Paul Gaultier, Paris Spring 2001 collection. Photographer: Giovanni Giannoni. Black is a symbol of sophistication in fashion, as shown by the appearance of this *haute couture* "little black dress" on the catwalk in designer Jean-Paul Gaultier's Spring 2001 show.

following expressions: white lies, white magic, white-collar worker.

White's negative connotations include: surrender, cowardliness, cover-up, and perversion of justice. It is used in the following expressions: white flag, white feather, and whitewash.

Black and white together equal authority and truth (written in black and white).

Gray is neither positive nor negative, and implies confusion, loss of distinction (gray area), age (dust, cobwebs, gray hair), intelligence (gray matter of brain), technology, shadows, and work (people in gray suits).

Red and Pink

Red is one of the oldest color names, is the first to be seen in a rainbow, and has the greatest emotional impact of all.

- Red's positive connotations include: love (red roses, red hearts), luck, passion (red-blooded), sexiness (red lipstick, red sports cars), festivity (Santa's clothing, red-letter day, from the red letters on calendars for holidays), importance (red carpet), compassion (Red Cross), dynamism, power, courage, and newness (red-hot news).
- Red's negative connotations include: war (red uniforms disguised blood from wounds), revolution and anarchy (red flag), prostitution (red-light district), the devil, danger, fire, debt (in business), and bureaucracy (red tape).

Pink's connotations are mostly positive: healthy (in the pink), pretty, feminine, sweet, and babyish. Sometimes pink is used disparagingly to describe a person with left-wing, but not necessarily extreme, political views.

Orange and Brown

Orange has been recorded verbally since the tenth century. Orange is present in nature, in the setting sun, in fall leaves, and in fruit and flowers. It stands out well and creates a sense of warmth and often behaves like yellow.

- Orange's positive connotations include: warmth, fruitfulness, brightness, cheerfulness, autumn, and spices.
- Orange's negative connotations include: brashness, danger (Occupational Safety and Health Administration (OSHA) coding). OSHA mandates that areas and parts of machinery be painted orange if they pose a danger.

Brown signifies earth, wood, coffee and chocolate, comfort, and security, but also gloom, melancholy, and boredom.

Yellow

Yellow is the most easily perceived of hues, with the highest luminosity rating after white. It is seen before other colors, especially when placed against black. This combination is often used as a warning sign—in

13.2 Monarch butterfly. This insect displays the yellow-and-black markings that serve as warnings to potential predators to keep their distance.

nature, by insects such as bees, and in industry, to signal hazardous situations (**fig 13.2**).

Yellow's positive connotations include: cheerfulness, sun, gold, happiness, vitality, hope, warmth, and optimism (yellow ribbon).
Yellow's negative connotations include: caution (traffic light), sickness (jaundice), betrayal, treason, age, and cowardice (yellow streak, yellow-bellied).

Green

Green is the largest color family discernible to the human eye, which is why our feeling toward green can be so varied.

Green's positive connotations include: environment, growth and renewal in spring, fertility (green man), freshness, nature (green thumbs), youth, health, peace and calm (green room in theater or television studio), things that are cool and refreshing, and wealth (greenbacks). Green's negative connotations include: poison, envy, inexperience and gullibility, immaturity, eeriness, nausea (green around the gills), rawness, sourness, jealousy (the green-eyed monster), and the alien (little green Martians).

Blue

In many cultures, blue is the color of spirituality. It means immortality in China, holiness in Judaism, and Krishna in Hinduism.

Blue's positive connotations include: royalty and aristocracy (blue blood), the best (blue ribbon, blue-chip stocks), heaven, coolness, truth, tranquility, conservatism (in apparel), loyalty and dependability (true blue), security, high technology (IBM is known as Big Blue), and things nautical (Navy blue uniforms).

Blue's negative connotations include: introversion, sadness, depression (the winter

13.3 Pablo Picasso, *The Old Guitarist*, 1903. Oil on panel, $48\frac{2}{3}$ x $32\frac{1}{2}$ in (123 x 83 cm). Art Institute of Chicago. Helen Birch Bartlett Memorial Collection. The predominantly blue tonality of this painting gives the subject its melancholy feeling.

blues) (**fig. 13.3**), and things that are cold (blue with cold), wintery, unexpected (out of the blue), low class (blue-collar worker), indecent (blue jokes), and censorious (blue pencil).

Purple, Violet, and Indigo

Purple is the hardest color for the eye to discriminate. It was originally made from a rare Mediterranean snail, hence cloth dyed purple was expensive and could be afforded only by priests and the aristocracy.

- Purple's positive connotations include: bravery (purple heart), aristocracy, spirituality, mystery, luxury, and royalty.
- Purple's negative connotations include: conceit, pomposity, mourning, death, and rage.

INFLUENCES OF THE DIMENSIONS OF COLOR

Just as specific colors or hues have different associations and emotional effects, so the other dimensions of color—value, intensity, and temperature—affect the viewer in different ways. When we speak of value the extremes of black and white come to mind. This combination produces the greatest clarity, and sharp contrast in values produces the effects of precision, firmness, and objectivity. Close values, on the other hand, produce haziness, softness, vagueness, quiet, rest, introspection, and brooding. Dark compositions impart feelings of night, mystery, and fear, while light compositions give feelings of illumination, clarity, and optimism. Dark values can

also seem quiet and subdued and can increase an object's perceived size. Middle values seem relaxed and less demanding and form combinations that are unnoticed. High intensities attract and give feelings of activity, and high-intensity backgrounds increase an object's intensity. Low intensities are quiet and subdued and are seldom noticed. Moderate intensities are also relaxed and undemanding.

Temperature affects our eye's interpretation of a composition. Warm hues suggest aggression, sunlight, heat, stimulation, cheerfulness, heaviness, and dryness. Cool hues imply sky, water, distance, shadows, quiet, lightness, and wetness. The hottest of the warm colors is red—often seen as the red family with red-orange offering the greatest heat. The coolest of the cool colors is blue, with blue-green recognized as the coolest. Warm colors advance toward the viewer; cool colors retreat into the distance. Our bodies physically react to color—warm colors will raise our blood pressure and even our body temperature; cool colors depress both blood pressure and body temperature and slow down our metabolism. Warm colors appear to advance toward the eye, making objects in those colors seem nearer than they actually are. A sofa in an intense red fabric, for example, will generally appear larger than the same piece in a cool color, such as blue. If the walls of a room are painted the same intense red, the walls will appear closer, decreasing the apparent size of the room. However, a very intense, bright cool color will seem to advance, but a dull warm color will recede (fig. 13.4).

13.4 The warm temperature of this fanciful child's room is achieved through the use of red tonality. The red is mixed with white to create a warm pink and is also added to all of the other colors in the room, especially the greens, adding warmth to them too. The natural woods used also impart warmth. The resulting effect provides a warm, cozy, safe feeling.

13.5 This modern parament set consisting of an altar frontal, chalice veil, and burse in the church of Mary Magdalen, Wandsworth Common, London, is executed in green for use during the liturgical seasons of Trinity and Epiphany.

RELIGIOUS AND CULTURAL COLOR SYMBOLISM

Humanity has historically represented the intangible aspects of life with tangible visualizations. **Symbolism** has employed color to impart messages in the religious, mystic, national, and cultural aspects of life throughout human history.

The Bible

The spectrum or visual array is mentioned in the Bible as the rainbow and symbolizes God's promise and His covenant with humanity. We also see the visual array mentioned in the breastplates used by the priests in the Ark of the Covenant and in Joseph's coat of many colors.

Christianity

In the New Testament of the Bible white represents the Lamb and Christ. Red and black are noted as representing chaos and destruction. Symbolic color usage by the Christian Church is first recorded in the Middle Ages, but historical research has shown some earlier customs concerning the liturgical use of color. During the ninth century black, purple, blue, yellow, and green were used for the vestment robes known as chasubles. The first use of order or sequence of colors appeared in the 1100s. Known as the "Jerusalem Sequence," the liturgical colors for the religious holidays or seasons were as follows: Advent-black; Christmas-red, white, gold; Epiphany-blue and gold; Lent-black; Easter-white; Ascension-blue; Pentecost—red. Feasts and saints' days were as follows: St. Stephen-red; Purification-black, Saints Peter and Paul-red; Feast of the Holy Cross-red. Following the Jerusalem Sequence, the Innocentian Sequence was put into practice during the reign of Pope Innocent III (reg. 1198-1216). White, red, black, and green were the colors used. The Sarum Sequences were put in place in England in the thirteenth and fourteenth centuries. The colors recorded are now reduced to two-red and white. In the seventeenth and eighteenth centuries color sequencing was formalized by the various Christian Churches, and this usage remains much the same today (fig. 13.5). Since World War II the sequences and symbolism inherited from the Middle Ages are being abandoned, and a greater freedom is evident in vestments and hangings, with an increasing variety and combination of colors.

The religious orders of the Christian Church also find symbolism in the color of the habits they wear. Black is utilized by the Benedictines, Cowley Fathers, Augustinians, and Jesuits. Gray has been the color used by the Franciscans (dark brown may also be used if they are a reformed branch of the order). White is worn by the Cistercians, the Reformed Branch of Benedictines, Premonstratensians, and the Order of the Holy Cross. The Dominicans wear black over white, and the Carmelites wear white over brown. These garment colors are rather drab, symbolizing the vows of poverty, humility, and service to God in contrast to the colors of the liturgical rites.

Various denominations of the Christian Church also employ their own color usage. Denominations known as the Eastern Rites have their own color preferences. The Byzantines used red for periods of

fasting and mourning. The Rutherman Rite uses white for the feasts of the Virgin and of saints who are not martyrs and for Sundays; red for the feasts of martyrs; and violet for the Vigils of Christmas and Epiphany, Lent, Holy Week, the Sorrows of Mary, the beheading of John the Baptist, Holy Cross, Wednesdays, and Fridays. Black is used for the service for the dead, and green is used for the days with ferial (any weekday except Saturday that is not a feast day or a vigil) office. The Ukrainian Rite employs white for high feasts as well as red for feast days, feasts of martyrs, and burials. The Armenian Church follows the Western Christian Church but with the following exceptions: Easter—red, funerals—white. The Coptic Church uses both white and red for Sundays and feasts, violet for Lent, and black for funerals.

Judaism

White is used symbolically in the Hebrew Bible to represent purity, as seen on the dove from the story of Noah. Judaism also utilizes various colors symbolically, and this usage has come down through the ages. Early Judaism shows that the priests (tribe of Levi) used only four basic colors for religious ceremonies: red, white, and two different purple-related hues. The Israeli flag uses the colors from the traditional Jewish prayer shawl (the *tallit*): sky blue and white, symbolic of heaven and earth. In the nineteenth century, both the cantor (*hazzan*) and rabbi wore the black gown and round black hat, a practice still observed in some congregations. On Yom Kippur (the Day of Atonement) it is the custom to wear a completely white garment symbolizing purity.

Islam

Green is the color of Islam. Because Islam does not recognize a priesthood set apart, "clerical" functions are discharged by the *ulama* ("the learned in the Law"), whose insignia is the *imamah* (a scarf or turban). A green turban usually denotes a *sharif*, or descendant of the Prophet Muhammad. Religious dress also serves a memorial function, as in the case of the religious leaders (*mullahs*) of the Shi'ites (Muslim members of the party of Ali), whose black gowns allude to the sufferings of Husayn (Ali's son by Fatimah, Muhammad's only surviving daughter), who was martyred at Karbala, in modern Iraq, in 680 C.E.

Many of the mystical dervish orders wear distinctive robes. The dervishes wear a black robe

(khirqah) over all other garments, which symbolizes the grave, and a tall camel's hair hat (sikke), which represents the headstone. Underneath are the white "dancing robes," consisting of a very wide, pleated frock (tannur), over which fits a short jacket. On arising to participate in the ritual dance, the dervish casts off the blackness of the grave and appears radiant in the white shroud of resurrection. The head of the order wears a green scarf of office wound around the base of his sikke.

The Islamic people regard green as representing the turban of Muhammad, fertility, foliage, and the Fatimid dynasty; white for the Ummayid dynasty; black for the Abbasid dynasty; and red for the sharifs of Mecca.

Buddhism and Taoism

To avoid the primary colors, Buddhist robes are of mixed or broken colors, such as orange or brown. A common term for the robe, *kasaya*, originally referred to the color saffron. Buddhist robes in China followed Indian tradition fairly closely, though under the Tang dynasty (618–907 C.E.) they are noted for being black. Taoist robes, in contrast, were yellow. In Japan devotees of the Shugen-do tradition (famous for its *yamabushi*, or mountain priests) wear white robes, symbolizing purity, during purification ceremonies and similar rituals.

Hinduism

The Hindus employ symbolic color as: white—Sattav, calmness, brightness, luminosity of knowledge; red—Rajas, activity, passion, energy, life source (a bride wears red to mark the "birth" of a new creative phase in her life); black—Tamas, emotion, inattention; blue—Krishna, universality, vastness of sea and sky. Saffron (yellow-orange) is used by the monks for robes, serenity, and renunciation.

There is little distinction between ordinary dress and religious dress in Hinduism. However, colors still have religious associations. For example, Krishna, the eighth avatar (incarnation) of Vishnu, is usually blue in color and is often depicted wearing yellow-orange clothes. Blue is the color of the infinite, the sky, and the ocean. The color yellow represents earth. When sand is introduced in a colorless flame, the flame turns yellow. The blue form of Krishna clothed in yellow-orange suggests the transcendent, infinite reality reduced to a finite being (fig. 13.6).

13.6 Bhanudatta, *Rasamanjari*, 1685. British Library, London. This painting employs arbitrary color in the figure of Krishna. The blue face and body of Krishna define his infinite being; yellow-orange clothes represent his finite, human nature.

During Holi, the festival of colors, revellers carrying *gulal* (colored powder) go from house to house smearing it on the faces of friends and acquaintances, while children with *pichkaris* (water sprinklers) roam the streets, squirting colored water on passers-by.

A comparison of various religions using the same colors is as follows:

- White—purity: Christianity, Judaism, Buddhism
- Black—death: Christianity, Islam
- Blue—sky: Christianity, Judaism, Hinduism.

See Appendix 9 for color symbols in various religions.

CULTURAL SYMBOLISM

The peoples of the earth also see colors as symbolically different. Each culture has its own usage that is

unique to its life and history. Each of the Chinese dynasties had its own royal colors: Sung (960–1279)—brown, Ming (1368–1644)—green, Ch'ing (1644–1912)—yellow (used only by the emperor). First rank was coral, second rank was blue, third rank was purple, and fourth rank was white. The Chinese also saw red as symbolizing fertility (it was worn by brides), joy, revolution, new age, fire, and South; yellow was seen as earth and as an auspicious, imperial color; white as metal; blue-green and green as wood; and black as water.

Japan's rich history finds the following historical uses of color: dark violet—imperial color; red—circulation, health, Kabuki (a type of Japanese theater); and black—humility and poverty. The Kabuki colors are red for bravery, justice, and strength; and blue for invisibility and the darkness of black night. A cross-cultural study has shown, however, that in Japan blue

and green hues are perceived to be "good" and the redpurple range as "bad." In the United States, by contrast, the red-yellow-green range is considered "good," with oranges and red-purple "bad." We must be aware, therefore, that color associations are often specific to particular cultures.

The ancient Egyptians (approximately 3000 to 500 B.C.E.) saw purple as the hue of the earth; white as a crown dominion over Upper Egypt and the god Horus; red as a crown dominion over Lower Egypt and the god Shu; blue for the god Osiris (the god of the underworld) and Amen (the god of life and reproduction); green for the gods Isis and Osiris, vegetation, and death; black for Seth (the god of the north and evil) and darkness; and yellow for corn and Neith (the god of the earth).

The history of the Greeks shows that color usage began in ancient times with blue as the symbol of the sea and the deity Zeus (which continues to the present day with blue as the symbol of the Virgin Mary). Green was seen as the symbol for Hermaphrodite, titillation, and hatefulness.

The ancient Romans used blue to stand for the god Jupiter. The togas worn by Roman men also had color symbolism: purple and gold for emperors, white for days of rejoicing, and dark hues for mourning.

The Navaho have five sacred colors: white, black, yellow, blue, and red. In some communities of the Southeastern United States, front porch ceilings are painted blue to keep ghosts at bay; in the Southwest many Native Americans also paint their doors blue, again to keep the bad spirits away.

Most African people see black as the color of death and evil. In India red is the color of the goddess Lakshmi, beauty, and wealth. In Persia and Turkey red symbolizes joy and happiness, and tribal cultures view red as blood. As could be expected, the Irish have a reverence for their historical symbol—the green shamrock—as well as for the lush green of the countryside of the "emerald isle." For the Irish, green, therefore, is a color of pride and patriotism as well as of hope.

THE ZODIAC

Since ancient times people have relied on the Zodiac in some form or another to govern their lives. The signs of the Zodiac have used imagery symbolically throughout history.

- Cancer—white (moon, silver, pearl)
- Leo—yellow (sun, gold, topaz)
- Capricorn and Aquarius—black (Saturn, lead, diamond)
- Libra and Taurus—green (Venus, copper, emerald)
- Pisces and Sagittarius—blue (Jupiter, tin, sapphire)
- Virgo and Gemini—purple (Mercury, quicksilver, amethyst)
- Aries and Scorpio—red (Mars, iron, ruby).

We also find that various colors are associated with the different signs and symbols.

- White—purity and the moon
- Silver—the moon
- Gold—happiness and the sun
- Yellow—the sun
- Black—penitence
- Green—love, hope, and Mercury
- Blue—piety and Jupiter
- Purple—majesty and rank
- Red—courage and Mars.

ACADEMIC COLOR

The universities in the United States use six colors symbolically as academic colors. The appropriate degree and concentration colors are usually incorporated into the hoods worn.

- Red—blood, worn by Christian religious dignitaries, symbolizes Christ's sacrifice; used for the degree program of theology
- Blue—truth and wisdom, used for the degree program of philosophy
- White—purity; used for the degree program of arts and letters
- Green—regeneration; used for the degree program of medicine
- Purple—dignity; used for the degree program of law
- Yellow—light; used for the degree program of science.

FLAGS AND HERALDRY

Flags are probably the most potent examples of abstract color symbolism. They have a huge impact as emblems of national and regional pride. Many European designs have their roots in heraldry, which originated when most people were illiterate but could

14.2 Prince Rahotep and his wife Nofret, *c.* 2610 B.C. Painted limestone, 47 ½ in (122 cm) high. Egyptian Museum, Cairo. The well-preserved paint is indicative of the ancient Egyptians' skill in the preparation of pigments and their application to limestone. In traditional style, Rahotep's skin is painted in a dull-red color and Nofret's in creamy yellow. Their eyes have been outlined in black. The queen's necklace has traces of Egyptian blue.

14.3 Ixion Room, House of the Vetii, Pompeii, A.D. 63–79. The ash and mud that buried Pompeii after the catastrophic eruption of Mount Vesuvius in A.D. 79 acted as a preservative. Many wall paintings look as though they have been freshly executed, so brilliant remain their blue and red pigments.

adorned them. The Greek pottery that has survived provides us with visual examples of ancient Greek life through the adornment that employed black, white, terra cotta, and some purple glazes. These pieces were also probably further embellished with tempera paint coloration, which has disappeared over time.

The Greek Color Palette

The Greek color palette has its foundation in that used by the Egyptians but with several changes: white (a lead white), light brown (an ocher earth color), purple (a reddish violet also known as Tyrian purple), black (from smoke and soot), yellow (a clear yellow known as Naples yellow), yellow-orange (termed a royal yellow), brown (an earth or dirt brown), gray, green (known as Greek green or verdigris), and blue (a malachite blue). See Appendix 10. The ancient Greeks developed white lead (lead carbonate), verdigris, and vermilion. Verdigris (the "green of Greece") is hydrated copper acetate—a gray-green or bluish patina that forms on copper, brass, or bronze surfaces. It tends to be impermanent, being affected by other pigments and the atmosphere. Distilled verdigris was purified with vinegar. Vermilion is produced from natural cinnabar and is chemically known as mercuric sulfide. According to the Greek philosopher Theophrastus

(c. 372–c. 287 B.C.E.), it was obtained from inaccessible cliffs by shooting arrows to dislodge it. Vermilion is also found in relics of Assyrian and other early cultures.

Tyrian purple, the imperial purple of the Romans, was first used by the Greeks. As Plato makes clear in the *Republic*, it was used by the ancients for major rites of passage, such as births, deaths, and marriages, and regarded by them as the most beautiful color of all, in part because it was held to contain equal proportions of dark and light. It was prepared from the shellfish *Murex trunculis* and *Murex brandaris*. According to Pliny the Elder's first-century C.E. *Natural History*, the most desirable shades of murex purple varied from the reddish or pinkish to the bluish or violet, according to the fashion of the times.

Ancient Rome

The Greek color traditions carried on into ancient Rome, which used a similar palette and used art in the same ways. The Romans greatly admired Greek civilization and copied its art—at times line for line. However, the ruins of Pompeii show us that perspective in painting was being developed and that the use of warm hues, especially red, was the vogue of the day (fig. 14.3). The style of interior decoration at

Pompeii was not to hang paintings but rather to paint directly onto the walls. The themes of the murals are varied and include mythology, landscape, patterns, brightly colored imitation marble, and porticos. Some artists achieved unqualified excellence, such as an unknown artist from Capania in the first century B.C.E. who painted the frieze of the Dionysiac mysteries, discovered in 1930. The deep red background of the paintings is still fresh after two thousand years.

The Romans also used color in fashion to denote social rank, with gold and purple representing royal or high status. Mosaic work came into prominence during the classical Roman era, and the colors employed were influenced by the outlining that the technique requires. The Roman palette, while similar to the Greek, became richer and brighter and included: white (a lead white), black, warm red, Tyrian purple (a reddish purple), blue-green, foliage green, yellow, earth brown, purple, sea foam green, cool red (cinnabar and madder lake), and gray. See Appendix 10.

The Middle Ages

The Middle Ages began with a period known as the Dark Ages. During this period art abandoned perspective and reverted to symbolic use of color.

Early Medieval Mosaics

Artists of the early Christian Church used mosaic brilliantly at sites such as churches in Ravenna, Italy, to inject drama into the biblical stories they were depicting. Bright colors, including gold, were fused into little glass cubes called *tesserae*. These could be set at angles to catch the light as the spectator moved, which was particularly effective for focal points, such as saints' haloes. Red *tesserae* were randomly scattered to give warmth to flesh tones. In many later medieval churches no surface was left uncolored. The sumptuous effect was supplied by Bible stories in fresco, imitation mosaic, painted ornament, and even hanging cloths of gold that were really painted illusions.

Medieval Manuscript Illumination

In the early medieval period (375–1015 C.E.) innovations occurred, especially in the field of manuscript illumination. The Phoenicians had discovered Tyrian purple in the eighth century, and eighth-century scribes developed ultramarine blue. The scribes in the

numerous scriptorias used watercolor on vellum or parchment and employed a palette consisting of ultramarine blue (from lapis lazuli), orpiment yellow (from arsenic and sulphur), ruby red (from lead), verdigris green (from copper acetate), red (from kermes lake), vermilion, orange, and coral pink. See Appendix 10.

Medieval Stained Glass

The medieval period also saw the introduction of the art of stained glass, which was used to enhance the magnificent churches of the entire Middle Ages. Light was all-important in religious architecture, and we find the stained glass palette as: red, blue (usually as a background), yellow or gold, and green. The symbolism of these colors is identical to that of the Christian color symbolism (see Chapter 13). The windows included a range of blues, greens, browns, pinks, and purples, and imagery was outlined in black. See Appendix 10.

Medieval Tapestries

The Bayeux Tapestry, one of the masterpieces of the Middle Ages, was created by stitching colored wool onto bleached linen (crewel embroidery). It is over 230 feet long and depicts the Norman invasion of England in 1066 (fig. 14.4). The craftspeople used five predominant colors: terra cotta, old gold (a brownish yellow), blue-green (which is grayed), deep blue (which is tinged with green), and olive green. In addition, the palette included sage green, dark blue, yellow, blue, red, and green. See Appendix 10.

During the Gothic period (1140–1500) tapestry weaving flourished. One of the most famous of these tapestries, the Unicorn Tapestries (1495–1505), employed a typical color palette. The weavers used only three colors—red (madder), yellow (weld), and blue (woad)—but these three dyestuffs were mixed with various mordants, which gave an expanded palette: red, magenta red, pink, yellow, brown, pale yellow-green, blue, dark blue, midnight blue, bluegray, white, and forest green. See Appendix 10.

The Renaissance

The period after the Middle Ages is known as the Renaissance, which lasted in Europe from about 1200 to about 1700. It was a period of great advances in art. The world of art exploded with explorations into creating impressions of space through the use of perspective and shading and imparting realistic

14.4 The Bayeux Tapestry, detail of Viking ships, *c*. 1070–80. Bayeux Tapestry Museum. Now light brown with age, the tapestry contains some seventy scenes from the Norman Conquest of England, embroidered in worsteds of many colors.

imagery, no matter what the message. Color mixing became a sophisticated technique, and the palette expanded, especially after oil paints were introduced. In the eleventh century a monk called Theophilus developed a recipe for adding mineral pigments to a varnish, made from dissolving resins, such as amber and copal, in linseed, castor, or fish oil. As early as the thirteenth century oil was used for painting details over tempera pictures. Oil paint, as it became known, became more widespread during the Renaissance, and drying and semi-drying oils, such as walnut, poppy,

and safflower, began to be used. Drying time was further decreased by adding metallic oxides, such as litharge (lead monoxide, a heavy, yellowish powder) or white lead. The most commonly used colors were: Naples yellow, royal yellow, yellow ocher, natural sienna, dark sepia, vermilion, red lake, Tyrian purple, violet, ultramarine blue, Egyptian blue, malachite, green, verdigris, earth green, white, and black. See Appendix 10.

Color usage during this period depended on the artists' needs, and an expanded palette and facility for

14.5 Jan van Eyck, *The Arnolfini Wedding*, 1434. Oil on wood, $32\frac{1}{4}$ x $23\frac{1}{2}$ in (81.9 x 59.7 cm). National Gallery, London. Despite the stylized appearance of the figures and the stretched perspective, van Eyck's great skill with color makes this room a real space. His brilliant rendering of shadows and reflective surfaces, such as the brass candelabrum, makes us aware of the even flow of light. The bride's green dress (and the dog) are symbols of fidelity.

mixing pigments afforded artists almost unlimited means of expression. The Flemish painter Jan van Eyck (*c*. 1395–1441) employed oil paints that allowed the creation of colors that had never before been possible because of the mixing qualities of the medium (**fig. 14.5**). We must also note that van Eyck, in common with other northern Renaissance painters, used color as well as one-point perspective to create depth in his compositions, which was a change from the flat surfaces seen in the Middle Ages. By the early sixteenth century oil paint was the preferred medium for easel painting in Europe. Oil paint is easily handled, can be blended, and can be applied as

a transparent glaze. The color is the same when dry as it is when wet. Artists who used quick-drying tempera had to work quickly, but those using oil could build up a picture slowly. Early pigments, however, caused many problems for the painters: fading or darkening, the difficulty of mixing certain colors together, or their toxicity, not to mention the artists' labors in purifying and preparing each pigment by hand.

As the Renaissance progressed, art became known for the effects imparted rather than for a particular palette. Paintings were huge, usually taking the form of frescos because fresco painting was at its height during this period. Leonardo da Vinci (1452–1519) was a master at interpreting color sensations. He felt that colors could be mixed from four basic hues: red, green, yellow, and blue, which make up the visual wheel (see figs. 4.6, 7.6). He developed the concepts of aerial perspective and of soft shading, known as *sfumato*.

Michelangelo (1475–1564) is the artist who probably most exemplifies the use of color during the Renaissance. His fresco painting, especially in the Vatican's Sistine Chapel, shows color usage at its zenith. He employed the technique of glazing colors to create optical mixing interactions as well as color contrasts to create space. Color now carried an emotional message to all.

The Baroque

During the latter part of the Renaissance a new movement emerged known as the Baroque (1600–1750). The individual artists of this era became recognizable and known for the ways in which they employed color. Peter Paul Rubens (1577-1640) used a technique called imprimatura, with an intense chromatic scale, and experimented with the effects of light and shadow. Diego Velázquez (1599-1660) worked in what was known as manera abreviada. He felt that surface color was the result of color plus light. While each surface had a particular hue, this surface was altered by the quality of light hitting it. His color usage has a loose quality that was to be a great influence on the modern art world to come. Rembrandt van Rijn (1609-1669) took from the past and expounded on this knowledge. His works dwell on the changes perceived between light and dark. The effects of illumination were imparted in the most subtle of nuances. His work took chiaroscuro to new heights of perception (see fig. 6.13). The technique of chiaroscuro is also seen in the work of the Italian Baroque painter Caravaggio (1573–1610).

In addition to the art given us by the Baroque painters, the media of interior design also brought forth great changes. The Baroque interior shone with ornate embellishments and the use of gold everywhere. Brilliant color and pattern filled the interiors of the Baroque era.

The Modern World and Color

The modern world of art took its cue from the advances of the Renaissance and forged ahead to give an art that was built on individuality and innovation. The artist, architect, and designer relied on emotions, visual effects, and experimentation built on a foundation of previous knowledge. Communication now allowed for a rapid dissemination of ideas, concepts, and techniques. The late eighteenth and the nineteenth centuries afforded the painter, dyer, and weaver a palette of at least 30,000 colors.

Individuality in art flourished as never before, and artists began to form groups that led to movements in art. Even within these movements, however, the artists remained individual and their work was recognizable from each other's. The movements were

rather an imparting of similar ideas and concepts, beginning with Neoclassicism.

Neoclassicism and Romanticism

During the first of the movements of the modern era known as Neoclassiciam and Romanticism (1750–1850). painters explored ways of convincingly capturing the effects of light in a static, two-dimensional form. They wished to capture the moment. In England the landscape painter Joseph Mallord William Turner (1775-1851) was totally absorbed with recording color and light and differing weather conditions in all environments. The Spanish painter Francisco Goya (1746–1828) also concerned himself with color and light and employed a bright, luminous palette to convey his standpoint, which was largely political and representational. The French painters Jean-Auguste Ingres (1780–1867) and Eugène Delacroix (1798–1863) were much more idealistic and romantic in their subject matter and relied on the effects of illumination to impart their message. Delacroix, in particular, analyzed the ways in which color is used, and his paintings offer the viewer an idealistic illuminated composition with color used to convey space as well (fig. 14.6).

14.6 Eugène Delacroix, Liberty Leading the People, 1830. Oil on canvas, 102 x 127 in (259 x 323 cm). Louvre, Paris. The political manifesto of the French Revolution (Liberty, Equality, Fraternity) is illustrated in the red, white, and blue colors of the Tricolor and reinforced throughout the composition. The various shades of blue in the sky, in the waistcoats, jackets, and uniforms of the falling and fallen victims, and in the dead man's sock—all play off against their darker, richer hue in the flag. The reds and off-whites dispersed throughout the painting also subtly resonate with the stronger hues in the flag.

Advances in chemistry introduced many synthetic colors during the eighteenth and nineteenth centuries: cobalt blue in 1775, cobalt green in 1780, chrome yellow in 1809, emerald green in 1814, cadmium yellow in 1819, cerulean blue in 1821, zinc white in 1834, viridian in 1838, cobalt yellow in 1861, and alizarin crimson in 1869. Also in the eighteenth century, terra di colonia, or Cassel earth, was renamed Van Dyke brown after the great painter who loved this dark transparent color. See Appendix 10.

Impressionism and Postimpressionism

The color theorist and physicist Michel-Eugène Chevreul (1786–1889) explored and recorded color theory from antiquity. His experiments in color interactions led him to develop theories about simultaneous contrast, color harmony, and visual color mixtures. This work greatly influenced Delacroix but more importantly led to the revolutionary art movement known as Impressionism. Art historians feel that Impressionism began in 1874 with *Impression: Sunrise* by Claude Monet (1840–1926) (see fig. 12.13). The Impressionist movement found artists creating their works in their actual environment. The

results were compositions that no longer relied on memory or notes but that actually recorded the color seen at a particular time of day and in specific lighting conditions (see fig. 12.3). They were now painting "on site." Impressionism concerned itself with color and its nuances rather than with the precise rendering of imagery and line. This color was imparted by creating color interactions and the use of patches of color to create an impression. Painters who followed the Impressionists used different means to render light. The Postimpressionist painter Vincent van Gogh (1853-1890) employed broad strokes of color either with a brush or palette knife directly from the paint tube to impart luminosity (placement of values), movement (using color progression), and brilliance (pairing complementary hues) (fig. 14.7).

Georges Seurat (1859–1891) studied how color and vision interacted and employed optical mixing in his Postimpressionist works. He worked with a palette that was limited and that allowed the color placements to fuse visually and impart luminosity. In short, he substituted the eye-brain function for actual pigment mixing on his paint palette. He became the leading practitioner of the pointillist style (see fig. 11.7).

14.7 Vincent van Gogh, Starry Night, 1889. Oil on canvas, $29 \times 36^{-1/4}$ in $(73 \times 92 \text{ cm})$. Museum of Modern Art, New York, van Gogh created energy by imparting rapid movement using luminosity, color progression, and paired complementary hues in the night sky. This activity is contrasted with the calm of the landscape beneath the sky through the use of close-valued analogous colors and shades of colors.

14.8 William Morris interior. The wallpaper and upholstery fabric shows Morris's use of tonality (orange is added to each color) in these naturally inspired designs. The overall warmth of the designs is blended with the centerpiece of the room—the hearth. The brown (dark orange) dominates the mantle area, reinforcing the warmth even when the hearth is not lit.

Decorative Arts in the Nineteenth Century

These color revolutions spilled over into the decorative arts. One of the most influential of the decorative artists of the time was William Morris (1834–1896), whose work pervaded every aspect of interior design—wallpaper, textiles, furnishings, and architecture. Art was no longer confined to hanging on the wall but was used to create environments. Morris's subject matter was usually taken from nature, and his color was gentle and easy to live with (see Appendix 10). His creations almost always explored the concept of tonality and every color used contained some of a common color in it. The result was unity (fig. 14.8).

Modernism and the Late Twentieth Century

As art became more diversified, individual artists fostered movements of their own, especially in the twentieth century. Cubism burst on the scene. Multiple perspectives of an image were combined to create a new image, and form became more important than color. Shadows were gone, and representationalism was replaced by the abstraction of form.

In 1905 a group of young French painters, including Henri Matisse (1869–1954) and André Derain

(1880–1954), exhibited works with such naïve bright colors that they were dubbed "les fauves" (wild beasts). The Fauves employed pure hues and were examples of artists using arbitrary color.

The use of color reemerged with the advent of fantasy. Artists such as Paul Klee (1879–1940), Marc Chagall (1887–1985), and Vassily Kandinsky (1866–1944) (fig. 14.9) were abstracting imagery but using color to provide the emotional message. Color and imagery were back together, but far from the way color was used during the Renaissance. Was color to take over and become the all-important factor of any artwork? Absolutely. Abstract expressionism, color field painting, op art, and pop art were to follow (see fig. 9.1). The works of Frank Stella (b. 1936) typify the return of color as the most important aspect of a work. Color pigment mixing, color placement, and color interactions were now the dominant considerations in the creation of a work of art.

Acrylic paints were developed during the 1950s. The main advantage of this new meda was the short

14.9 Vassily Kandinsky, Several Circles, Number 323, 1926. Oil on canvas, 55% x 55% in (140 x 140 cm). Guggenheim Museum, New York. Despite the overall effect of apparently arbitrary colors in this abstract, metaphysical, even sensual composition, the circle clusters demonstrate Kandinsky's careful choice of analogous and complementary colors. Kandinsky believed that there was a close affinity between harmony in color and in music.

14.10 Helen Frankenthaler, *The Bay*, 1963. Acrylic on canvas, 6 ft $8\frac{3}{4}$ in x 6 ft $9\frac{3}{4}$ in (2.05 x 2.12 m). Detroit Institute of Arts. Gift of Dr. and Mrs. Hilbert H. DeLawter. For this color field painting, Frankenthaler initially thinned her paint and then poured it onto the canvas in veils of color. The advantage of acrylic is that different layers will not blend even when wet. The blue, especially, leaks like water into other areas of the picture plane but does not blend with them. The overall effect is reflective, even poetic.

drying time, but in addition, the colors were brilliant. Advances in art media were such that by 1980 90,000 colors were commercially produced. The world of art now had what seemed to be unlimited color, and the challenge has become how to use this color to the greatest advantage. To meet this challenge, the artist, designer, and architect must acquire a thorough knowledge of how color works.

Mark Rothko (1903–1970) was a master of a branch of abstract expressionism called color field. Rothko's large, somber paintings contain soft, cloudy forms with frayed edges **scumbled** onto thinly painted, almost dyed fields of color to produce a luminous grandeur that elicits a metaphysical or religious experience from the viewer. Color field painters relied soley on areas of color placement to impart their messages

In the early 1950s Helen Frankenthaler (b. 1928) inspired a new movement with her original technique of staining unprepared canvas by pouring acrylic paint on it (**fig. 14.10**). The color field school, which included artists such as Kenneth Noland (b. 1924) and Morris Louis (1912–62), employed broad swathes of color, typically calm in mood and inward-looking. Despite the ubiquity of conceptual art, there were still

artists who took delight in color and paint: the sublime flower studies of Georgia O'Keeffe (1887–1986), for example, or the California landscapes of David Hockney (b. 1937). Artists of the late twentieth century went beyond pigment, using transmitted light, neon, or video to create works of art. In the light installations of James Turrell (b. 1943), especially his magical Skyspace structures around the world, he uses the sky itself to color the insides of white-painted "rooms" (fig. 14.11).

COLOR APPLICATION IN CONTEMPORARY ARTS

Art has pervaded every aspect of contemporary life, and we end with a brief summary of how color can be utilized in the present—in environmental arts (architecture, landscape, interior, and product design), studio arts (sculpture, ceramics, glass, photography, and fiber arts), fashion (clothing and jewelry), and commercial arts and technology (graphic design, printing, computer technology, and the internet). As mass media has evolved, art has become more accessible to artisans, craftsmen, as well as to viewers and consumers. Therefore, global awareness of art and color usage has become more integral to every art form.

14.11 James Turrell, *Daygo*, 1990. Barbara Gladstone Gallery, New York. The boldness of the blue against its complementary orange is accentuated when the viewer discovers upon closer inspection that this is not in fact a blue surface on the wall but a hole in the wall through which blue light is shining.

Environmental Arts Architecture

Our environment is a world of color both natural and manipulated by humanity. Architecture in all forms relies on the proper use of color. Buildings can blend with their surroundings or be in contrast with them. Frank Lloyd Wright's residential architecture blended with the surroundings, and his houses, such as Fallingwater, became one with nature. Along coasts homes in fishing villages are often painted in bright colors so that the inhabitants might more easily find their way into the safety of their harbours.

The surface of a building affects how it and its color are perceived. Texture can be rough or smooth.

The rougher a texture is, the darker it will appear to be. The use of contrast also affects architectural perception. Light/dark contrasts will create three-dimensional effects where none exist. We also find that the more a surface is broken up, the smaller it appears. Smooth, flat surfaces can appear to be larger. Well thought out color usage can reverse these effects. A building containing many windows set into a white grid or surface will appear to be smaller than a building that is the same size but that has blue-tinted windows set into a steel grid or surface that will enlarge its appearance. It must be noted that architectural color is often impermanent. It changes because of weathering and staining of materials—the

once-white Gothic cathedrals are now deep gray—or, if it is superficial, it can be easily altered or removed. Over the course of centuries the colored stucco veneer of ancient Greek temples and the bright marble facings on Roman brickwork have been removed. Today home improvement emporiums allow consumers to experiment with various siding, paint, and roof color choices on computers before they make a final decision.

The color used on a building or its parts, such as the roof, will affect the environmental temperature of the building. White reflects heat, while dark colors absorb heat and retain warmth. Now we see that a dark blue building will absorb heat and remain warmer while at the same time appear to be cooler and larger.

The materials that are used in architecture traditionally have symbolic effects. The all-glass, cool blue building implies industry, while the gray stone one suggests reverence, hallowed ground, and solidarity, an impression that stems from the majesty of medieval church buildings that were conceived as tangible symbols of heaven. In the ninth century B.C.E. Assyrians and Babylonians decorated their buildings with glazed tiles. From the thirteenth century onward, the Persians used mosaic tiles and lustrous materials

14.12 Left: Charles W. Moore and William Hersey, Piazza d'Italia, New Orleans, 1978–79. The garish neon lights attract the eye to the imposing turquoise central entablature and its rounded arch, and to the rosy red Corinthian columns. The curved colonnades alternate red and yellow colors. This is kitsch classicism—a temple executed in a fairground style.

14.13 Right: Renzo Piano and Richard Rogers, Pompidou Center, Paris, 1978. The use of various colors to "code" the service ducts combines practicality and aesthetics in this innovative structure. The impact of the color on the viewer focuses concentration on the beauty rather than on the function of the color usage.

to impart a message of luxury and power. Mosques, too, are often decorated with colorful mosaics, tiles, and carvings.

The de Stijl group created a color revolution in architecture, using brilliant flat colors inspired by the artist Piet Mondrian (1872–1944). The Postmodern period, beginning in the 1970s, heralded profound changes in architectural color by such architects as Charles W. Moore (1925–93) (**fig. 14.12**), Robert Venturi (b. 1925), and Michael Graves (b. 1934). High-tech architects were using color too. Richard Rogers (b. 1933), for example, used color coding on the exposed service ducts around the inside-out

Pompidou Center in Paris (fig. 14.13). Modern tragedies have given rise to many new monuments of remembrance—the stark reflective blackness of the Vietnam Veterans Memorial in Washington, D.C. (the blackness of grief rendered in a high luster, imparting a heavenly, heroic quality), and the calm colors of the Oklahoma bomb memorial give a feeling of dignity and repose as well as repeating the earth colors of the Oklahoma countryside that was home to so many of the victims.

Computers allow architects to render a building in any number of "skins" or material forms as well as color combinations.

Landscape Design

Architecture is coupled with landscape, and the art of landscaping should coordinate the buildings with the land that surrounds them. Landscaping elements are, of course, limited by the site and the weather conditions imposed on them. We know that colors advance and recede: warm colors and pure hues advance, and a garden filled with warm foliage and brilliant, pure-hued flowers will appear smaller than one planted in cool colors. Perennial flowers are generally softer and duller in color, but these, too, can be made more brilliant by the use of gray foliage within the planting. The addition of dusty miller within a perennial border will show off the flower colors to a heightened degree. Annuals, on the other hand, provide brilliant color. The use of analogous colors in plantings provides a pleasing, flowing, and enlarging effect in a garden. Contrasting color schemes in plantings will have a high impact and draw the viewer's attention. Keep in mind the proportional use of color when working with garden color schemes. For instance, a small amount of yellow is most

effective, but a large bed of brilliant yellow will overpower everything around it.

The color imparted by architecture affects the colors imparted by the landscape surrounding it. Shrubbery surrounding a brick building can be either warm or cool green. If they are warm green, the shrubs and the brick will have a tonality of yellow in both—the orange of the brick and the yellow-green of the foliage both contain yellow. However, if cool green foliage is used the effect will be one of complementary contrast—the orange of the brick and the blue-green of the foliage. The landscape artist must make conscious, well-thought-out color decisions to create the desired effect. There are now many landscape and garden-planning computer software programs available to the landscape designer that will save time and money, and allow the overall effects of landscaping color to be viewed before planting.

The media of television and video have found great popularity with the home gardener. Perhaps the most interesting of the subjects offered—apart from garden

14.14 Gardens at Monticello, Charlottesville, Virginia. Thomas Jefferson blended the circular shapes of the structure (the dome and floor plan) with the arcs shown in the roundabout gardens at Monticello. The warmth of the brick and the white on the architecture are repeated by the use of color in the seasonal garden plantings surrounding the home. Courtesy Monticello—Thomas Jefferson Foundation, Phillips, 1995.

makeovers—are tours of world-famous gardens and landscapes. Through the magic of these programs the gardener can visit the formally laid out, eighteenth-century gardens and landscapes of Versailles, the formality of English manor gardens, and the charm of cottage gardens. The ease of modern travel allows us to enjoy historic sites as well as historic homes and their gardens. For instance, the gardens at Thomas Jefferson's Monticello home are a perfect example of the marriage of architecture and horticulture (fig. 14.14). The home gardener can now duplicate historic environmental designs both inside and outside the home.

Interior Design

Furniture design was also liberated by Postmodernism, particularly by the Milan-based Memphis Group, which was founded in 1980 by Ettore Sottsass (b. 1917). The crazy colors and kitsch textures had a retro, 1950s feel and made extensive use of plastics and plastic laminates (fig. 14.15).

We saw in Chapter 13 how the use of color influences interior design, be it office, commercial, religious, or residential space. Residential interior design is most influenced by individual preferences, which are based on cultural, environmental, and personal choices. There are numerous books illustrating color harmonies, as well as interior design magazines, book, videos, and television shows. A popular trend is to change or up-date interiors. This trend is not new during the 1930s and 1940s many homes had a summer set and a winter set of slipcovers for furniture that set a seasonal mood by changing the color used. We also find that interior design accessories change with the season as well as the holiday being celebrated: red and pink for Valentine's Day; green for St. Patrick's Day; pastels for spring and Easter; red, white, and blue for the Fourth of July; oranges, browns, and red for fall; blue for winter and Chanukah; and red and green for Christmas.

Product Design

Commercial products have gone from dull to vibrant colors for all types of product we use in our lives.

In addition to his furniture designs, Ettore Sottsass co-designed a famous Olivetti typewriter. Recently, the mainly beige (or sometimes black) world of computers has been turned upside-down by the translucent iMac designs by Jonathan Ive (b. 1967).

14.15 This Memphis Group settee shows how color was the overriding component of the group's designs. The sleek lines of the furniture's shape are enhanced by the brilliant use of color. Private collection.

Bondi blue was the first iMac color, followed by the "flavors": strawberry, blueberry, grape, tangerine, and lime. This fad has now spread to cell phones and other personal data objects, which are available in a rainbow of colors (fig. 14.16).

Car colors have come a long way from Henry's black Model T. But bear in mind that research has shown that silver cars have the happiest drivers, while the owners of pastel-colored cars are the most depressed. Drivers of white vehicles are least likely to be involved in an accident, and drivers are most at risk from an accident if they are in a yellow car. Industrial research laboratories have developed hydrocarbon and oxygenated fluids that, even though colorless, greatly enhance the auto paint colors as well as extending their durability.

The products used in everyday life have also become more colorful, especially kitchen tools and appliances—the Kitchen-Aid mixer is now available in an assortment of colors. Product designers have found that product color attracts buyers, no matter what the product's use (fig. 14.17).

Forecasts for the next color of consumer items are discussed and predicted by international color

14.16 iPods have joined the colorful product trend with production of iPods in a variety of colors allowing the consumer a personal choice.

14.17 Klaus Schnitzer, *Toothbrushes*, color transparency. Everyday objects available in a choice of color encourage use as well as identifying ownership—each family member has his or her own colored toothbrush.

committees, and new fashion trends trickle down, from fabric and women's clothing to home interiors, then to automobiles, and finally to architecture, depending on the lead times involved. Now most marketing departments rely on color forecasting, and there are numerous organizations that specialize in color trends. A listing of these organizations throughout the world is available from the Inter-Society Color Council. These organizations issue periodic reports as well as hold conferences to disseminate information throughout the world. See also the *Graphic Design* section in this chapter.

Studio Arts

The studio arts can be two- or three-dimensional or a combination of both. Some are considered to be a part of the world of fine arts, and others are considered craft. But all studio arts can be a part of both the craft and fine art genres.

Sculpture

It is usually thought that sculpture is devoid of color and that any color sensation is the result of the materials employed. Contrasting materials, the inherent surfaces of materials, and the materials' reflective qualities contribute to the monochromatic color sensation of sculpture. Contemporary sculptures, however, have returned to the ancient practices in color usage, and we now see color applied to threedimensional forms and as an integral component of the sculpture's overall statement. Many sculptors are using color in outdoor works that are in direct contrast with the surroundings in which they are placed (fig. 14.18 and see fig. 9.19). Careful thought must be given to how this contrast will take place. A violet- or red-hued sculpture in a green outdoor setting will result in a complementary color sensation. Sculpture can be greatly enhanced by applying color. Outlining a sculpture's components can create focal points, as can the use of pure hue colors, fine detailing, and those concepts imparted in the section on emphasis discussed in Chapter 9. The use of computer imaging can allow the sculptor to view sketches or a work from all angles before proceeding to give it physical form, and color usage can be determined by having the computer image imported into various surroundings on the screen so that the color can be adjusted prior to the final execution of the work.

Ceramics

Ceramics have always been among the most colorful of household artifacts, from the orange and black vases of the Greeks, to the blue and white porcelain of the Ming dynasty in China, to the bright but highly toxic orange uranium glazes of the 1920s.

The ceramic artist is well aware of the colors that are imparted by the use of different types of clay. These qualities of clay serve the same purpose as the painter's background. As various types of paint and drawing materials impart different types of color so, too, do the various types of glazes available to the ceramic artist (fig. 14.19 and see fig. 4.3). A matte glaze imparts a dull finish to a surface, while other glazes provide a high sheen. Transparent glazes allow the clay to show through in much the same manner as the paper in watercolor painting. Here the color interaction of optical mixing must be taken into consideration. A basic color tool for the ceramic artist is to create tiles of various clays with patches of glaze colors on them. These fired sampler tiles can serve as a color chart for reference and allow for more intelligent color choices in a work.

Glass

Glass can be either sculptural in form or somewhat two-dimensional (tesserae and stained glass). No matter what the function of a glass artwork, the qualities of the medium must be taken into account. Glass-making usually results in a transparent product, and this quality means that the surroundings seen through it will affect the perception of its color. It is possible to make glass opaque, translucent as well as transparent in nature. The addition of metal oxides to the production process will result in colors that are brighter. Designers working with tesserae must take care that the grouting is an integral part of the design and color interactions. Stained-glass color is the most permanent of the man-made color media and it resists fading. Stained glass also relies heavily on the color concepts of chromatic light and outlining (see fig. 10.15).

Photography

The development of high-resolution films has made a huge difference to color photography (see Chapter 4). The very nature of the film components shows us that low-speed films are less grainy. The drawback to low-speed film is that low lighting conditions are problematic. Bracketing (shooting the same picture at

14.18 Robert Minervini, *Destination Infinity*, 1996. Stainless steel and steel outdoor sculpture. Commissioned work on the campus of Montclair State University, Montclair, New Jersey. Minervini's use of color contrasts with the landscaping and architectural colorations on this campus. The sheen of the sculpture's materials adds to the contrast.

14.19 William McCreath, *Disco Blue*, 1989. Multiple fired earthenware, $1\frac{1}{2} \times 16 \times 12\frac{3}{4}$ in (4 x 40 x 32 cm). Collection of the artist. The glazes chosen for this piece show a sensitivity to color proportional use as well as color contrast resulting in a cohesive joining of material and color.

14.20 Klaus Schnitzer, *Amaryllis*. Color transparency. Notice how the black background and mounting meld all the imagery to burst forward in brilliant color.

different exposures) offers the photographer choices so that the optimum result can be achieved. Lighting conditions affect the photographer's work. Fluorescent light, for example, casts a tonality across the entire scene and gives photographs an unwanted tonality. Filters can correct this deficiency. When you are shooting outdoors remember the tonality that is imparted by certain times of day and weather conditions. An overcast day will not give unwanted tonality to a photograph, but bright sunlight often diminishes the tonality in an outdoor shot.

Mounting color photographs on a black background will intensify the color of the photograph because the black surrounding the photo will act as a barrier and not allow the color to spread as it would on a white background. (fig. 14.20)

Color photographers have the advantage of twentieth-century technological advances to manipulate their work. Enhancement is the most often used tool, and there are several ways to manipulate a color transparency. The first is by airbrushing. When airbrushing is employed it is important to match the values as closely as possible. Retouching is also an enhancement tool. Here the dyes used must be the same brand as the film that was used to create the transparency. Color photographs can now be imported into computers and manipulated to achieve the exact result the photographer wishes. The advent of the digital camera is revolutionizing the art of photography. Digital images can be imported, combined, and manipulated, presenting a myriad

possibilities. While computer enhancement is a wonderful tool, it is only as effective as the color knowledge the enhancer possesses. Many advertising photographs are simply enhanced with no thought to the principles of color. The most common error is to eliminate color tonality and, in so doing, destroy the unity of the composition.

Fiber Arts

Fiber art is one of the earliest of the media known to man. There are many types of fiber art, but the commonest are weaving, embroidery, and quilting. There is evidence of fiber clothing, furniture covers, hangings, and tents on ancient Egyptian tomb paintings. Greek vases from the seventh and sixth centuries B.C.E. depict people wearing embroidered garments. Quilted garments were worn as armor by the ancient Persians. Some of the most impressive embroidered and woven garments were produced in the Far East. The Chinese imperial dragon robes were executed in silk and metal thread embroidery on silk fabrics. The embroidery of India, especially from the Mughal period (from 1556) found its way to Europe, and during the late seventeenth to early eighteenth centuries East India trade became the foundation of English embroidery. In Europe until the Renaissance embroideries were mainly ecclesiastical, but the art of embellishing fabric became a part of working-class craft, and examples of folk or peasant embroideries are cherished today.

All fiber arts are based on subtractive color, which is used to generate the materials utilized, and partitive color, which utilizes these materials in a side-by-side setting. The fiber artist must be aware that the dyes used to create the yarn colors can be either natural or synthetic. Natural dyes will fade but keep their original color in a weakened form. Synthetic dye colors change to a different color as they fade.

Weaving requires an over and under manipulation of yarns, and the process is most reliant on the optical mixing of the yarn colors used. In addition to the concept of optical mixing, the weaver should be aware of the influence of value orders in the piece (see Appendix 7).

The embroiderer must take into account the effect of the background textile on a work. This is especially true for the embroidery technique known as blackwork. Here the background textile and thread patternings should rely on the legibility criteria

14.21 Pamela Scheinman, *Protuzoa*, 1983. Painted, pleated, and resist-dyed satin, 38 x 50 x 2 in (96.5 x 127 x 5 cm). The use of color progression creates movement within this piece imparting a fluttering effect to each element as well as to the overall composition. Scheinman is able to create these visual effects by using various fiber coloration techniques.

explained in this book (see Appendix 8). All embroidery should take into account optical mixing and value order effects. Unfortunately, yarn color cards are arranged in "families" of colors. These families are often mistaken to be values of a color, when they are actually different hues. For example, on most color cards, yellow is followed by a yellow-yellow-orange, which is not a darker yellow. Color content recognition is all important in creating valid color interactions (see Appendix 1 and Appendix 6).

Quilting relies on the principles of optical mixing, especially the concept of Albers' interaction (see Chapters 3 and page 101). Color repeats must be carefully balanced on the overall piece. Print fabrics are often used, and the colors within these prints optically mix when viewed at a distance to form a "new" color. The quilter must be aware of these changes before stitching a piece. The nature of quilts is the joining of color shapes. Keeping in mind how color affects shape and which shape and color combinations are advantageous will result in a unified work (see cover illustration).

Some of the most vibrant colors are found in batik and silk painting (fig. 14.21). Batik is a wax-resist fiber art that produces a characteristic white outline. Hot wax applied to fabric serves as a resist, preventing the dye from reaching the fabric. The wax cracks during liandling, allowing some dye to reach the fabric. Batik masters employ the process of repeated waxing and

tub-dyeing to achieve the final result. This method involves an understanding of color mixing and overdyeing as each layer of dye is applied over the last, producing a new color. Indonesian batiks are some of the finest examples of the batik artform. In silk painting, a resist is applied to the outline of the image and other areas of the design. Resists are available as a clear liquid, which allows the fabric to remain white, as well as colors, including metallic finishes. Dye is then painted onto the areas inside the resist lines, fixed by steaming, heating, or ironing, and the fabric is finally washed or dry cleaned.

By their nature, the fiber arts are time consuming to execute, and preplanning on a computer makes it possible to determine the way in which color can be used and the effects that its use will have. While actual weaving can be executed by hooking a computer to a loom, the color aspects can be preplanned using a computer to determine the effects that various color combinations will have. The quilter also has the advantage of being able to preview how color placement will be seen on the overall quilt by using a computer. A scanner can import quilt fabrics and patterns to give the best end results. Computer software programs are available for many of the fiber art media, and organizations such as the Embroiderers' Guild of America, the American Needlepoint Guild, quilting, smocking, and knitting organizations, have all added color to their educational programs.

14.22 Yves Saint Laurent, Paris Spring 1965 collection. Yves Saint Laurent adapted the primary colors and design of the painter Piet Mondrian to fashion

Fashion Clothing

The colors of early fashions were dictated by the available dyes and fabric colors. As the palette expanded, so did the ways in which color was used on clothing. Today's clothing, while often following trends, combines an endless palette as well as embellishments of fiber art. Color trends, while not individually long lasting, have emphasized a number of art movements during the twentieth century, such as the Mondrian fashion adaptations (fig. 14.22). While these fads did not have a long-term effect, they do reveal the impact that fine art and its use of color have had on mass-market clothing.

Someone who is interested in fashion will be aware of the ways in which color affects their overall appearance. There are now books and magazine articles devoted to coordinating skin and hair colors with clothing colors. These publications advise readers on what colors of clothing and cosmetics will most enhance their appearance. We have come a long way from the time when ladies of a certain age wore black, navy, or purple and men had only white shirts for dress wear.

Among the many publications available to the fashion industry and consumers, *The Fairchild Dictionary of Fashion* by Charlotte Mankey Calasibetta and Phyllis Tortora (New York, Fairchild Publications, 2003) is a useful reference for people who work with historical and modern fibers.

Jewelry

Jewelry has been long associated with the use of precious stones and semi-precious gemstones. These stones have been historically valued for their clarity and beauty of color and are usually transparent or translucent. How a stone is cut will affect its color—smooth cuts will enhance color, and faceted cuts will enhance brilliance (also termed fire). Stones are usually set into a material such as gold, silver, platinum, or copper, and the color of a stone can be heightened by the choice of its setting. A blue stone set in gold or copper will be more effective than if it were set in silver or platinum (fig. 14.23). However, any stone can be enhanced by outlining it with a thin enameled outline. For instance, a red ruby becomes redder when it is outlined with blue-green.

This complementary pairing allows the colors of the stones to reach their full potential. Since the 1920s plastics have opened up the range of colors available to the jeweler at little expense, first imitating tortoiseshell and jet, but later coming into their own as versatile materials. Acrylics are now found in a huge range of colors and can be machined and treated to produce a wide range of finishes.

14.23 This assortment of rings, all with blue stones, shows the difference imparted by the use of different materials used as the setting for these rings. Notice how the blue is more brilliant when set in gold.

Commercial Arts and Technology Graphic Design

Our lives are strongly influenced by commercial art, and the graphic designer has come to the forefront of this ever-expanding career path in commercial art. The greatest impact on commercial art has been the development of computer technology. In fact, the computer has revolutionized graphic design (fig. 14.24). The evolution of graphic design to a form of visual art from just imparting information began with the Bauhaus School. This German art school put forth the premise that all objects used as well as seen in an individual's life should reflect beauty and a proper and innovative use of the principles and elements of design. A teapot, for example, is no longer a utilitarian object but rather an object that should be pleasant to look at as well. Form and function now joined with aesthetics in all aspects of life.

The graphic designer deals with a myriad products—packaging, advertising, displays, posters, logos, products, presentations, videos, web sites, and CD-roms, to name but a few. Paramount to the graphic designer's work is that the result of these creations must be noticed and sell. The viewer's attention must be captured and held until the desired message is digested, and color is the tool that can accomplish this goal. Color is the first thing to be noticed and will be remembered for longer than written copy. To this end, when proper color usage is paired with copy the result is a successful product or advertising campaign.

Pure hues and warm hues capture the viewer's attention quickly. However, we find that in the long term large quantities of pure hues can be jarring. Taking account of the roles governing the proportion of color is imperative if a designer is to achieve a balance between short-term and long-term retention. Legibility is the most important factor in graphic design, and the use of typography relies heavily on principles of legibility. The most common use of this theory can be seen in the telephone book's yellow pages. This advertising section of the book is easily read because it uses black print on a yellow ground. Logos rely on legibility and combinations of colors as a way of identifying a product, company, or institution. It is important that logo colors are consistent because the color is remembered for longer than the image. For example, in the mid-twentieth century, when Esso became Exxon the logo changed but the use of red and blue did not. Many products,

14.24 John Luttropp, *Hardware*, 1991. This computer-generated design brings graphic design into the realm of fine art. The use of color relies heavily on the color illumination concept of luster.

companies, and institutions are recognized almost solely by their use of color. A can of Coke is familiar anywhere in the world because of the consistent use of the red-red-orange (known as Coca-Cola red) even when the product name is written in Japanese or Arabic.

Color symbolism also has a great impact. It is important that this symbolism coordinates with the product being marketed. The American Express card was originally green, and in the United States money is usually green: hence American Express became a form of instant money. Color preferences change throughout the world—in the United States the preferred color is blue (medium to pure value), but in Japan it is white.

Cost is always a factor for the graphic designer. The fewer colors that are used, the more economical the project will be. The graphic designer must be able to combine colors in such a manner that few colors provide the greatest impact. Complementary combinations are only one solution.

The graphic designer should study the history of graphic design and advertising, noting especially how colors are associated with certain products through time.

Printing

The graphic designer works closely with the printing industry, and here, too, the computer has revolutionized how the industry functions. The printed page has now become alive with color because the computer has made color printing more economical

and time efficient that it was in the past. Electronic systems such as CEPS (color electronic pre-press system) have allowed the artistic process and the industrial process to combine to produce the desired product. CEPS has four components: the central processing unit computer, the scanner (input device), the work station, and the film recorder (output device that does the image setting). These components must be calibrated and coordinated to produce an ideal final result. To this end the original art must be high quality. Two other systems that can be utilized are the CAD (computer aided design) system and the CAM (computer aided manufacturing) system.

The actual printing process is ink based. There are three procedures available: four-color process, six-color process, and flat/match process.

The four-color printing process utilizes three ink primaries—cyan, magenta, and yellow—as well as black (key), in the **CMYK system**. Each primary color is made into a screen. The screen consists of the primary color converted into tiny dots. The separate primary screens are printed on top of each other to form the colors, and the black screen provides the values of these colors. When viewed on the printed page these tiny dots optically mix to produce the image (see fig. 4.7).

The first step in the four-color printing process is to generate color separations to obtain the screens. The imagery is photographed or scanned into a scanner. As this is done, red, green, and blue filters capture the colors. The red filter captures only blue and green, thus creating the cyan screen. The green filter captures only the red and blue, thus creating the magenta screen, and the blue filter captures only the red and green, creating the yellow screen. The actual printing is done one screen at a time in the following order: yellow, then magenta, then cyan and lastly the black screen (fig. 14.25). Color screen matching can be greatly aided by the use of a color atlas for matching and adjusting color.

Hexachrome, or hifi, printing uses six colors, adding orange and green to CMYK, to increase the range of colors (the gamut) that can be reproduced.

Flat/match color printing relies on transparent color overlays to produce the color imagery. Here the Pantone Matching System (PMS) is the most often utilized color system. PMS consists of nine basic colors—yellow, warm red, rubine red, rhodamine red, purple, violet, reflex blue, process blue, green—plus

black and white. The ink colors are derived from mixing parts of these nine basic colors plus black and white to produce the desired colors for the transparent overlays. The overlays are masks that are generated for each color desired. The Pantone Matching System consists of 1024 color mixtures for the inks. This color matching sytem provides a universal color consistency in the industry (see fig. 4.8). The flat/match color printing process is more expensive than the four-color process but provides truer color matching.

The type of paper stock that is used also affects the color result. Coated paper has a clay coating, and color printed on coated paper is more brilliant. Uncoated stock, while less expensive, absorbs the ink and the colors will be altered and duller. The color alteration is most apparent in newsprint.

Computer Technology and the Internet

The middle of the twentieth century was most profoundly affected by the development of the electronic media, and we are now in the computer age. From the start, computers allowed the user to import concepts and make electronically any changes that were desired. Some people were skeptical about this reliance on technology, but now, in the twentyfirst century, we view the computer and its abilities as simply another tool to employ in both work and leisure. Any computer system purchased today will probably be outdated in a year or two, but two things about color usage and the computer remain constant—the reactions and interactions that colors have with each other and their effect on the viewer. Therefore, it is important that designers know how color works so that they can use it effectively in this computer literate world. To this end, the user must be familiar with the principles of color previously discussed in this book.

Most computer displays are based on the cathoderay tube (CRT). An electron gun at the back of the CRT scans the whole screen in horizontal lines. If this scanning is done sixty times a second it would be termed 60Hz. The faster the scanning capability, the higher the definition becomes. Each scan line is chopped into chunks, called pixels (picture elements). The resolution (fineness) of a display is measured as the number of pixels horizontally by the number of scan lines vertically and, as can be expected, higher numbers bring higher quality images to the screen.

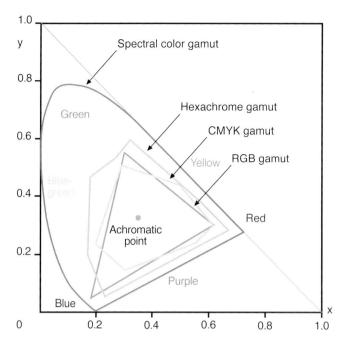

- Spectral color gamut
- Hexachrome gamut
- CMYK gamut
- RGB gamut

14.25 RGB versus CMYK color gamuts. The gamuts are plotted in a CIE. standard color space diagram (see page 19). RGB displays about 70%, and CMYK 30%, of colors detectable by the eye. The two extra colors (orange, green) added to CMYK by hexachrome printing increase a CMYK gamut dramatically.

Color-display systems come in two parts: the color screen itself (the monitor) and the graphics card that drives it. Traditional tubes are based on the light wheel, or additive color, whose primary colors are red, green, and blue (RGB) (fig. 14.25). The number of colors a monitor can display depends on the amount of VRAM (video random access memory) on the graphics card. It consists of layers or planes with one bit (a 1 or 0) stored for each pixel on each plane. The number of planes, and hence the number of bits allocated to each pixel, determines how many colors can be displayed. Therefore, the digital camera with the highest number of pixels will provide the best color.

The color coming from a color monitor is transmitted light and will never be the same as the color seen on the printed page. This is a problem for designers working on a computer. On the monitor the designer is working with RGB (additive color) but the printer is based on CMYK (process color—subtractive

color) (see fig. 14.25). The computer designer can run text samples of colors seen on the screen/print-out, recording what commands result in the desired color palette for future reference. Computer color atlases are also available.

Color printers have become increasingly sophisticated, and there is a wide range of affordable models even for the personal computer user. The color images produced can be further refined by using color photo quality paper rather than plain paper.

The Internet has brought the information highway to businesses, institutions, organizations, and homes worldwide, and computer users have about one hundred million sites on color alone to explore. Websites abound, and website designing has become a viable and profitable business. The designing of these sites depends on the monitor image, and the RGB gamut is, therefore, most often employed.

Conclusion

This whistlestop tour of color applications in fine and applied art is intended to inspire readers to give their own imaginations free rein. Though we have been able only to scratch the surface, it is clear that history and technological advances provide an almost limitless variety of examples of how humans have used color and will continue to innovate through time.

As a final word, it must be stressed that any aspect of our lives that uses color benefits from the knowledge of how color can be utilized. Make notes on how color will be used following the concepts of color reaction and interaction that have been set forth before starting any project. When used properly, the color that surrounds us can provide clarity to the statements we wish to convey and in so doing enrich our world.

Exercises

- 1 Find examples of compositions that use complementary and analogous colors from the history of art.
- 2 Compare portraits by van Eyck, Rembrandt, and van Gogh. How does their different use of color affect our reading of these pictures and the scenes depicted in them?

Appendices

APPENDIX 1

Color Content Identification Charts

The first of these four charts shows neutral values progressing from cool white to cool black and warm white to warm black. The three color content identification charts that follow show how primary and secondary hues can be combined with black and white to produce a range of values and how each primary can be combined with its complementary secondary hue plus the neutrals to vary both value and intensity.

The system identifies each hue by its intial: Y = yellow, R = red, B = blue, V = violet, G = green, and O = orange. For each pair of complements, the primary hue and its color identification label appear at the top, and the secondary hue and its label appear at the bottom of the chart.

The first pair of rows indicates changing values of the pure primary hue by the addition of neutrals; reading from left to right, the hue letter is followed by the letter T plus a number from 1 to 7. T1 represents the lightest value, produced by adding white, and T7 is the darkest value, produced by adding black. In the same manner, the bottom pair of rows of the chart shows changing values for the pure secondary hue.

In the eight middle pairs of rows, shades denoting mixtures of the complementary pigments are shown by the hue letters and a number from 1 to 7 indicating the amount of the secondary hue added to the primary. For example, Y/VI indicates the smallest amount of violet added to yellow. Combined with the value numbers, the system allows the user to identify easily the content of a color. For example, Y/VITI is the smallest amount of violet plus white added to yellow.

Neutrals Black-White

Cool White				Cool				Cool Black
WC	C1	C2	C3	C4	C5	C6	C7	BLC

Warm White				Warm				Warm Black
ww	W1	W2	W3	W4	W5	W6	W7	BLW

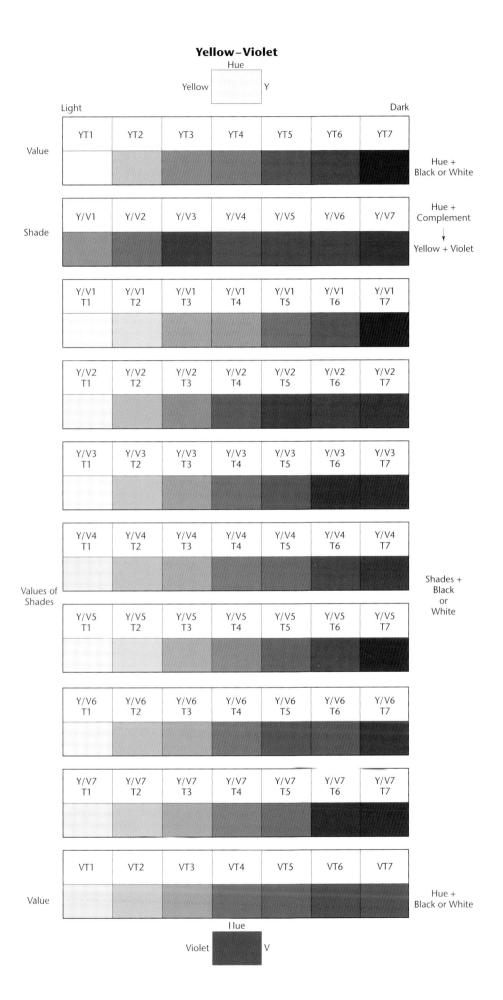

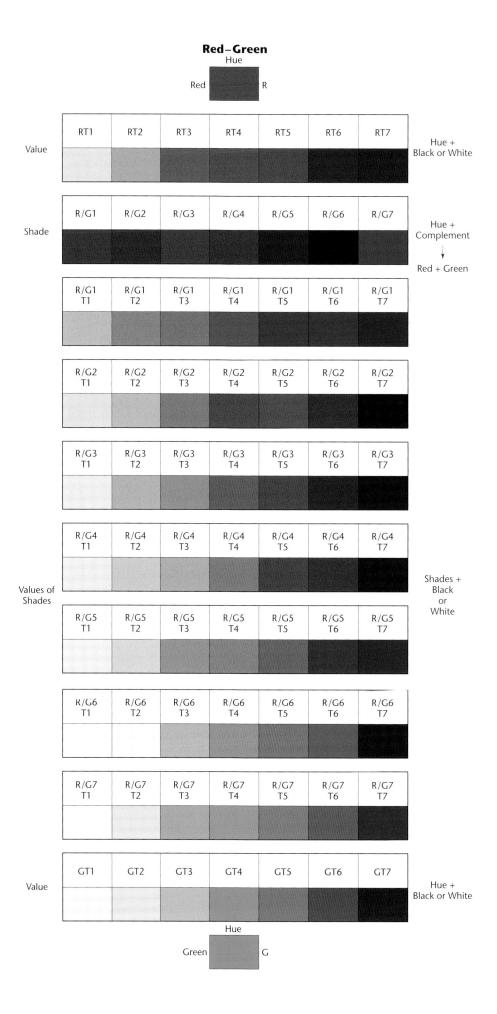

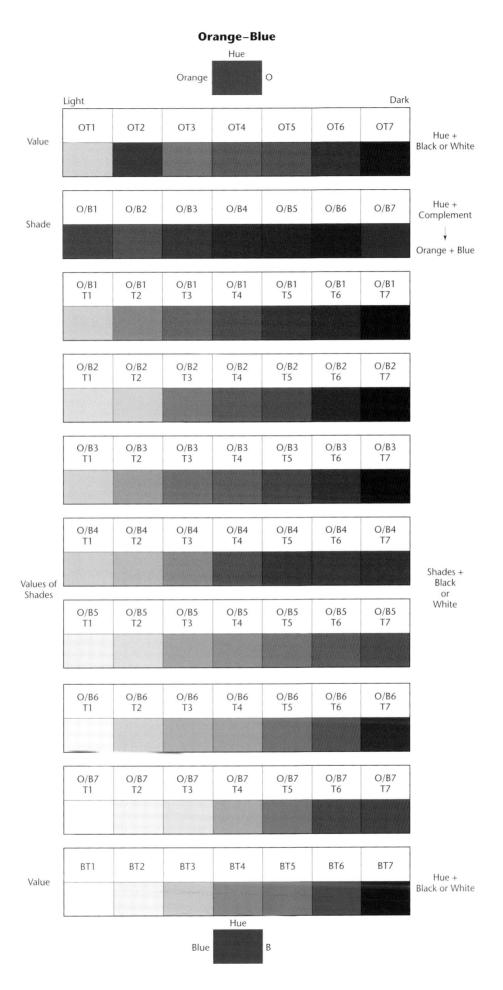

Chronological List of Color Theorists

Empedocles (492-431 B.C.) see Chapter 3

Greek philosopher who formulated the first color theories and identified hues as white, black, yellow-green, and red. He determined that color is perceived by the eye.

Democritus (460-360 B.C.) see Chapter 3

Greek philosopher who stated that color is the result of atomic arrangements. He identified hues as white, black, yellowish-green, and red.

Plato (428-347 B.C.) see Chapter 3

Greek teacher and philosopher who declared that color is a sensation that allows man to describe what he sees. He identified hues as black, white, red, and yellow.

Aristotle (384-322 B.C.) see Chapter 3

Greek philosopher who wrote *De Coloribus* in which he attempted to explain the composition of colors and how they are related. He identified hues as white, black, red, yellow, brown, violet, green, and blue.

Leonardo da Vinci (1452-1519) see Chapter 3

Italian artist and scientist who wrote *Treatise on Painting* in which he identified white, yellow, green, blue, red, and black as simple or primary colors. He discovered that when placed side-by-side, complementary colors intensify each other. He developed atmospheric perspective, chiaroscuro, and sfumato.

Marco Antonio de Dominis (1560-1624)

Italian theologian and natural philosopher who discovered that a mixture of colored light forms white light which is the additive principle of colored light.

Sir Isaac Newton (1642-1727) see Chapter 3

English physicist who, using a prism, discovered the spectral array of hues as red, orange, yellow, green, blue, indigo, and violet. He formed the first color wheel.

J. C. Le Blon (1667-1741)

French printer who discovered that all hues could be derived from red, yellow, and blue pigments.

Moses Harris (1731-1785) see Chapter 3

English entomologist and engraver who wrote *The Natural System of Colors*. He presented the first pigment wheel utilizing red, yellow, and blue as primaries. The wheel is divided into eighteen equal hue divisions and each division is then graded by value.

Johann Wolfgang von Goethe (1749–1832) see Chapter 3 German poet who wrote *Theory of Colors* in which he developed a two-dimensional wheel based on a triad of the primaries red, yellow, and blue with secondaries as complementary hues of the primaries. He also formulated a color triangle, and assigned numbers to each of the hues according to their relative luminosity.

Philip Otto Runge (1777-1810) see Chapter 3

German painter who published *The Color Sphere*, the first three-dimensional color model. Using red, yellow, and blue as primaries, the sphere is arranged with hue mixtures of black and white

Thomas Young (1773–1829) and Hermann Helmholtz (1821–1894) English and German physicists who developed a theory stating that colored lights, when mixed in the correct proportions, can produce any hue. They determined that the eye contains cones that are sensitive to only red, green, and blue—the primary colors.

J. C. Maxwell (1831–1879) see Chapter 3

Scottish physicist who experimented with color combinations involving the concept of additive color. He developed a color triangle with the primaries green, blue, and red at the points and green-blue, yellow, and purple forming the sides with white in the center, and was a pioneer in the field of color photography.

Michel Eugène Chevreul (1786–1889) see Chapter 3
French chemist who wrote *The Principles of Harmony and Contrast of Colors* and determined that hues could be obtained from mixtures of red, yellow, and blue. He developed the laws of simultaneous contrast, successive contrast, and optical mixing and set forth harmonies known as color schemes.

Ogden Rood (1831-1902) see Chapter 3

American physicist who wrote *Modern Chromatics* in which he determined that colors differed one from another as a result of purity, luminosity, and hue. He developed a three-dimensional color wheel based on the primaries red, green, and blue arranged so that the complementary hues were the result of afterimaging.

Ewald Hering (1834-1918) see Chapter 3

German physiologist who used the primaries red, yellow, blue, and green to create a color diagram based on perception and not the physical mixing of colors.

Albert Munsell (1858-1918) see Chapter 3

American color theorist who wrote *Color Notation* in which he stated that color could be described in three variables—hue, value, and chroma. He determined that there were five principal hues—red, yellow, blue, green, and purple and developed a three-dimensional color tree.

Walter Sargent (1868-1927)

American artist/teacher who wrote *The Enjoyment and Use of Color* which stated that there are four basic colors—red, yellow, blue, and green.

Wilhelm Ostwald (1853-1932) see Chapter 3

German chemist who based his color model on geometric progression and described all colors as a combination of hue, black, and white.

Paul Klee (1879-1940)

Swiss artist who worked with six hues—violet, red, yellow, green, and blue, and developed a color circle which was divided into three parts and then subdivided into six parts.

C.I.E. (1931 and 1953) see Chapter 3

International Commission on Illumination (Commission Internationale de l'Eclairage) which explored the need for standardization of color notations.

Johannes Itten (1888-1967) see Chapter 3

Swiss teacher/artist who wrote *The Art of Color* and *The Elements of Color*. He developed his color star by flattening out Runge's sphere and set forth six contrasts of color—light/dark, cold/warm, complementary, simultaneous contrast, quality or saturation, and quantity or extension.

Alfred Hickethier (1903-1967) see Chapter 3

German painter concerned with color reproduction in printing who wrote *Hickethier Color System* and *Color Mixing by Numbers*. He used a color solid in the form of a cube with the primaries yellow, magenta, and cyan. His system allowed very precise mixing of color.

Josef Albers (1888-1976) see Chapter 3

Bauhaus teacher/artist who wrote *Interaction of Color* and had an interest in simultaneous contrast.

Faber Birren (1900-1988) see Chapter 3

American art historian who wrote over twenty-four books on color and developed the Rational Color Circle which groups thirteen colors around a gray which is displaced from the center and thus presents a system which assigns more space to the "warm" colors between red and yellow than the "cold" colors between green and violet. He took account of the eye's ability to distinguish more warm colors, which are therefore granted greater importance in art.

Harald Kueppers (1928-)

German color theorist who wrote *Color Atlas: A Practical Guide to Color Mixing* and *The Basic Law of Color Theory.*He used the primary colors violet-blue, green, and orangered to form a color diagram which took the form of a rhombohedron.

Frans Gerritsen (1953-) see Chapter 3

Dutch color theorist/artist who wrote *Theory and Practice* of Color and Evolution in Color. He based his work on the laws of perception and used primaries that the eye sees—red, green, and blue. He attempted to put all future color research on a sound scientific basis.

APPENDIX 3

Coloring Agents—Dry Binders

Medium/Material	Binder	Medium/Material	Binder
Pencil	Graphite	Graphite	Greasy, dark-gray form of carbon
Chalk	Non-fat—clay, kaolin		mixed with clay to make lead powdorod form. May be used as
Crayon	Fatty or greasy—wax		dry pigment or in paints
Conté crayon	Oil	Pastel	Powdered pigment or chalk pressed
Oil pastel (Craypas)	Linseed oil and solids (wax)		into stick form. Hardness determined by amount of binder used. Chalk controls depth of color
Colored pencil	Wax		
Litho crayon	Greasy solid		

APPENDIX 4

Coloring Agents—Liquid Binders

Medium/Material	Binder	Medium/Material	Binder	
Ink	Liquid	Distemper	Water soluble glue or gum,	
Oil paint	Oil paint Linseed oil (vegetable based oil).	(poster paint)	opaque, inexpensive	
	Serves as a natural polymer. Will not	Lithography ink	Oil based ink	
	warp a surface but can rot fibers. Slow drying. Darkens as it dries	Ceramic glaze	Made of three basic ingredients: silica, flux and alumina as well as pigments.	
Encaustic	Hot beeswax. Used in early painting, preceded oil paints		Can be either transparent or opaque. Matte glaze—dull surface when fired.	
Fresco	Water. Water paint is painted on fresh lime plaster and the two substances fuse together		Fritted glazes—contain water soluble chemicals to enhance color clarity; two types are "f-series"—semiopaque, brilliant colors, used with	
Egg tempera	Egg yolk and linseed oil or water. Transparent, dries quickly. Does not blend well		pottery clays; "high fire glazes"— porcelain, stoneware, have matte, textured, and transparent gloss glazes.	
Acrylic	Acrylic polymer. Quick drying and		May also contain lead	
	flexible. Comes in matte or glossy	Casein	Milk-derived polymer	
	form.	Stained glass	Metal-based pigment in liquid molten	
Watercolor	Gum arabic, glycerine and/or honey. Transparent		glass	
		Enamel	Pigment plus powdered glass. Fused to	
Gouache (designer colors)	Opaque white plus watercolor		metal by heat	

APPENDIX 5

Coloring Agents—Pigment Origins and Characteristics of Common Colors

Alizarin: originally a vegetable dye from	Earth colors: browns, low intensity	Sap green: organic, vegetable
madder, highly fast, brilliant red, transparent	earth pigments such as iron oxide or clays, common names are raw	Sepia: organic, animal
Aureolin: transparent	sienna, raw umber, burnt sienna, burnt umber, yellow ocher	Titanium white: mineral, slightly pink
Blue: indigo plant	Flake white: mineral, pure white lead	Ultramarine blue: mineral, deep blue pigment, transparent, historically
Burnt sienna: heated clay from Sienna, Italy, mineral, transparent	Green: malachite	was powdered lapis lazuli
Burnt umber: mineral	Indigo: organic, vegetable	Umber: clay from Umbria, Italy
Cadmium: opaque	Lead white: mineral, slightly gray	Vermillion: opaque
Cadmium yellow: greenokite,	Mars yellow: transparent	Yellow ocher: mineral, opaque
permanent but dulls quickly	Prussian blue: transparent	Zinc white: oxide of zinc, mineral, slightly yellow
Carmine: organic, vegetable	Raw sienna: pure ground clay from	0 ,,
Chrome yellow: turns green or greenish	Sienna, Italy, mineral, transparent	
black in time	Red: cochineal (insects)	
Cinnabar red: sulphide of mercury	Rose madder: organic from roots	
Cobalt blue: opaque	Royal purple: sea snails' mucus	

Hue—Various Art Media Matched to Color-Aid Paper Pure Hues

Luma Water Color Formulas

The numbers indicate the number of drops required. When mixing be precise and do not add excess water. Make sure the brush is cleaned thoroughly after each color. Make sure the color is painted evenly and solidly without streaking or allowing the white paper to show through.

YELLOW: sunshine yellow YELLOW-ORANGE-YELLOW: 22 sunshine yellow, 1 permanent crimson

YELLOW-ORANGE: 14 sunshine yellow, 1 permanent crimson

ORANGE-YELLOW-ORANGE: 8 sunshine yellow, 1 permanent crimson

ORANGE: 4 sunshine yellow, 1 permanent crimson

ORANGE-RED-ORANGE: 2 sunshine yellow, 1 permanent crimson

RED-ORANGE: 1 permanent crimson, 1 sunshine yellow

RED-ORANGE-RED: 2 permanent crimson, 1 sunshine yellow

RED: permanent crimson

RED-VIOLET-RED: 1 permanent violet, 1 permanent crimson

RED-VIOLET: permanent violet

VIOLET-RED-VIOLET: 2 permanent violet, 2 permanent crimson, 1 permanent blue

VIOLET: 3 permanent violet, 1 permanent blue

VIOLET-BLUE-VIOLET: 2 permanent violet, 2 permanent blue

BLUE-VIOLET: 3 permanent blue, 2 permanent violet

BLUE-VIOLET-BLUE: 3 permanent blue, 1 permanent violet

BLUE: 9 permanent blue, 1 permanent crimson

BLUE-GREEN-BLUE: 10 permanent blue, 2 permanent green, 1 permanent crimson

BLUE-GREEN: 4 permanent green, 17 permanent blue

GREEN-BLUE-GREEN: 4 permanent green, 7 permanent blue

GREEN: 3 permanent green, 1 permanent blue

GREEN-YELLOW-GREEN: 1 sunshine yellow, 6 permanent green, 1 permanent blue

YELLOW-GREEN: permanent green YELLOW-GREEN-YELLOW: 2 sunshine yellow, 1 permanent green

CYAN: 10 permanent blue, 4 permanent green

MAGENTA: 12 permanent violet, 3 permanent crimson

Windsor & Newton Designer Colors

The numbers indicate the number of drops required.

YELLOW: spectrum yellow YELLOW-ORANGE-YELLOW: 1 spectrum yellow, 1 marigold YELLOW-ORANGE: marigold

ORANGE-YELLOW-ORANGE: 2 winsor orange, 1 marigold

ORANGE: winsor orange

ORANGE-RED-ORANGE: 1 scarlet,

2 winsor orange

RED-ORANGE: scarlet

RED-ORANGE-RED: 1 scarlet, 1 crimson

RED: crimson

RED-VIOLET: 1 quinacridone red, 3 quinacridone violet

VIOLET-RED-VIOLET: quinacridone violet

VIOLET: 2 quinacridone violet, 1 dioxazine violet

VIOLET-BLUE-VIOLET: dioxazine violet BLUE-VIOLET: 1 dioxazine violet, 1 ultramarine

BLUE-VIOLET-BLUE: 1 dioxazine violet, 4 ultramarine

BLUE: ultramarine

BLUE-GREEN-BLUE: 1 turquoise green, 3 ultramarine

BLUE-GREEN: turquoise green

GREEN-BLUE-GREEN: 4 turquoise green, 1 brilliant green

GREEN: 1 turquoise green, 1 brilliant green

GREEN-YELLOW-GREEN: 1 turquoise green, 4 brilliant green

YELLOW-GREEN: 1 spectrum yellow, 2 brilliant green

YELLOW-GREEN-YELLOW: 2 spectrum yellow, 1 brilliant green

CYAN: process cyan MAGENTA: process magenta

Rotring Colors

The numbers indicate the number of drops required.

YELLOW: 1 lemon yellow, 1 yellow gold

YELLOW-ORANGE-YELLOW: 1 orange, 6 lemon yellow

YELLOW-ORANGE: 1 orange, 2 lemon vellow

ORANGE-YELLOW-ORANGE: 1 orange, 1 yellow gold

ORANGE: orange

ORANGE-RED-ORANGE: 2 orange, 1 red

RED-ORANGE: 1 red, 1 orange

RED-ORANGE-RED: 2 red, 1 orange

RED: red

RED-VIOLET-RED: 1 purple, 1 red

RED-VIOLET: purple

VIOLET-RED-VIOLET: 1 blue violet, 1 purple

VIOLET: blue violet

VIOLET-BLUE-VIOLET: 1 blue, 2 blue violet

BLUE-VIOLET: 1 blue, 4 blue violet

BLUE-VIOLET-BLUE: 1 blue, 1 blue violet

BLUE: blue

BLUE-GREEN-BLUE: 1 turquoise, 1 blue

BLUE-GREEN: turquoise

GREEN-BLUE-GREEN: 1 green, 1 turquoise

rturquoise

GREEN: green

GREEN-YELLOW-GREEN: 2 green, 1 lemon yellow

YELLOW-GREEN: 1 green, 1 lemon yellow

YELLOW-GREEN-YELLOW: 1 green, 4 lemon yellow

CYAN: none

MAGENTA: none

Liquitex Acrylic Paints

YELLOW: yellow medium Azo or cadmium yellow light
YELLOW-ORANGE-YELLOW: none
YELLOW-ORANGE: brilliant
orange/cadmium orange hue
ORANGE-YELLOW-ORANGE: none
ORANGE: none
ORANGE-RED-ORANGE: scarlet
red/cadmium red light hue

RED-ORANGE: naphthol red light RED-ORANGE-RED: none RED: acra violet RED-VIOLET-RED: deep magenta **RED-VIOLET:** none VIOLET-RED-VIOLET: prism violet VIOLET: dioxazine purple VIOLET-BLUE-VIOLET: none BLUE-VIOLET: none BLUE-VIOLET-BLUE: none BLUE: brilliant blue purple BLUE-GREEN-BLUE: cerulean blue hue (ultramarine blue) BLUE-GREEN: none GREEN-BLUE-GREEN: phthalocyanine green GREEN: permanent green deep GREEN-YELLOW-GREEN: none YELLOW-GREEN: permanent green YELLOW-GREEN-YELLOW: vivid lime green CYAN: none MAGENTA: none

Liquitex Concentrated Artist Colors

YELLOW: brilliant yellow YELLOW-ORANGE-YELLOW: none YELLOW-ORANGE: brilliant orange ORANGE-YELLOW-ORANGE: none **ORANGE**: none ORANGE-RED-ORANGE: scarlet RED-ORANGE: none RED-ORANGE-RED: lacquer red RED: naphthol crimson **RED-VIOLET-RED:** raspberry **RED-VIOLET:** none VIOLET-RED-VIOLET: none VIOLET: prism violet VIOLET-BLUE-VIOLET: none BLUE-VIOLET: twilight BLUE-VIOLET-BLUE: none BLUE: none BLUE-GREEN-BLUE: swedish blue **BLUE-GREEN:** none GREEN-BLUE-GREEN: none GREEN: none GREEN-YELLOW-GREEN: christmas YELLOW-GREEN: green YELLOW-GREEN-YELLOW: none CYAN: brilliant blue MAGENTA: none

PrismaColor Markers

Hues are created by layering colors in the order shown. The first number is laid down first with the second number on top of it to create the hue.

YELLOW-ORANGE-YELLOW: PM 15

YELLOW-ORANGE: PM 16 ORANGE-YELLOW-ORANGE: PM 13 ORANGE: PM 14, PM 13 ORANGE-RED-ORANGE: PM 13, PM 5 RED-ORANGE: PM 6, PM 4, PM 6 **RED-ORANGE-RED: PM 4** RED: PM 5, PM 4, PM7 RED-VIOLET-RED: PM 53, PM 7 RED-VIOLET: PM 53, PM 51, PM 53 VIOLET-RED-VIOLET: PM 53, PM 51 VIOLET: PM 51, PM 168 VIOLET-BLUE-VIOLET: PM 168, PM 45 **BLUE-VIOLET: PM 45** BLUE-VIOLET-BLUE: PM 42, PM 44 BLUE: PM 42, PM 44, PM 48 BLUE-GREEN-BLUE: PM 40, PM 48 BLUE-GREEN: PM 125, PM 37 GREEN-BLUE-GREEN: PM 185 GREEN: PM 186, PM 185 GREEN-YELLOW-GREEN: PM 165, YELLOW-GREEN: PM 165, PM 167. YELLOW-GREEN-YELLOW: PM 167. PM 24 CYAN: PM 39 MAGENTA: PM 53

PrismaColor Pencils YELLOW: 916 canary yellow YELLOW-ORANGE-YELLOW: 917 yellow orange YELLOW-ORANGE: 918 orange **ORANGE-YELLOW-ORANGE: 921** vermillion red ORANGE: none ORANGE-RED-ORANGE: 922 scarlet RED-ORANGE: 924 crimson red RED-ORANGE-RED: 923 scarlet lake RED: none RED-VIOLET-RED: none RED-VIOLET: 931 purple VIOLET-RED-VIOLET: none VIOLET: 932 violet VIOLET-BLUE-VIOLET: none **BLUE-VIOLET:** none BLUE-VIOLET-BLUE: 933 blue violet BLUE: 902 ultramarine BLUE-GREEN-BLUE: 906 copenhagen blue BLUE-GREEN: 908 dark green GREEN-BLUE-GREEN: 907 peacock GREEN: 909 grass green GREEN-YELLOW-GREEN: none YELLOW-GREEN: none YELLOW-GREEN-YELLOW: 912 apple green

CYAN: 903 true blue MAGENTA: 930 magenta

Duncan Gloss Ceramic Glazes

YELLOW: sun yellow GL 670 YELLOW-ORANGE-YELLOW: orange peel GL 657 YELLOW-ORANGE: pumpkin orange GL ORANGE-YELLOW-ORANGE: none ORANGE: tangerine GL 632

ORANGE-RED-ORANGE: none RED-ORANGE: none RED-ORANGE-RED: christmas red GL

RED: matador red GL 614

RED-VIOLET-RED: none RFD-VIOLET: none VIOLET-RED-VIOLET: none VIOLET: none VIOLET-BLUE-VIOLET: none BLUE-VIOLET: midnight blue GL 784 BLUE-VIOLET-BLUE: royal blue GL 634 BLUE: aegean blue GL 676 BLUE-GREEN-BLUE: catalina blue GL 648

BLUE-GREEN: basque blue GL 661 GREEN-BLUE-GREEN: none GREEN: emerald green GL 609 GREEN-YELLOW-GREEN: none YELLOW-GREEN: none YELLOW-GREEN-YELLOW: green mint

GL 671 CYAN: none MAGENTA: none

GREEN: 909

D.M.C. Embroidery Floss

YELLOW: 444 YELLOW-ORANGE-YELLOW: 972 YELLOW-ORANGE: 741 **ORANGE-YELLOW-ORANGE: 970** ORANGE: 946 ORANGE-RED-ORANGE: 608 **RED-ORANGE: 606 RED-ORANGE-RED: 350 RED: 326** RED-VIOLET-RED: none **RED-VIOLET:** none VIOLET-RED-VIOLET: none VIOLET: none VIOLET-BLUE-VIOLET: none **BLUE-VIOLET: 791** BLUE-VIOLET-BLUE: none BLUE: 796 **BLUE-GREEN-BLUE: 824** BLUE-GREEN: 806 or 3765 **GREEN-BLUE-GREEN: 991**

GREEN-YELLOW-GREEN: 699 or 700

YELLOW-GREEN: 701

YELLOW-GREEN-YELLOW: 699 or 700

BLACK: 310

WHITE: blanc or white

Susan Bates/Anchor Embroidery

YELLOW: 291

YELLOW-ORANGE-YELLOW: 303

YELLOW-ORANGE: 314

ORANGE-YELLOW-ORANGE: 324

ORANGE: 330

ORANGE-RED-ORANGE: 335

RED-ORANGE: 334 RED-ORANGE-RED: 9036

RED: 47

RED-VIOLET-RED: 65 RED-VIOLET: 94

VIOLET-RED-VIOLET: 101

VIOLET: 112

VIOLET-BLUE-VIOLET: 119

BLUE-VIOLET: 178
BLUE-VIOLET-BLUE: 941

BLUE: 132

BLUE-GREEN-BLUE: 147 BLUE-GREEN: 162

GREEN-BLUE-GREEN: 189

GREEN: 923

GREEN-YELLOW-GREEN: 228

YELLOW-GREEN: 244

YELLOW-GREEN-YELLOW: 239

BLACK: 403 WHITE: 1

Paternayan Persian Wool Yarn

YELLOW: 772

YELLOW-ORANGE-YELLOW: 770

YELLOW-ORANGE: 813

ORANGE-YELLOW-ORANGE: 811

ORANGE: 810

ORANGE-RED-ORANGE: 821

RED-ORANGE: 820 RED-ORANGE-RED: 951

RED: 941

RED-VIOLET-RED: 903 KED-VIOLET: none

VIOLET-RED-VIOLET: none

VIOLET: 311

VIOLET-BLUE-VIOLET: 330 BLUE-VIOLET: none

BLUE-VIOLET-BLUE: 340

BLUE: 541

BLUE-GREEN-BLUE: 551 BLUE-GREEN: 581

GREEN-BLUE-GREEN: 574

GREEN: 681

GREEN-YELLOW-GREEN: 620

YELLOW-GREEN: 696

YELLOW-GREEN-YELLOW: 631

BLACK: 220 WHITE: 260

Medici Wool Yarn

YELLOW: none

YELLOW-ORANGE-YELLOW: 8742

YELLOW-ORANGE: 8941 ORANGE-YELLOW-ORANGE:

none

ORANGE: 8908

ORANGE-RED-ORANGE: none

RED-ORANGE: 8128 RED-ORANGE-RED: 8127

RED: 8103

RED-VIOLET-RED: none

RED-VIOLET: 8123

VIOLET-RED-VIOLET: none

VIOLET: 8794

VIOLET-BLUE-VIOLET: none

BLUE-VIOLET: none

BLUE-VIOLET-BLUE: none

BLUE: 8720

BLUE-GREEN-BLUE: 8993

BLUE-GREEN: 8207

GREEN-BLUE-GREEN: none

GREEN: none

GREEN-YELLOW-GREEN: none

YELLOW-GREEN: none

YELLOW-GREEN-YELLOW: none

BLACK: noir WHITE: blanc

Appleton Crewel Wool Yarn

YELLOW: 550-3

YELLOW-ORANGE-YELLOW: none

YELLOW-ORANGE: 550-6

ORANGE-YELLOW-ORANGE: none

ORANGE: none

ORANGE-RED-ORANGE: 440-3

RED-ORANGE: 440-5

RED-ORANGE-RED: 500-1

RED: 500-2

RED-VIOLET-RED: none

RED-VIOLET: none

VIOLET-RED-VIOLET: 450-5

VIOLET: none

VIOLET-BLUE-VIOLET: none

BLUE-VIOLET: 460-5

BLUE-VIOLET-BLUE: none

BLUE: 820-3

BLUE-GREEN-BLUE: none

BLUE-GREEN: 480-6

GREEN-BLUE-GREEN: 520-7

GREEN: 430-6

GREEN-YELLOW-GREEN: 420-8

YELLOW-GREEN: none

YELLOW-GREEN-YELLOW: none

BLACK: 993 WHITE: 991

Au Ver A Soie Silk Yarn

YELLOW: 543

YELLOW-ORANGE-YELLOW: 545

YELLOW-ORANGE: 624

ORANGE-YELLOW-ORANGE: 633

ORANGE: 646

ORANGE-RED-ORANGE: 913

RED-ORANGE: 636

RED-ORANGE-RED: 915

RFD: 945

RED-VIOLET-RED: 3026

RED-VIOLET: 1046

VIOLET-RED-VIOLET: 1315

VIOLET: 3315

VIOLET-BLUE-VIOLET: 1345

BLUE-VIOLET: 1415

BLUE-VIOLET-BLUE: 116

BLUE: 4924

BLUE-GREEN-BLUE: 115

BLUE-GREEN: 126 or 1726

GREEN-BLUE-GREEN: 1825 or 205

GREEN: 216

GREEN-YELLOW-GREEN: 235

YELLOW-GREEN: 224

YELLOW-GREEN-YELLOW: 224

BLACK: noir

WHITE: blanc

D.M.C. Rayon Floss

YELLOW: none

YELLOW-ORANGE-YELLOW: none

YELLOW-ORANGE: none

ORANGE-YELLOW-ORANGE: none

ORANGE: none

ORANGE-RED-ORANGE: 30606

RED-ORANGE: none

RED-ORANGE-RED: 30666

RED: 30321

RED-VIOLET-RED: none

RED-VIOLET: 30915

VIOLET-RED-VIOLET: none

VIOLET: none

VIOLET-BLUE-VIOLET: none

BI LIE-VIOLET: 30336

BLUE-VIOLET-BLUE: none

BLUE: 30797

BLUE-GREEN-BLUE: none

GREEN-BLUE-GREEN: none GREEN: 30909

BLUE-GREEN: none

GREEN-YELLOW-GREEN: none

YELLOW-GREEN: none

YELLOW-GREEN-YELLOW: none

BLACK: 30310

WHITE: 35200

APPENDIX 7

Value Orders

NATURAL

Dark, medium, light

Light, medium, dark

ARCHITECTURAL

Light, medium, dark

TYPOGRAPHICAL Dark, medium, light

HUE ORDER RANGES

Pure hue, dark-value hues, black Light-value hues to dark-value hues

Light-value hues and black

Dark-value hues to white

Pure hues, light-value hues, white

APPENDIX 8

Color Legibility Rankings

Background Color	Lettering/Line Color	Background Color	Lettering/Line Color
1 yellow	black	16 red	black
2 black	yellow	17 orange	blue
3 white	green	18 green	yellow
4 white	red	19 red	yellow
5 white	black	20 red	white
6 blue	white	21 black	red
7 yellow	blue	22 orange	white
8 white	blue	23 green	black
9 black	white	24 white	orange
10 yellow	green	25 blue	orange
11 orange	black	26 orange	yellow
12 yellow	red	27 orange	red
13 blue	orange	28 red	blue
black	orange	green	red
14 blue	yellow	29 orange	green
15 green	white		

Expiation

Suffering

Penance

Love

God the Father

Color Symbols in Religion

CHRISTIANITY Royalty Brown or Gray White Sackcloth of mourning and penitence Imperial Power Christmastide Renunciation of the world Trinity Green Ashes Ascension Degradation **Epiphany** Easter Trinity Season Humility All Saints Spiritual death **Budding and Living Vegetation** Transfiguration God providing for man's needs Silver Pope Hope Innocence Spring Innocence Life **Holiness** Joy Life Charity Triumph Regeneration of soul through good Purity works JUDAISM Light Doctrine of the Church White Holiness of Life Yom Kippur Cleanliness Old Rose Purity God our Savior Heaven and earth Red Invitation to rejoice Martyrs' Days Blue **Dedications** Gold Sky Church Anniversaries Divine or celestial light Pentecost The Glory of God Reformation Day **ISLAM** Cardinal Black Green Bishop Death Islam Blood Mourning Fire Solemnity Black Hate Negation Suffering of Husayn Martyrs Sickness The grave Penance Black and White Passion of Christ White Humility Thanksgiving Resurrection Life of the Church Purity of life Tongues of Fire Yellow or Saffron Christian Zeal **BUDDHISM** Robe of glory White Sovereign Power Deceit Purity Ordinations Treason Shugen-do Jealousy Purple Degradation Yellow Lent Infernal light **Taoism** Advent Bishop Blue Purification of sin HINDUISM Advent **Passion** Pre-Lent Blue

Mourning Heavenly love Yellow
Truth Royalty Earth

Penance

Color of the firmament

Purification of sin

Unveiling of truth

Blessed Virgin

Krishna

Infinity

Ocean

Sky

Historical Color Palettes

Numbers in () are for D. M. C. Embroidery Floss (#D) and/or Anchor Embroidery Floss (#A)

PRE-HISTORIC 30,000 B.C.
White (blanc D, #1A)
Warm light brown (#363A)
Dark brown (#359A)
Dark red (#1015A)
Blue-violet (#119A)
Dark warm gray/black (#3799D)

EGYPTIAN 3200 B.C.—663 B.C.
Medium dull green-blue-green (#877A)
Pale green (#219A)
Pale blue-green (#928A)
Dark blue-violet (#177A)
Medium dull red-orange (#11A)
Dull yellow-orange-yellow (#891A)
Medium rust (#338A)
Dark warm gray/black (#3799D)
Light grayed blue-violet (#341D)
Dull dark red-violet (#1019A)

GREEK 6th—5th Century B.C.
Pale rust (#1010A)
Dark warm gray/black (#3799D)
Dull red (#1014A)
Medium rust (#338A)
Yellow-orange-yellow (#303A)
Light yellow-orange-yellow (#293A)
Dull blue (#827D)
Lavender (#108A)
Dull light red-violet (#894A)
Pale dull green (#966D)

POMPEII 79 A.D.
Black (#310D, #403A)
Dull medium red-violet-red (#42A)
Medium violet-red-violet (#98A)
Dull green-blue-green (#3817D)
Dull yellow-green (#3347D)
Light yellow-orange-yellow (#297A)
Medium taupe (#677A)
Grayed blue-violet (#340D)
Dark dull green-blue-green (#503D)
Dull red-violet (#3803D)

MEDIEVAL (BAYEAUX TAPESTRY) c. 1085 Dark dull green (#878A) Dull medium red-violet-red (#896A)
Dull dark yellow-orange (#901A)
Dull light blue (#1038A)
Dull dark blue-green (#675A)
Light dull green-yellow-green (#369D)
Medium dull yellow-green (#844A)
Very pale yellow (#3823D)

GOTHIC (ILLUMINATIONS) 13th—16th Century Yellow (#290A) Medium dull blue (#161A) Dark dull blue-violet-blue (#979A) Light dull green (#3813D) Pale red-violet (#3609D) Medium rust (#922D) Medium dull yellow-green (#581D) Dark dull blue-green (#991D) Light medium blue-green (#167A) Medium orange-red-orange (#329A)

RENAISSANCE 14th—15th Century White (blanc, D, #1A) Yellow (#290A) Yellow-orange-yellow (#298A) Medium yellow-orange (#1002A) Warm brown (#780D) Very dark brown (#381A) Orange (#333A) Medium dark dull red-orange (#13A) Dark red-violet-red (#65A) Medium green-yellow-green (#244A) Medium light green-yellow-green (#243A) Dull dark yellow-green (#845A) Medium dark blue (#132A) Blue-violet (#123A) Violet-red-violet (#99A) Dark warm gray/black (#3799D)

COLONIAL AMERICA—1700s
Dull medium blue (#813D)
Medium dull blue-green-blue (#3810D)
Dark dull green-blue-green (#503D)
Light green (#241A)
Pale yellow-green-yellow (#278A)
Very pale dull yellow-orange-yellow (#956A)
Pale dull brown (#376A)
Medium light brown (#376A)
Medium dull red-orange-red (#38A)
Medium dull blue (#161A)

VICTORIAN MID-END 19th Century Medium dull yellow-orange-yellow (#890A) Warm medium red-orange (#33A) Medium violet-red-violet (#92A) Medium dull violet-red-violet (#98A) Medium light blue-green (#187A) Dark dull red (#3350D) Dull medium green (#3052D) Dark dull green (#3362D) Medium dark rust (#921D) Black (#310D, #403A)

INDIA
Very pale dull red-orange (#6A)
Pale yellow-orange-yellow (#300A)
Yellow-orange-yellow (#302A)
Medium violet-blue-violet (#1030A)
Dull orange-yellow-orange (#326A)
Pale green-blue-green (#206A)
Pale red-violet-red (#36A)
Grayed light blue (#1033A)
Dark rust (#341A)
Medium light yellow-green (#238A)

CHINA
Red-orange-red (#29A)
Medium light yellow-orange-yellow
(#295A)
Medium light green (#226A)
Pale yellow-green (#254A)
Pale violet-red-violet (#90A)
Medium light rust (#868A)
Very pale dull yellow-green (#259A)
Pale blue-green (#928A)
Medium dull blue (#161A)
Dull medium blue-violet (#176A)

JAPAN
Blue-violet (#123A)
Medium dull blue-violet (#813D)
Medium light dull green (#988D)
Pale dull brown (#677D)
Light red-orange (#352D)
Pale yellow (#727D)
Medium dull blue (#932D)
Warm medium gray (#452D)
Medium dull brown (#436D)
Black (#310D, #403A)

Glossary

Achromatic: No hue present; without chroma.

Achromatic simultaneous contrast: Simultaneous contrast that concerns itself with the interactions of black, white, and grays.

Additive color: The process of mixing the colors of light together.

Afterimage: A reaction seen when the observer's brain supplies the opposite or complementary hue after the observer stares at a particular hue.

Analogous color scheme: A color scheme based on three or more hues located next to each other on the color wheel.

Analogous hues: Hues adjacent to each other on the color wheel.

Aniline dye: The first synthetic dye, based on alcohol and coal-tar derivatives.

Arbitrary color: The effect of color as produced by the artist imposing feelings on an object's color. This effect abandons natural color.

Architectural order: A sequence with the lightest value at the top and the darkest at the bottom.

Artificial light: Light created by artificial means. Three types: incandescent (warm), electric arc, and fluorescent.

Asymmetrical balance: Balance that relies on non-symmetrical design components, in which both sides of the work are not the same or divisible.

Atmospheric perspective: The color reactions that occur when colors are perceived from a distance. As objects become more distant from the eye the value contrast lessens, the edges become less defined, and the hues become more neutral or dull with a bluishgray cast.

Azo dye: A dye based on petroleum.

Balance: The overall appearance of a work that imparts unity. There are three types: symmetrical balance, asymmetrical balance, and radial balance.

Bezold effect: The effect that occurs when colors are changed by juxtaposing them with different colors. Also known as the spreading effect.

Binder: A vehicle that transforms pigments into a workable tool.

Broken hue: A color that is a combination in unequal proportions of all the primaries. Also termed broken color.

Broken tint: A broken hue with the addition of white or black. Also known as nature gray.

Cast shadow: A shadow thrown by an object onto an adjacent surface.

Chiaroscuro: The use of light and shadow effects in a painting.

Chroma: The saturation or brightness of a color. Chroma can also define the purity of a hue and describe a hue or color's strength.

Chroma strength: The degree of difference in pure hue strength. Yellow has the greatest chroma strength.

Chromatic: Having a hue.

Chromatic black: Black that is the result of mixing red, yellow, and blue together.

Chromatic grays: See warm grays

Chromaticity: In lights, a measure of the combination of hue and saturation in a color.

Chromatic simultaneous contrast: Simultaneous contrast that concerns itself with hue/color changes that occur due to the influence of the surrounding hues/colors.

Chromotherapy: The use of color for healing purposes.

CMYK system: The four-color (cyan, magenta, yellow, black or "key") screen system used to reproduce color photographs.

Color blindness: Defective color vision that results in color identification confusion.

Color harmonies: *See* color schemes.

Color schemes: Partitive combinations of pure hues and their variations that are harmonious.

Color theory: The study of color that uses various types of order, observation, scientific fact, and psychology to explain color reactions and interactions.

Color wheel: A circular model showing color relationships.

Colored gray: The resulting color derived from adding a pure hue's exact value of gray.

Complementary color scheme: A color scheme built on two hues directly opposite each other on the color wheel.

Complementary hues: Hues directly across from each other on the color wheel.

Cones: Cells in the retina that are sensitive to bright light and color.

Contrast: The visual difference between colors.

Cool grays: The result of mixing white with a commercially produced black

Cool hues: Cool hues are usually related to blue and include: yellow-green, green, blue-green, blue, blue-violet, and violet. Blue-green is the coolest hue.

Core of shadow: The most concentrated area of darkness on an object.

Deuteranopia: A form of color blindness in which sensitivity to green is reduced.

Diffraction: The breaking up of a beam of light into a series of dark or light bands or colored spectra, after hitting an obstacle.

Dimension: The property of a color. There are four: hue, value, intensity, and temperature.

Disappearing boundaries: The effect obtained when adjacent hues of the same or near value are in a partitive setting.

Discord: The effect obtained when the value of a hue is opposite to its natural order.

Dissolving boundaries: The effect obtained when equal-valued related broken colors are found in a partitive setting.

Divisionism: The optical mixing of lines, crossed lines, or dots of different colors on a ground other than white.

Double complementary color scheme: A color scheme based on two sets of complementary colors. When the hues are spaced equidistantly on the color wheel, this is known as a quadrad color scheme.

Dye: A pigment dissolved in a fluid.

Earth color: A broken hue found in nature.

Electric arc light: An artificial light that uses various gases to impart a variety of film colors to a surface.

Emphasis: The creation of areas of visual importance for the viewer to focus upon.

Equivocal space: When the eye goes in and out of space simultaneously, so that space appears to change as we view it.

False pairs: The colors resulting from the mixtures of pairs of orange, purple, and green.

Far-reaching space: Space that usually extends far beyond the picture plane.

Film color: The effect on a surface color when certain atmospheric conditions are imposed on it.

Flat color: A single solid area of color used as a design element in printing; also match or spot color.

Flat composition: A composition that relies on hue changes and does

not usually have fine shading or modeling.

Fluorescent light: An artificial light that casts a blue tonality.

Focal point: An area within a composition that provides emphasis and causes the viewer to be drawn to it.

Form: A three-dimensional shape that implies volume.

Fovea: The area at the back of the retina that contains only cone cells and therefore is the area of sharpest color definition.

Frit: A glass color made by roasting an ore with other ingredients.

Gesso: A primer that provides a uniform painting surface.

Glazing: The layering of transparent colors.

Gravure: A printing method in which printing is done from a plate etched with a pattern of recessed cells in which the ink is held. The greater the depth of a cell, the greater the strength of the printed ink. Gravure plates are expensive to make but the process is economical for high-volume printing and reproduces illustrations well.

Harmony: The visual agreement of all the parts of a work which results in the unity of the work.

Hexachrome: A type of printing that adds orange and green to the CMYK system to increase the range of colors.

Highlight: The lightest value on an object's surface.

Hue: The identification or name of a color.

Illusionary space: Two-dimensional space that can be created by color values.

Incandescent light: A type of artificial light that bathes the area in a yellowish glow; also called warm light.

Intensity: Saturation, or the degree of purity of a hue.

Intensity scale: An arrangement of color chips that are the result of mixtures of various quantities of pure hue pigment wheel complementary color.

Integral tripack: Photography film with three layers of gelatin each of

which takes care of a different color.

Interaction: A color's reaction to its placement or position.

Interference of light: The color reaction caused by changing the viewer's position; the blocking of some light or illumination by another object; or a weather condition

Intermediate hue: *See* secondary color.

Interpenetration: A color interaction that occurs along the edges of abutting areas of color.

Intervaled scale: A color scale that forms a smooth equal visual transition from one component of the scale to the next.

Iridescence: The play of colors due to a change of position that results in a glittering effect.

Irradiation: Contrasts created between an object and the ground.

Ishihara test: A test used for color blindness and color confusion diagnosis.

Kinetic effect: The effect resulting from warm/cool contrast.

Lake: A pigment that is combined with a dye to extend the pigment range.

Law of field size: The effect that illumination imposes upon a work.

Light notations: Notations as assigned by Goethe to hues, denoting their strength.

Light wheel: A color wheel arrangement of hues that are the result of projected colored lights. Its primaries are red, green, and blue, and this wheel is the basis for additive color.

Line: A continuous mark on a surface, which imparts motion and contour to images.

Linear composition: The crisp, clean delineation of forms.

Local color: The effect of color as seen in clear daylight.

Logical shading: Shading seen when no definite light source is noted.

Lost-and-found contour: The effect of shapes and forms melting or integrating with the background.

Low intensity colors: Colors that are broken or complementary mixtures (shades).

Luminance: A measure of the value (lightness or darkness) of a mixture of lights.

Luminosity: The ability of a color to give a glowing impression.

Luster: The perception that imparts the impression of subdued light.

Middle-value gray: A mixture of black and white that is neither more black nor white but visually equal.

Medium space: The depth that is conveyed by ordinary vision; also known as moderate space.

Monochromatic color scheme: The use of a single hue and its variations to impart color to a composition.

Mordant: A substance that helps fiber accept and set dyes.

Munsell wheel: A color wheel with hues arranged based on afterimaging. Its principal (primary) colors are yellow, red, violet, blue, and green. This wheel is the basis for partitive color.

Natural order: Using a black background and sequencing to gray and then white, or having a white background and sequencing to gray and then black.

Natural pigments: Pigments that are derived from animal, vegetable, and mineral substances.

Negative afterimage: An afterimage that is seen as the complementary hue of the observed color area.

Neutral: A color such as black, white, or gray that does not contain any pure hue.

Objective color: See local color.

Optical color. The effect of color as seen in lighting conditions other than white daylight, such as rain, sunrise, sunset, candlelight, etc.

Optical mixing: A color phenomenon based on color fusing that occurs in an eye/brain interaction. A new color is created when colors are optically fused.

Pantone Matching System: See PMS system.

Parent: The hue that comprises the greatest visual portion of any color.

Partitive color: The process of placing colors side by side to produce different reactions.

Pastels: Light discords of hues.

Phantom colors: Colors created by the viewer's eye/brain function, resulting from the simultaneous viewing of one or two colors that are spaced a short distance from each other on a neutral background.

Pictorial composition: A composition that imparts the illusion of space and depth and uses shading and modeling.

Pigment: A powder that is in a binder which covers a surface or adheres to a surface. Pigments provide color.

Pigment wheel: A color wheel arranged to facilitate working with subtractive color. Based on the mixing of pigments, its primary colors are red, yellow, and blue.

PMS system: The Pantone Matching System. This system, based on nine colors, black, and transparent white, shows the percentages of colors required to produce a particular color.

Pointillism: The optical mixing of lines, crossed lines, or dots of different colors on a white ground.

Positive afterimage: An afterimage that is the same as the color viewed.

Primary color: A hue that cannot be obtained by mixing. Mixing primary colors forms other hues and colors.

Principal color: One of the five primary hues in Munsell's color model (yellow, red, violet, blue, and green).

Process wheel: A color wheel based on primary hues of yellow, magenta, and cyan. The wheel works with subtractive color and is used for color printing, photography, and certain types of ink manufacture.

Progression: The repeating of a design element in an orderly format that imparts change and therefore motion.

Proportion: The relationship formed between one part of a design and another part, one part and the whole piece, and all the parts to each other and the whole.

Protanopia: The most common type of color blindness, which confuses red and orange with yellow and green.

Pure hue: A hue that contains no black, white, gray, or complementary color in its mixture.

Purkinje effect: The effect of lighting variations on color brightness; also Purkinje shift.

Quadrad color scheme: *See* double complementary color scheme.

Quaternary: The mixture of a primary hue and a tertiary hue in visually equal proportions.

Quinary: The mixture of a secondary hue and a tertiary hue in visually equal proportions.

Reflected light: Light bounced back from nearby surfaces.

Refraction: The bending of a ray of light when it enters a different material.

Repetition: The repeating or sequencing of design elements within a composition.

Retina: The light-sensitive inner lining of the back of the eye.

RGB: Red, green, and blue: the additive primaries used in color television and other color display systems.

Rhythm: A design principle that imposes order and unity using various forms of repetition.

Rods: Cells in the retina that are sensitive to dim light, but not to color.

Saturation: The relative purity of a hue. All pure hues are fully saturated.

Scale: The concept of size relationships.

Scumble: To apply a layer of opaque or semi-opaque pigment irregularly, so that some of the color underneath remains visible.

Secondary color: A hue resulting from the mixing of a primary hue and an adjacent primary hue. Also termed intermediate hue.

Sfumato: A technique in which lines are softly graded and blended to give a smoky effect. Glazing can also be used to achieve sfumato.

Shade: A dull color resulting from mixing a pure hue with its complementary pigment wheel hue.

Shadow: The casting of light that results in the defining or transposition of a shape into a form.

Shallow space: Images in a barely perceptible space.

Shape: An image that conveys area.

Simultaneous contrast: A partitive color reaction when color is in a complementary setting.

Space: Space refers to the distance, void, or interval between objects.

Split complementary color scheme: A color scheme formed from any hue and the two hues at each side of its complementary hue.

Spreading effect: *See* Bezold effect.

Stable: Easily recognized (of hues).

Structural color: An illusionary color that gives us information about the material composition of an object.

Subtractive color: The process of mixing pigments together.

Successive contrast: A color interaction based on afterimaging.

Surface color: The hue that most closely describes the color of an image or parts of an image.

Symbolism: The use of visual imagery to represent a message or concept.

Symmetrical balance: Balance that relies on a "mirror image" of design components, in which both sides of the work are equal.

Synergistic color: Color interactions developed by Arthur Hoener based on using orange, green, and violet as the primary colors.

Temperature: The warmth or coolness of a color.

Tertiary color: A hue that results from the mixing of a primary hue and an adjacent secondary hue.

Texture: The quality of surface and its relative smoothness or roughness. Texture may be actual or implied.

Tint: The color resulting from adding black or white to a hue.

Tinting strength: How a pigment's intensity reacts when mixed with white and the binder.

Tonality: The dominance of one hue in a composition.

Toning: The procedure of working a composition on a mid-value surface.

Translucent: Denotes that light can pass through the material but the material is not entirely transparent.

Transparency: When objects overlap but are still seen in their entirety.

Transparent: Denotes that light can pass through the material, and things within or behind the material can be seen clearly.

Triad color scheme: A color scheme formed by three hues that are equidistant from each other on the color wheel.

Triadic color system: A rule that there should be an equal balance between sunlight and shadows in a composition.

Tritanopia: A form of color blindness in which sensitivity to blue is reduced.

Typographical order: Sequence with the darkest value at the top and the lightest at the bottom.

Value: The lightness or darkness of a color.

Vehicle: A binding agent for pigments.

Visible spectrum: The range of colors that can be perceived by the human eye. When light is projected through a prism, the array order is: red, orange, yellow, green, blue, indigo, and violet.

Visual array: The arrangement of colors as produced by Newton in his prism experiments.

Visual vibration: The effect of pairing equal valued complementary hues in a partitive setting.

Visual wheel: A color wheel arrangement with the primaries yellow, red, blue, and green. It is based on partitive color.

Warm grays: Grays that result from mixing white with a black that is generated by mixing red, yellow, and blue together.

Warm hues: Warm hues are usually related to red and include: yellow, yellow-orange, orange, red-orange, red, and red-violet. Red-orange is the warmest hue.

Warm light: See incandescent light.

Wavelength: A measure of light: the distance between crests in a wave of energy.

Bibliography

- Aims, Jim. *Color Theory Made Easy*. New York: Watson-Guptill, 1996
- Albers, Josef. *Homage to the Square*. New York: Museum of Modern Art, 1964
- Albers, Josef. *Interaction of Color*. New Haven, CT: Yale University Press, 1975
- Albers, Josef. Search versus Re-search. Hartford, CT: Trinity College Press, 1969
- Allen, Jeanne. *Designer's Guide to Color 3*.
 San Francisco, CA: Chronicle Books, 1986
- Anderson, Sara. *Colors*. New York: E.P. Dutton, 1988
- Ardley, Neil. *The Science Book of Color*. San Diego, CA: Harcourt Brace Jovanovich, 1991
- Armstrong, Tim. Colour Perception. Stradbroke, Norfolk, UK: Tarquin Publications, 1991
- Beyer, Jinny. Jinny Beyer's Color Confidence for Quilters. Gualala, CA: Quilt Digest Press, 1992
- Birren, Faber. *Color and Human Response*. New York: Van Nostrand Reinhold, 1978
- Birren, Faber. *Color and Perception in Art.*New York: Van Nostrand Reinhold, 1976 (reprinted West Chester, PA: Schiffer Publishing, 1986)
- Birren, Faber. Color: A Survey in Words and Pictures. Secaucus, NJ: Citadel Press, 1963
- Birren, Faber. *Color in Your World*. New York: Collier Books, 1978
- Birren, Faber. *Creative Color*. New York: Reinhold Publishing Corporation, 1961 (reprinted West Chester, PA: Schiffer Publishing, 1987)
- Birren, Faber. Light, Color and Environment. Third edition, West Chester, PA: Schiffer Publishing, 1988
- Birren, Faber. Principles of Color. West Chester, PA: Schiffer Publishing, 1987
- Birren, Karen (ed.). A Grammar of Color. New York: Van Nostrand Reinhold, 1969
- Borgeson, Bet. *Color Drawing Workshop*. New York: Watson-Guptill, 1984
- Brusatin, Manlio. *A History of Colors*. Boston, MA: Shambhala, 1991
- Carter, Rob. *Digital Color and Type*. Switzerland: RotoVision, 2002
- Chevreul, M.E. *The Principles of Harmony* and Contrast of Colors. West Chester, PA: Schiffer Publishing, 1987
- Chijiiwa, Hideaki. Color Harmony. Rockport, MA: Rockport Publishers, 1987

- Clegg, Emma. *The New Color Book: 45,000 Color Combinations for your Home.* San Fransisco: Chronicle Books, 2004
- Clinch, Moira (ed.). *The Watercolor Painter's Pocket Palette*. Cincinnati, OH: North Light Books, 1991
- Cook, Alton, and Fleury, Robert. *Type and Color*. Rockport, MA: Rockport
 Publishers, 1989
- Cornell, Judith. *Drawing the Light from Within*. New York: Prentice Hall, 1990 (reprinted Wheaton, IL: Quest Books, 1997)
- De Grandis, Luigina. *Theory and Use of Color*. New York: Abrams, 1986
- Doyle, Michael E. *Color Drawing*. New York: Van Nostrand Reinhold, 1993
- Eckstein, Helene W. Color in the 21st Century. New York: Watson-Guptill, 1991
- Eiseman, Leatrice. *Pantone Guide to Communication with Color*. Florida: Grafix Press Ltd., 2000
- Eiseman, Leatrice, and Herbert Lawrence. *The Pantone Book of Color*. New York: H.N. Abrams, 1990
- Ellinger, Richard Gordon. *Color Structure* and Design. Scranton, PA: International Textbook Co., 1976 (reprinted New York: Van Nostrand Reinhold, 1980)
- Emery, Richard. *Color on Color*. Rockport, MA: Rockport Publishers, 1993
- Emery, Richard. *Type and Color 2*. Rockport, MA: Rockport Publishers, 1994
- Fabri, Ralph. *Color*. New York: Watson-Guptill, 1967
- Falk, David S., Brill, Dieter R., and Stork, David G. *Seeing the Light*. New York: Harper & Row, 1986
- Felix, Monique. *The Colors*. Mankato, MN: Creative Education, 1991
- Finlay, Victoria. *Color, a Natural History of* the Palette. New York: Ballantine Books, 2002
- Gage, John. *Color and Culture*. Boston: Little, Brown & Co., 1993
- Galton, Jeremy. *Color*. Edison, NJ: Chartwell Books, 1994
- Garau, Augusto. *Color Harmonies*. Chicago, IL: University of Chicago Press, 1993
- Gerritsen, Frans. *Evolution in Color*. West Chester, PA: Schiffer Publishing, 1988
- Gerritsen, Frans. *Theory and Practice of Color*. New York: Van Nostrand Reinhold, 1983
- Gerstner, Karl. *The Forms of Color*. Cambridge, MA: MIT Press, 1986
- Goethe, Johann Wolfgang von. *Theory of Colors*. Cambridge, MA: MIT Press,
- Guptill, Arthur. Color in Sketching and Rendering. New York: Reinhold Publishing, 1935
- Hall, Marcia. *Color and Meaning*. New York: Cambridge University Press, 1992

- Hickethier, Alfred. *Color Mixing by Numbers*. New York: Van Nostrand Reinhold, 1970
- Hirsch, Robert. Exploring Color Photography. Madison, WI: Brown & Benchmark, 1993
- Holtzchue, Linda. *Understanding Color*. New York: Van Nostrand Reinhold, 1995
- Hope, Augustine, and Walch, Margaret. *The Color Compendium*. New York: Van Nostrand Reinhold, 1990
- Howard, Constance. *Embroidery and Colour*. New York: Van Nostrand Reinhold, 1976
- Hubbard, Hesketh. *Notes on Colour Mixing*. London: Windsor & Newton, 1955
- Itten, Johannes. *The Art of Color*. New York: Van Nostrand Reinhold, 1973
- Itten, Johannes. *The Color Star*. New York: Van Nostrand Reinhold, 1986
- Itten, Johannes. *The Elements of Color*. New York: Van Nostrand Reinhold, 1970
- Jackson, Carole. Color Me Beautiful. Washington, DC: Acropolis Books,
- Jeunesse, Gallimard, and de Bourgoing, Pascale. *Colors*. New York: Scholastic Inc., 1987
- Jillybean and Watson, Barbara, *Let's Color*. Georgia: Demis Products Inc., 1988
- Justema, William and Justema, Doris.

 Weaving and Needlecraft Color Course.

 New York: Van Nostrand Reinhold, 1971
- Kobayashi, Shigenobu, and Nippon Color and Design Research Institute Inc. *A Book of Colors*. Tokyo and New York: Kodansha International, 1987
- Kobayashi, Shigenobu. *Color Image Scale*. Tokyo and New York: Kodansha International, 1991
- Kriesberg, Irving. Working with Color. Upper Saddle River, NJ: Prentice Hall, 1986
- Küppers, Harald. *The Basic Law of Color Theory*. Woodbury, NY: Barron's, 1982 Küppers, Harald. *Color Atlas*. Woodbury,
- NY: Barron's, 1982 Lamb, Trevor, and Bourriau, Janine.
- Color: Art and Science. New York: Cambridge University Press, 1995 Lambert, Patricia Staepelagre, Barb.
- Lambert, Patricia, Staepelaere, Barbara, and Fry, Mary. Color and Fiber. West Chester, PA: Schiffer Publishing, 1986
- Lambert, Patricla. Controlling Color. New York: Design Press, 1991
- Lidzey, John, Mirza, Jill, Harris, Nick and Galton, Jeremy. *Color Mixing for Artists*. New York: Barrons, 2002
- Lüscher, Max. *The Lüscher Color Test*. New York: Random House, 1969
- Mante, Harald. *Color Design in Photography*. New York: Van Nostrand Reinhold, 1972
- Martin, Judy. Airbrushing Shadows. Cincinnati, OH: North Light Books,

- Martin, Judy. *Dynamic Color Drawing*. Cincinnati, OH: North Light Books, 1989
- Martin, Judy. *High Tech Illustration*. Cincinnati, OH: North Light Books, 1989
- Martin, Judy. Rendering Highlights. Cincinnati, OH: North Light Books, 1988
- Martin, Judy. Rendering Metals. Cincinnati, OH: North Light Books, 1989
- Martin, Judy. Rendering Transparency. Cincinnati, OH: North Light Books, 1989
- Marx, Ellen. *Optical Color and* Simultaneity. New York: Van Nostrand Reinhold, 1983
- Matthaei, Rupprecht. *Goethe's Color Theory*. New York: Van Nostrand Reinhold, 1971
- Munsell, Albert. A Color Notation. Eleventh edition, Baltimore, MD: Munsell Color Co. Inc., 1946
- Nemser, Cindy. Benn Cunningham: A Life with Color. Post, TX: JPL Art Publishers, 1989
- Padgham, C.A., and Saunder, J.E. The Perception of Light and Color. New York: Academic Press, 1975
- Parramon, José María. *The Book of Color*. New York: Watson-Guptill, 1993
- Parramon, José María. *Color Theory*. New York: Watson-Guptill, 1988
- Poling, Clark. *Bauhaus Color*. Atlanta, GA: High Museum of Art, 1975
- Portmann, Adolf, et al. *Color Symbolism*. Zurich: Spring Publications, 1977
- Quiller, Stephen. *Color Choices*. New York: Watson-Guptill, 1989
- Quimby, Nellie Earles. Beauty in Black and White. Richmond, VA: Dietz Press, 1953
- Rabergh, Hilkka. Ferga Forma Forverkliga. Västerås, Sweden: ICA, 1985
- Rainwater, Clarence. *Light and Color*. New York: Golden Press, 1971
- Reed, Hal. Analogous Color Wheel. Woodland Hills, CA: Art Video Productions, 1987
- Riedy, Mark. Airbrush Techniques: Liquids. Cincinnati, OH: North Light Books, 1988
- Riedy, Mark. Airbrush Techniques: Reflective Surfaces. Cincinnati, OH: North Light Books, 1988
- Riedy, Mark. Airbrush Techniques: Textured Surfaces. Cincinnati, OH: North Light Books, 1988
- Riedy, Mark. Airbrush Techniques: Transparent/Translucent Objects. Cincinnati, OH: North Light Books, 1988
- Rogondino, Michael and Rogondino, Pat. Computer Color. San Francisco, CA: Chronicle Books, 1990

- Rood, Ogden. *Modern Chromatics*. New York: D. Appleton & Co., 1879 (reprinted New York: Van Nostrand Reinhold, 1973)
- Rossolti, Hazel. *Color*. Princeton, NJ: Princeton University Press, 1983
- Sargent, Walter. The Enjoyment and Use of Color. New York: Dover Publications, 1964
- Schwarz, Hans. *Color for the Artist*. New York: Watson-Guptill, 1968
- Shibukawa, Ikuyoshi, and Takahashi, Yumi. *Designer's Guide to Color 5*. San Francisco, CA: Chronicle Books, 1991
- Sidelinger, Stephen J. Color Manual. Upper Saddle River, NJ: Prentice Hall, 1985
- Silver, Burton. *Colorfax International*. Berkeley, CA: Ten Speed Press, 1991 Smith, Charles. *Student Handbook of Color*.
- New York: Reinhold, 1965
- Stierlin, Henri (ed.). *The Spirit of Colors*. Cambridge, MA: MIT Press, 1981
- Stockton, James, et al. *Designer's Guide to Color*. San Francisco, CA: Chronicle Books, 1984
- Stockton, James, et al. *Designer's Guide to Color 2*. San Francisco, CA: Chronicle Books, 1984
- Swirnoff, Lois. *Dimensional Color*. Boston, MA: Birkhäuser, 1989 (reprinted New York: Van Nostrand Reinhold, 1992)
- Tilton, John Kent, and Scalamandré Śilks, Inc. *History of Color as used in Textiles*. New York: The Company, n.d.
- Tison, Annette, and Taylor, Talus. *Adventures of Three Colors*. Columbus, OH: C.E. Merrill, 1980
- Tucker, Marcia. *The Structure of Color*. New York: Whitney Museum of American Art, 1971
- Verity, Enid. *Color Observed*. New York: Van Nostrand Reinhold, 1980
- Walch, Margaret, and Hope, Augustine. *Living Colors*. San Francisco, CA: Chronicle Books, 1995
- Weigle, Palmy. Color Exercises for the Weaver. New York: Watson-Guptill, 1976
- Wilcox, Michael. *Color Mixing Swatch Book*. England: Michael Wilcox School of Color Publishing, 2001
- Wilcox, Michael. *Blue and Yellow Don't Make Green*. Rockport, MA: Rockport Publishers, 1989 (reprinted Cincinnati, OH: North Light Books, 1994)
- Wilcox, Michael. Color Mixing System for Oil Colors. New York: Watson-Guptill, 1983
- Wilcox, Michael. Color Mixing System for Watercolors. New York: Watson-Guptill, 1983
- Wilcox, Michael. *Color Theory for Oil Colors or Acrylics*. New York: Watson-Guptill, 1983
- Wilks, Mike. *The Weather Works*. New York: Holt Rinehart and Winston, 1983

- Willis, Lucy. *Light*. Cincinnati, OH: North Light Books, 1988
- Wolfrom, Joen. *The Magical Effects of Color*. Lafayette, CA: C&T Publishing, 1992
- Wong, Wucius. Principles of Color Design. New York: Van Nostrand Reinhold, 1997
- Woolery, Lee. Marker Techniques Workbook 2. Cincinnati, OH: North Light Books, 1988
- Woolery, Lee. Marker Techniques Workbook 3. Cincinnati, OH: North Light Books, 1988
- Yenawine, Philip. *Colors*. New York: Museum of Modern Art, 1991
- Zelanski, Paul, and Fisher, Mary Pat. *Color*. Englewood Cliffs, NJ: Prentice Hall. 1994
- Zender, Mike. *Getting Unlimited Impact with Limited Color*. Cincinnati, OH: North Light Books, 1994

Additional publications

- Metropolitan Museum of Art. *Josef Albers* at the Metropolitan Museum of Art. New York: Metropolitan Museum of Art, 1971
- Montclair Art Museum. *Josef Albers: His Art and His Influence*. Montclair, NJ: Montclair Art Museum, 1981
- Solomon R. Guggenheim Museum. *Josef Albers: A Retrospective*. New York: Solomon R. Guggenheim Foundation, 1988
- Artist's Color Wheel, USA. New York: The Color Wheel Co., 1989
- Color. New York: Leon Amiel Publisher,
- Color on Color Guide Volume 4, USA. New York: Wyerheuser Company, 1978
- Color Fun. Laguna Hills, CA: Walter Foster Publishing, 1988
- Color Harmony Workbook. Rockport, MA: Rockport Publishers, 1999
- Color and Shape. Buffalo, NY: Albright-Knox Art Gallery, 1971
- Color Spectrum. Philadelphia, PA: Panel Prints, 1987
- Complete Process Color Finder. Rockport, MA: Rockport Publishers, 1991
- The Desktop Color Book. San Diego, CA: Verbum Books, 1992
- How to Mix and Use Color. Philadelphia, PA: Binny & Smith, 1989
- *Interchem: The Color Tree.* New York: Interchemical Corp., 1965
- Light. Loughborough, Leics., UK: Ladybird Science, 1987
- Mix and Match Designers' Colors. New York: Van Nostrand Reinhold, 1990
- Precise Color Communication. Toyko, Japan: Minolta Corporation, 1988
- Sight, Light and Color. New York: Arco Publishing, 1984

A	and complementary hues 53, 7.9	Cézanne, Paul: Pink Onions 32, 8.4
abstract expressionism 143	symmetrical 68-69, 9.9	Chagall, Marc 143
academic hoods 127	Baroque art 140-41	Charlottesville: gardens at Monticello
achromatic color 23, 49	batik 153	14.14
acrylic paints 11, 26, 27, 143-44, 14.10	Battleground, The (Wyeth) 5.4	Chartres Cathedral: Carpenter's Guild
additive color 8, 11	Bauhaus school 19, 20, 155	Signature window 10.15
aerial perspective see atmospheric	Bay, The (Frankenthaler) 14.10	Chauvet cave, Ardèche Valley, France
perspective	Bayeux Tapestry 138, 14.4	14.1
afterimages 11, 17, 57-58, 94-95, 8.3 , 11.1	Before Apples (McCreath) 4.3	Chevreul, Michel-Eugène 16, 142, 162
ageing and vision 133	Bezold effect 97, 11.5	chiaroscuro 13, 41, 47, 88, 90, 140-41
air-traffic control centres 132	Bhanudatta: Rasamanjari 13.6	China 122, 126, 129, 170
Albers, Anni 21	Bible, the 124	Christianity 124–25, 138, 169, 13.5
Albers, Josef 20–21, 163	binders 23, 26, 163, 164	cathedrals 146
color triangle 20, 3.13	Birren, Faber 21, 163	chroma 17, 49
"Homage to the Square" series 101, 11.11	black 9, 10, 26, 39, 40, 44, 49, 6.10 , 7.1 ,	chromatic simultaneous contrast 96,
Alice (Modigliani) 10.12	8.2, 13.1	11.3, 11.4
Allies Day, May 1917 (Hassam) 118, 13.7	outlining 85	chromaticity 23
Amaryllis (Schnitzer) 14.20	symbolism and associations 5, 120, 124,	chrome 91, 10.20
America, Colonial 170	125, 126, 127, 13.1	chromotherapy 132
analogous color schemes 67, 75, 9.4 , 9.5 , 9.21	temperature 56, 57, 8.2	CIE (Commission International de
analogous hues 43	and white 43, 121, 123, 6.7 , 6.8	l'Eclairage) 19, 163
analogous rhythms 67, 9.4 , 9.5	blackwork 153–54	color diagram 19, 3.11
aniline dyes 25, 26	blood pressure 132	Close, Chuck 98
animals 130, 131	blue 9, 11, 12, 39, 130, 131, 1.5 , 1.6 , 2.2–2.4 ,	Lucas 1 11.9, 11.10 CMYK printing 156, 14.25
Anuszkiewicz, Richard: Entrance to Green	2.6, 2.7, 5.1	Cole, Thomas: <i>The Course of Empire: The</i>
9.1 Analogu not Assented (Minorwini) 0.40	symbolism and associations 5, 122–23,	Savage State 1.8
Apology not Accepted (Minervini) 9.19	124, 125, 126, 127, 1.9 , 13.3 temperature 42, 56, 123	Colonial America 170
arbitrary color 6, 73-74, 1.9 architectural order 47, 168, 6.12	1	color 2–3
architectura order 4/, 100, 6.12	Boating Party, The (Cassatt) 9.8 Bochner, Mel: Vertigo 4.2	additive 8, 11
Aristotle 162	borders for artworks 84–85	arbitrary 6, 73–74, 1.9
Arnolfini Wedding, The (van Eyck) 14.5	Bosschaert, Ambrosius, the Elder:	legibility 87, 168
art history 134–44	A Bouquet in an Arched Window 8.6	local 6, 1. 7
Assyrians 146	boundaries, disappearing and dissolving	optical 6, 1.8
asymmetrical balance 69, 9.8 , 9.9	43-44, 6.9	partitive 8, 9, 11, 2.4 , 2. 7
atmospheric (aerial) perspective 13, 59,	Bouquet in an Arched Window, A	perception of 4–5, 1.6
79-80, 8.6 , 10.3	(Bosschaert) 8.6	phantom 102
Australian aboriginal painting 135	bracketing (photography) 151–52	physiology of 3–4, 1.2 , 1.3
automobiles 120, 149, 1. 7	brass 91, 10.20	and psychology 5, 130–34
azo dyes 25	breathing, color 133	and shapes 88–89
	broken hues 5.6	structural 112–13
В	broken tints 40	subtractive 8, 23-26, 2.1 , 9.12
babies and color 132	brown 131, 142	synergistic 102
Babylonians 146	symbolism 121, 124, 125	see also color schemes; color wheels;
backgrounds 59	Buddhism and color 125, 169	hues
and hue intensity 53	buon fresco 135	Color-Aid papers 34, 50, 165-67
and hue repetition 67, 9.8		color blindness 133
and hue temperature 59, 8.4	C	color breathing 133
and hue values 44, 80, 6.10, 10.4	Calder, Alexander 74	color field painters 144
metallic 62-63, 8.8	camouflage 130, 13.8	Color Index, The 24
and optical mixing 102	candlelight 92	color projection 133
and shading 92	cars 120, 149, 1. 7	color schemes 16, 75
and simultaneous contrast 95-96	Cassatt, Mary; The Boating Party 9.8	analogous 67, 75, 9.4, 9.5, 9.21
and spatial effects 78-80, 10.1-10.3	cast shadows 41, 42, 105, 6.4	and balance 69
for transparent objects 82, 10.8	cave painting 134-35, 14.1	complementary 75, 9.22
balance 67-68	ceramics 24, 4.3 , 7.8	double complementary 75-76, 9.23
asymmetrical 69. 9.8. 9.9	glazes 4, 151, 14.19	and harmony 75–76

monochromatic 67, 75, 9.5, 9.20	Credi, Lorenzo di: Drapery for a Standing	film, color 30-31, 4.9
quadrad 76	Man 6.3	film color 84, 111, 10.11
split complementary 76, 9.24	Cubism 80, 143	flags 127–29
triad 40, 76-77, 9.25	cultural associations 5, 120, 126-27	flat compositions 68, 9.7
Color Sphere, The (Runge) 15–16	cyan 9, 10, 11, 35, 2.3 , 2.6 , 5.3	fluorescent lights 92, 103, 111
color therapies 132–33		focal points 72, 73, 9.16, 9.17, 9.18
color wheels and other systems 8–9	D	food colors 130, 131
Albers's triangle 20–21, 3.13	da Vinci see Leonardo da Vinci	form 88–89
Birren's circle and triangle 21	Dalux fluorescent lights 92	form shading 88
CIE diagram 19, 3.11	Davis, Stuart 109–10	form shadow 88
Goethe's wheel and triangle 14–15, 3.3	New York Mural 12.7	fovea 3, 1.3
Harris's wheel 14, 3.2	Daygo (Turrell) 14.11	frames for artworks 84–85
Hering's diagram 16, 3.7	Delacroix, Eugène 141, 142	Frankenthaler, Helen 144
Itten's wheel 19–20, 3.12	Liberty Leading the People 14.6	The Bay 14.10
light wheel 11, 35, 2.6	Democritus 13, 162	3
	-,	fresco painting
Maxwell's triangle 16, 3.5	depression 132	Egyptian 135, 140
Munsell's wheel and tree 10–11, 12,	depth, intensity and 54	Roman 137–38, 14.3
16–18, 35, 2.4, 2.5, 3.8, 3.9	Derain, André 143	frit 135
Newton's wheel 13–14, 3.1	Destination Infinity (Minervini) 14.18	_
Ostwald's solid 18, 3.10	deuteranopia 133	G
pigment wheel 9, 35, 2.2	di Credi, Lorenzo see Credi, Lorenzo di	Gauguin, Paul 110
process wheel 9-10, 35, 2.3, 5.3	diffraction 115	Three Tahitians 12.8
Rood's wheel 16, 3.6	digital photography 152	Gaultier, Jean-Paul: "Little black dress" 13.1
Runge's sphere 15-16, 3.4	Disco Blue (McCreath) 14.19	Gerritsen, Frans 21–22, 163
visual wheel 11-12, 2.7	discords 40-41, 6.2	gesso 4, 27
Coloribus, De (Aristotle) 13	distance, illusion of 80, 10.3	Giotto 135
colorpuncture 133	divisionism 97-98, 11.6	glass 82-83, 151, 10.8
complementary hues 11, 17, 50-51, 7.4	Dominis, Marco Antonio de 162	glazes
and balance 53, 7.9	double complementary color schemes	ceramics 4, 151, 14.19
contrast 53	75-76, 9.23	painting 52, 7.7
equal value 54, 7.10	Drapery for a Standing Man (Credi) 6.3	Goethe, Johann Wolfgang von 14–15, 55,
false pairs 51, 7.5	drawing 39, 87–88, 10.16	61, 69–70, 75, 162, 3.3, 7.11, 9.13 ,
glazes 52, 7.7	dyes 11, 23–26, 27, 134	9.20-9.25
intensity 50–53, 54–55, 7.3, 7.4	dyslexia 132	color triangle 14–15, 3.3
and optical mixing 97	1,52	color wheel 14, 3.3
outlining 85–86, 10.13	E	Gogh, Vincent van 142
and proportion 54–55	earth colors 37	Starry Night 14.7
and temperature 56	Egyptians, ancient 127, 135, 152, 170, 14.2	gold 62-63, 8.8 , 8.9
see also color schemes	elderly people 133	
composition	electric arc lights 92	rendering 91, 10.20
and balance 67–69		Golden Cell (Blue Profile), The (Redon)
flat 68, 9. 7	embroidery 27, 120, 152 emotion and color 42, 123, 130–31	opp.1, 1.9
		golden rectangle 72, 9.17, 9.18
and hue 37–38, 44–45, 52–53, 59–61	see also psychological factors	Goodwin, John 70, 75, 9.21
and hue temperature 59–61	Empedocles 13, 162	Gothic cathedrals 146
intensity 52–55, 70–71	emphasis 72–74, 9.15	see also Chartres
linear 92	Entrance to Green (Anuszkiewicz) 9.1	gouache painting 27
pictorial 67–68, 9. 7	equivocal space 80	Goya, Francisco 141
and proportion 54–55, 61–62, 69–71	Estes, Richard: Woolworth's 10.19	graphic design 155
scale 71–72, 9.14	Evans, Ralph M. 97	Graves, Michael 147
and value 43–48	Experiment on a Bird in an Air Pump, An	gray 39, 6.1
computers 11, 23, 149, 156–57	(Wright) 10.8	and adjacent hues 44, 95, 6.11 , 11.2
contrast	Expressionists 6	colored 40, 49-50, 78, 7.2
and balance 69	Eyck, Jan van 140	middle-value 39, 6.1
complementary hues 53	The Arnolfini Wedding 14.5	neutral 51, 7.5
and emphasis 74	eye, human 3-4, 1.2 , 1.3	optical mixing 43
pattern 69, 9.10		symbolism and associations 121
primary hues 38	F	temperature 57, 8.2
simultaneous 13, 16, 95-96, 11.3, 11.4	fabric see textiles	Greco, El 47
successive 15, 16, 94–95	false pairs 51, 7.5	View of Toledo 47, 6.15
and value 43, 6.7 , 6.8	far-reaching space 80, 10.5	Greece, ancient 127, 135–37, 146, 152, 170
cool hues 56, 61–62, 85, 123, 131	fashion 154	green 4, 9, 10, 11, 12, 39, 131, 1.5 , 1.6 ,
copper 91, 10.20	Fauves, The 6, 143	2.2-2.4, 2.6, 2.7, 5.1, 5.3
core of shadow 41, 6.3	fiber arts 152–53	symbolism and associations 122, 124,
cosmetics industry 131	see also embroidery; tapestries;	125, 126, 127, 13.5
Course of Empire: The Savage State (Cole) 1.8	textiles	temperature 56
Crayola crayons 120	Fighting "Téméraire," The (Turner) 6.14	grounds 26–27, 96
	oming remember, The (Turner) 0.14	Divando 20 2/, 90

Н	iron 91, 10.20	luster 116, 12.16
Hardware (Luttropp) 14.24	Ishihara tests 133	Luttropp, John: Hardware 14.24
harmony 74–76	Islam and color 125, 129, 169	
Harris, Moses 14, 162	Itten, Johannes 19–20, 163, 3.12	M
color wheel 14, 3.2	Ive, Jonathan 149	magenta 9, 10, 11, 35, 2.3, 2.6, 5.3
Hassam, Childe: Allies Day, May 1917 118, 13.7		manuscript illumination 138
health care 131, 132-33, 13.9	J	Matisse, Henri 143
Helmholtz, Hermann 17, 162	Japan 126–27, 155, 170	The Red Studio 1.1
heraldry 127–29	jewelry 135, 154, 14.23	matting 84-85
Hering, Ewald 16, 162	Judaism and colors 122, 125, 169	Maxwell, J. C. 16, 162
primaries 16, 3.7		color triangle 16, 3.5
Hersey, William see Moore, Charles W.	K	McCreath, William
hexachrome printing 156	Kalf, William: Still-Life with the Drinking-	Before Apples 4.3
Hickethier, Alfred 20, 163	Horn of the Saint Sebastian Archer's	Disco Blue 14.19
numbering system 5.3	Guild, Lobster and Glasses 10.2	medieval color 138, 170
highlights 40, 41, 42, 89–90, 6.2–64, 10.18 ,	Kandinsky, Vassily 20, 143	medium space 80, 10.5
10.20	Several Circles, Number 323 14.9	Memphis Group 149, 14.15
Hinduism and color 122, 125–26, 169, 131.6	kinetic effects 61, 8.7	metals 62–63, 90–91, 10.20
Hockney, David 144	Klee, Paul 51, 143, 163	see also gold; silver
Hoener, Arthur 98, 101–2	Kueppers, Harald 102, 163	Michelangelo 140
"Homage to the Square" series (Albers)	Rucppers, Haraid 102, 103	Minervini, Robert 74
101, 11.11	L	Apology not Accepted 9.19
	lakes (pigments) 24	Destination Infinity 14.18
hospitals 131, 132, 13.9 hues 3, 16, 17		Mistress and Maid (Vermeer) 12.6
	landscape design 148–49, 14.14	
analogous 43, 6.9	Landscape with a Specific View (Veritas,	Modern Chromatics (Rood) 16
backgrounds see backgrounds	Utilitas, Venustas) (Ligare) 6.6	Modigliani, Amedeo 85 Alice 10.12
broken 37, 43, 5.4–5.6 , 6.9	languages and color 120	
complementary see complementary	Last Supper, The (Leonardo) 4.6	Mona Lisa (Leonardo) 7.6
hues	Lawrence, Jacob: The Studio 5.2	Mondrian, Piet 147, 154, 14.22
in compositions 37–38, 44–45, 52–53,	Le Blon, J. C. 162	Monet, Claude 98
52-54, 59-60	legibility of colors 87, 168	Impression: Sunrise 142
discords 40-41, 6.2	Leonardo da Vinci 11, 13, 52, 140, 162	Le Soleil dans le Brouillard 64, 12.13
intensity see intensity	The Last Supper 4.6	monochromatic color schemes 67, 75,
mixing 34–37	Mona Lisa 7.6	9.5, 9.20
primary 9, 11, 12, 16, 17, 38, 2.2–2.7 , 3.7	Liberty Leading the People (Delacroix) 14.6	monochromatic rhythms 67, 9.5
pure 34, 69, 72, 5.1 , 5.2 , 9.10 , 9.15	Ligare, David: Landscape with a Specific	Monticello gardens, Charlottesville 14.14
quarternary 37	View (Veritas, Utilitas, Venustas) 6.6	Moore, Charles W. 147
quinary 37	light 4, 91–92, 103, 10.21	(with William Hersey) Piazza d'Italia,
secondary 9, 11, 12, 38, 2.2-2.7, 5.7	artificial 92	New Orleans 14.12
tertiary 9, 38, 2.2–2.4 , 2.7 , 5. 7	chromatic 112, 12.11	Moore, Henry: <i>Sheep # 43</i> 10.16
values 39-40, 6.1	electric arc lights 92	mordants 24
	film color 84, 111, 10.11	Morris, William 143, 14.8
I	fluorescent 92, 103, 111	mosaics 138
icons 63, 8.8	and hue 39	Moulin de la Galette, Le (Renoir) 12.3
illnesses 132–33	incandescent 92, 111	Munsell, Albert 10-11, 162
illusionary space 80	mixing colors 23, 4.1	color theories 10-11, 12, 16-18, 35, 50, 51,
iMac colors 149	theatrical 8, 11, 23	2.4, 2.5, 3.8, 3.9
Impression: Sunrise (Monet) 142	in time and weather 5-6, 92, 104,	
Impressionism 16, 27, 57, 100, 142	109-11, 12.9	N
see also Monet, Claude	types 92-93	Native Americans 127
In the Patio, 1 (O'Keeffe) 12.10	visible spectrum 4, 1.4, 1.6	Navajo blanket 4.4
incandescent light 92, 111	see also shadows and shading	Natural Color System, Swedish (NCS)
India 127, 170	light installations 144, 14.11	16
indigo 25, 123	light wheel 11, 35, 2.6	Natural History (Pliny) 137
Ingres, Jean-Auguste 141	line 85–88, 10.12–10.16	Natural System of Colors, The (Harris) 14
installations, light 144, 14.11	linear composition 92	nature and color 130, 13.8
intensity 49–50	Liquitex acrylic paint 11	Nauman, Bruce: The True Artist Helps the
complementary hues 50–53, 54–55, 7.3 ,	local color 6, 1.7	World by Revealing Mystic Truths
	logos 155	12.17
7.4 in compositions 52, 55, 70, 71	lost-and-found contour 73	Navajo blanket 4.4
in compositions 52–55, 70–71	Louis, Morris 144	Neo-Impressionism 16, 27
spatial effects 54, 72, 84		Neoclassicism 141–42
interior design 4, 75, 85, 97, 123, 131–32,	Lucas 1 (Close) 11.9, 11.10	
141, 143, 149, 1.5 , 13.4 , 14.8	Luckiesch, M. 87	neutrals 11, 57
iPod colors 14.16	luminance 23	New Orleans: Piazza d'Italia (C. W
IQ testing 132	luminosity 15, 113, 12.12, 12.13	Moore) 14.12
iridescence 115, 12.14 , 12.15	and discords 40–41	New York Mural (Davis) 12.7

Newton, Sir Isaac 4, 13–14, 162	Pliny the Elder: Natural History 137	rock paintings, Australian 135
color wheel 14, 3.1	PMS see Pantone Matching System	rods and cones (eye) 3
Noland, Kenneth 144	pointillism 16, 97-100, 11.7-11.10	Rogers, Richard 147
	Pompeii 137–38, 170, 14.3	(with Renzo Piano) Pompidou Centre,
O	Pompidou Centre, Paris (Richard Rogers)	Paris 14.13
ochers 37	14.13	Romans, ancient 127, 137-38, 146
oil painting 27, 139-40	Postimpressionism 142	Romanticism 141-42
O'Keeffe, Georgia 110, 144	primary hues 9, 11, 12, 16, 17, 38, 2.2–2.7 ,	Rood, Ogden 16, 162
In the Patio, 1 12.10	3.7	color wheel 3.6
Oklahoma bomb memorial 147	primers 27	Rothko, Mark 144
Old Guitarist, The (Picasso) 13.3	principal colors 11	Rubens, Peter Paul 140
optical color 6, 1.8	Principles of Harmony and Contrast of	Runge, Philip Otto 15–16, 162, 3.4
optical mixing 16, 43, 97–102, 11.6–11.11	Colors (Chevreul) 16	Kunge, 1 mmp Otto 15-10, 102, 3.4
orange 9, 10, 12, 39, 130, 131, 1.5 , 1.6 ,	,	S
	printing 9, 20, 22, 23, 27–30, 155–57, 4.7 ,	
2.2–2.4, 2.7, 5.1, 5.3	4.8	saffron 125
symbolism and associations 121	process wheel 9–10, 35, 2.3 , 5.3	Saint Laurent, Yves 14.22
temperature 56	product design 149-50, 14.16 , 14.17	Sargent, Walter 21, 87, 162
order 45–48, 168, 6.12	proportion 54–55, 61–62, 69–71, 7.11 ,	saturation 11, 17, 3.8
Ostwald, Wilhelm 16, 18, 163	9.11-9.13	see also intensity
color solid 3.10	protanopia 133	scale 71–72, 9.14
outlining 85–88, 95, 10.13–10.15	Protuzoa (Scheinman) 14.21	Scheinman, Pamela: Protuzoa 14.21
	psychological factors 5, 130–34	Schnitzer, Klaus: Amaryllis 14.20
P	see also emotion and color	sculpture 150
paints 4, 27	Purkinje effect/shift 110-11	scumbling 144
acrylic 11, 26, 27, 143-44, 14.10	purple	secondary hues 9, 11, 12, 38, 2.2-2.7, 5.7
ancient Egyptian 135	associations 123	Self-Portrait on a Sill (Rembrandt) 6.13
gouache 27	Tyrian purple 137, 138	sequencing see order
ancient Greek 137	see also violet	Seurat, Georges 16, 98, 142
medieval 138	occ also violet	Sunday Afternoon on the Island of La
oil 27, 139–40	Q	Grande Jatte 11.7
Paleolithic 134–35	quadrad color schemes 76	
ancient Roman 137–38, 14.3	quarternary hues 37	Several Circles, Number 323 (Kandinsky)
		14.9
synthetic 142	quilting 152, 153	sfumato 13, 140, 7.6
tempera 135, 140	quinary hues 37	shades (hues) 50
watercolor 27, 39, 138	P	shadows and shading 41-42, 103-5, 6.4 ,
Paleolithic art 134–35, 170, 14.1	R	12.1, 12.2
Pantone Matching System (PMS) 29–30,	Rahotep and Nofret (sculpture) 14.2	cast shadows 41, 42, 105, 6.4
156, 4.8	raindrop patterns 42, 6.5	chiaroscuro 13, 41, 47, 88, 90, 140-41
Paris: Pompidou Centre (Richard Rogers)	Rasamanjari (Bhanudatta) 13.6	core of shadow 41, 6.3
14.13	red 4, 9, 10, 11, 12, 39, 130, 131, 1.5 , 1.6 ,	on fabrics 106-7, 6.3 , 12.6
partitive color 8, 9, 11, 2.4 , 2.7	2.2-2.4, 2.6, 2.7	form shading 88
pastels 40	discording 40	form shadow 88
pattern 69, 74, 9.10	symbolism and associations 5, 121, 124,	light sources 105, 12.4
perception of color 4-5, 1.6	125, 126, 127, 130, 131	logical shading 91
Persians 146–47	temperature 42, 56, 123	perspective of shadows 105-6, 12.5
perspective	Red Studio, The (Matisse) 1.1	reflected shadows 41, 42, 89-90, 6.4,
atmospheric (aerial) 13, 59, 79-80, 8.6 , 10.3	Redon, Odilon: The Golden Cell (Blue	10.18
of shadows 105-6, 12.5	<i>Profile</i>) opp. 1, 1.9	on surfaces 106-7, 6.3 , 12.6
pewter 91, 10.20	reflected color/shadow 41, 42, 89-90, 6.4,	and value 41-42, 6.4
phantom colors 102	10.18	shallow space 80, 10.5
photography 8, 9, 16, 27, 30–31, 39, 43,	reflective surfaces 89-91, 10.18	shape and color 88–89
151–52, 14.2 O	see also metals	Sheep # 43 (Moore) 10.16
color film 30-31, 4.9	refraction 115	Signac, Paul 98
Piano, Renzo see Rogers, Richard	religions and color 124–26, 169	silver 62–63, 8.8 , 8.9
Piazza d'Italia, New Orleans (C. W.	Rembrandt van Rijn 47, 140	rendering 91, 10.20
Moore) 14.12	Self-Portrait on a Sill 6.13	simultaneous contrast 13, 16, 95
Picasso, Pablo: The Old Guitarist 13.3	Renaissance 11, 47, 92, 138–40, 170	achromatic 95–96
pictorial compositions 67–68, 9. 7		
	Renoir, Pierre-Auguste: Le Moulin de la	chromatic 96, 11.3, 11.4
pigment wheel 9, 35, 2.2	Galette 12.3	Soleil dans le Brouillard, Le (Monet) 64, 12.13
pigments 4, 8, 23–27, 164, 4.5		Sottsass, Ettore 149
	repetition of hues 66–67, 74, 9.1 , 9.2 , 9.8	
pink 39, 121, 130	Republic (Plato) 137	space/spatial effects 10.5
Pink Onions (Cézanne) 32, 8.4	Republic (Plato) 137 restaurants 131	space/spatial effects 10.5 background values 78–80, 10.1–10.3
<i>Pink Onions</i> (Cézanne) 32, 8.4 pixels 156, 157	Republic (Plato) 137 restaurants 131 retina, the 3, 1.2, 1.3	space/spatial effects 10.5 background values 78-80, 10.1-10.3 equivocal space 80
<i>Pink Onions</i> (Cézanne) 32, 8.4 pixels 156, 157 plants 130	Republic (Plato) 137 restaurants 131 retina, the 3, 1.2 , 1.3 RGB system 157, 14.25	space/spatial effects 10.5 background values 78–80, 10.1–10.3 equivocal space 80 far-reaching space 80, 10.5
<i>Pink Onions</i> (Cézanne) 32, 8.4 pixels 156, 157	Republic (Plato) 137 restaurants 131 retina, the 3, 1.2, 1.3	space/spatial effects 10.5 background values 78-80, 10.1-10.3 equivocal space 80

shallow space 80, 10.5	reflective surfaces 89–91, 10.18 see also	vermilion 137
and temperature 79-80, 123	metals	Vertigo (Bochner) 4.2
and texture 89	and shadows 106	video graphics 11, 23
see also translucency; transparency	and temperature 89	View of Toledo (El Greco) 6.15
spectrum, visible 4, 1.4, 1.6	theatrical lighting 8, 11, 23	Vinci, Leonardo da see Leonardo da
perception curve 4–5, 1.6	Theophilus 139	Vinci
split complementary color schemes 76,	Theophrastus 137	violet 9, 10, 11, 12, 39, 1.4, 1.5, 1.6, 2.2-2.4,
9.24	therapies, color 132–33	2.7, 5.1, 5.3
stained glass 85, 138, 151, 10.15	Three Tahitians (Gauguin) 12.8	discords 40
Starry Night (van Gogh) 14.7	tints 39	symbolism 123
steel 91, 10.20	broken 40	temperature 56
Stella, Frank 143	tonality 38	Virgin and Child (Anon.) 8.8
Stijl, de 147	and harmony 75	visual vibration 101
Still-Life with the Drinking-Horn of the	and temperature 59–60	visual wheel 11-12, 2.7
Saint Sebastian Archer's Guild,	toning 43	volume color 83, 10.10
Lobster and Glasses (Kalf) 10.2	translucency 83, 10.9	
structural color 112–13	transparency 80–83, 10.6–10.8 , 10.19	W
	Treatise on Painting (Leonardo) 13	wall paintings
Studio, The (Lawrence) 5.2	triad color schemes 40, 76–77, 9.25	Egyptian 135
Study for Homage to the Square (Albers) 11.11		Paleolithic 134–35, 14.1
subtractive color 8, 2.1, 9.12	triadic color system 70, 9.12	Roman 137–38, 14.3
mixing 23–26	tritanopia 133	warm hues 56, 61–62, 85, 123, 131, 13.4
successive contrast 15, 16, 94–95	True Artist Helps the World by Revealing	Washington: Vietnam Veterans
Sugarman, George 74	Mystic Truths, The (Nauman) 12.17	Memorial, 147
Sunday Afternoon on the Island of La	Turner, J. M. W. 47, 141	
Grande Jatte (Seurat) 11.7	The Fighting "Téméraire" 6.14	water 83, 90, 10.10
sunlight 104, 109, 110, 12.3	Turrell, James 144	watercolors 27, 39, 138
symbolism of colors 5, 120–23	Daygo 14.11	wavelengths 3
flags and heraldry 127–29	typographical order 47, 168, 6.12	weather 104, 109–10
religious and cultural 124-27	Tyrian purple 137, 138	raindrops 42, 6.5
the Zodiac 127		weaving 152
symmetrical balance 68-69, 9.9	U	website design 157
synergistic color 102	Unicorn tapestries 138	white 4, 26, 39, 40, 44, 49, 6.10 , 7.1
		and black 43, 121, 123, 6.7
T	V	outlining 85
Taoism 125	values 3, 8, 17, 39-40, 6.1	symbolism and associations 5, 120–21,
tapestries 138	backgrounds 44, 80, 6.10 , 10.4	124, 125, 126, 127
Bayeux Tapestry 138, 14.4	in compositions 43–48	temperature 56, 57
television 8, 23	contrast 43, 6.7, 6.8	white light 4, 23, 4.1
tempera paints 135, 140	emotional meaning 42, 123	Woolworth's (Estes) 10.19
temperature of hues 56-59, 123, 8.1-8.4	emphasis 42–43, 72	Wright, Frank Lloyd 145
kinetic effects 61, 8.7	harmony 74	Wright, Joseph: An Experiment on a Bird in
metals 62–63	intensity 54	an Air Pump 10.8
progressions 67, 9.3	order 45–48, 6.12	Wyeth, Andrew: The Battleground 5.4
and proportion 61-62, 70, 9.12, 9.13	pattern 42	
and space 79-80, 123	spatial effects 78–83, 10.1–10.8	Y
and texture 89	toning 43	yellow 4, 9, 11, 12, 39, 131, 1.3 , 1.5 , 1.6 ,
tonality 59-60	see also shadows and shading	2.2–2.7, 5.1, 5.3
tertiary colors 9, 38, 2.2–2.4 , 2.7 , 5.7	van Eyck, Jan see Eyck, Jan van	discording 40
tesserae 138	van Gogh, Vincent see Gogh, Vincent van	symbolism 121–22, 124, 125, 126, 127, 13.2
textiles 8, 11, 24-25, 4.4	vehicles (binding agents) 26	temperature 56, 57–59
shadows un 109, 6.3, 12.6	Velásquez, Diego 140	Young, Thomas 162
see also embroidery	Venturi, Robert 147	
texture 4, 42, 89–90, 10.1 7	verdigris 137	Z
and emphasis 73	Vermeer, Jan: Mistress and Maid 12.6	Zodiac, the 127

Laurence King Ltd, Fairchild Publications, the picture researcher, and the author wish to thank the institutions and individuals who have kindly provided photographic materials or artwork for use in this book. Every effort has been made to contact copyright holders, but should there be any errors or omissions we would be pleased to insert the appropriate acknowledgment in the subsequent edition of this publication.

Literary Credit

Caption for fig. 3.6: Ogden N. Rood, Modern Chromatics, 1879. Facsimile edition, New York; London: Van Nostrand Reinhold Co., Inc., 1973, p. 163.

Illustration Credits

1.2, 3.6, 3.8, 3.9, 3.10: Color, 3e, by Paul Zelanski and Mary Pat Fisher, 1999 (Laurence King/Prentice Hall, Inc.).

Picture Credits

- © Succession H Matisse/DACS 2005
- Photo by Bruce White, copyright White House Historical Association
- David Kimber The Car Photo 1.7 Library, Dorset
- © British Museum 1.9
- Science Museum/Science and 2.5 Society Picture Library
- Alan Pipes 4.1
- William McCreath 4.3
- 4.4 Werner Forman Archive, London
- 4.5 © Margaret Courtney Clarke/Corbis
- 4.6 AKG London
- 5.2 © ARS, NY and DACS, London 2005
- Photo: Robert Newcombe 5.4
- Joanne Larson 5.5
- 5.6 Jessica Neimasz
- 5.7 Jennifer Kievit
- © RMN, Paris/Michèle Bellot 6.3

- Cathy Dikun Cosgrove
- Lorraine Spontak Moreno
- 6.16 Michael Bailey
- Deborah Scott 7.1
- Melinda Beavers 7.3
- 7.6 © Studio Fotografico Quattrone, Florence
- 7.8 © British Museum
- 7.10 Melinda Beavers
- 7.11 Dreux Sawyer
- Elly Madavi 8.2
- © Photo Josse, Paris 8.4
- 8.5 Glenn Mason
- Werner Forman Archive, London 8.8
- 9.1 © DACS, London VAGA, New York 2005
- Grace Kennedy 9.4
- Arna Arvidson 9.6
- April Hill
- Image © 2005 Board of Trustees, 9.8 National Gallery of Art, Washington
- Tricia Malecki 9.9
- Jo Motyka
- 9.18 Pamela Muller
- 9.19 Robert Minervini
- 9.20 Elly Madavi
- 9.21 Michele Nolan
- 9.22 James McGinnis
- 9.23 Xin Xu
- 9.24 Arna Arvidson
- 9.25 Carol von Achen
- 10.7 Mark Harnett
- 10.9 Spectrum, London
- 10.10 Estate of M. Anne Chapman
- 10.11 Michele Nolan
- 10.14 Arna Arvidson
- 10.15 Jane Taylor/Sonia Halliday Photographs, Western Turville
- 10.16 By permission of the Henry Moore Foundation
- 10.21 Steve Cummings
- 11.2 Elaine Brodie
- Danielle Pompeo
- 11.6 Deborah Scott

- 11.8 Elly Madavi
- 11.9, 11.10 Photographs by Ellen Page Wilson/John Back, courtesy of Pace Wildenstein, New York © 2000 Chuck Close
- 11.11 © The Josef and Anni Albers Foundation/VGBild-Kunst, Bonn and DACS, London 2005
- 12.2 Marianne Hauck
- 12.3 © Photo Josse, Paris
- 12.6 © The Frick Collection, New York
- © Estate of Stuart Davis/VAGA, New York/DACS, London 2005
- 12.10, 12.17 © ARS, NY and DACS, London 2005
- 12.14 Deborah Scott
- 13.2, 13.8, 13.9 Images Colour Library, London
- 13.3 © Succession Picasso/DACS 2005
- 13.4 Alamy/Elizabeth Whiting & Associates
- Courtesy Jill Liddell 13.5
- © Fotografica Foglia, Naples
- 14.4 By special permission of City of Bayeux
- 14.6 © Photo Josse, Paris
- 14.7 Scala
- 14.8 © Corbis/Michael Crockett; Elizabeth Whiting & Associates
- © ADAGP, Paris and DACS, London 14.9
- 14.12 © Norman McGrath
- 14.13 A. F. Kersting, London
- 14.14 Monticello—Thomas Jefferson Foundation, Inc., Phillips, 1995
- 14.16 © 2005 Apple Computer, Inc. All rights reserved
- 14.17 Klaus Schnitzer
- 14.18 Robert Minervini
- 14.19 Willam McCreath
- 14.20 Klaus Schnitzer
- 14.21 Pamela Scheinman
- 14.23 Alamy/plainpicture